American Pastels

American Pastels

IN THE METROPOLITAN MUSEUM OF ART

Doreen Bolger, Mary Wayne Fritzsche, Jacqueline Hazzi,
Marjorie Shelley, Gail Stavitsky, Mary L. Sullivan,
Marc Vincent, and Elizabeth Wylie

The Metropolitan Museum of Art

New York

Distributed by Harry N. Abrams, Inc., New York

This volume has been published in conjunction with the exhibition
Revivals and Revitalizations: American Pastels in The Metropolitan Museum of Art
held at The Metropolitan Museum of Art, New York,
from October 17, 1989, through January 14, 1990.

This publication has been made possible in part by a generous grant from
the National Endowment for the Arts
and the William Cullen Bryant Fellows of The American Wing,
The Metropolitan Museum of Art.

John P. O'Neill, *Editor in Chief*
Barbara Burn, *Project Supervisor*
Teresa Egan, *Managing Editor*
Pamela T. Barr, *Editor*
Joseph B. Del Valle, *Designer*
Matthew Pimm, *Production*
Steffie Kaplan, *Mechanical Artist*

Library of Congress Cataloging-in-Publication Data
Metropolitan Museum of Art (New York, N.Y.)
 American pastels in the Metropolitan Museum of Art / by Doreen
Bolger . . . [et al.].
 p. cm.
 Bibliography: p.
 Includes index.
 ISBN 0-87099-547-2.—ISBN
0-8109-1895-1 (Abrams)
 1. Pastel drawing. American—Catalogs. 2. Pastel drawing—19th
century—United States—Catalogs. 3. Pastel drawing—20th century—
United States—Catalogs. 4. Pastel drawing—New York (N.Y.)—
Catalogs. 5. Metropolitan Museum of Art (New York, N.Y.)—
Catalogs. I. Bolger, Doreen. II. Title.
NC885.M48 1989
741.973′074′7471—dc20 89-3310
 CIP

Photographs on pages 50, 63, 68, 70, 92, 124, 129, and 195 (top) were taken by Geoffrey Clements.
Unless otherwise noted, remaining photographs were made by The Photograph Studio, The
Metropolitan Museum of Art.

Typeset by Trufont Typographers
Printed and bound in Verona, Italy, by Arnoldo Mondadori Editore, S.p.A.

Jacket: Mary Cassatt, *Mother Feeding Child* (22.16.22)
Jacket verso: Georgia O'Keeffe, *A Storm* (1981.35)

Contents

Foreword

Since 1956, The Metropolitan Museum of Art and the Institute of Fine Arts, New York University, have cosponsored a certificate program in museology to prepare graduate students for curatorial careers in art museums. The value of the museum experience for art historians was recognized in the joint decision of the Institute and the Metropolitan to develop a course of study in connoisseurship and museum methodology. The resulting Museum Training Program was among the first of its kind to be offered in this country. The effectiveness and ultimate success of the program can be measured by the impressive number of former participants who currently serve as directors, curators, and senior administrators in museums throughout the country. The Metropolitan, for one, has profited handsomely from the program, counting its director and a major share of its curatorial staff as former graduates. According to Institute records, more than 25 percent of its alumni have entered the museum field in recent years.

Under the supervision of a committee of Institute faculty and Museum curators, the focus and format of the program have been modified over the years in an effort to maintain effectiveness. In 1982 prerequisites for admission into the program were revised to include the completion of all requirements for the master's degree and a successful Ph.D. candidacy interview. The program's nomenclature was also altered significantly: *Museum Training* was changed to *Curatorial Studies*, a title more descriptive of its purpose.

The three- to four-year program now offers courses and colloquia that focus on issues of museology, both past and present, and concludes with a nine-month internship in the Museum. Through these studies the graduate student is introduced to the different media, materials, and techniques of conservation, and to the assessment of quality, style, and authenticity of works of art. The student profits from a first-hand knowledge of the role and responsibilities of the curator—to the work of art and to the institution of which he or she will be a critical part. The program provides each participant with a broad understanding of the history, standards, and professional concerns of art museums.

Participants in Curatorial Studies II have focused on projects involving the organization and installation of exhibitions drawn from the Met's permanent collections. In the fall of 1982 Suzanne Boorsch, Associate Curator in the Department of Prints and Photographs, led a class in the formation of a handsome exhibition of prints depicting the architecture of the Vatican, which complemented the Museum's major loan exhibition *The Papacy and Art: Treasures from the Vatican Museums.* The following autumn, students worked with Doreen Bolger, then Associate Curator in the Department of American Paintings and Sculpture, and with Marjorie Shelley, then Associate Conservator for Prints and Drawings, cataloguing the Museum's collection of American pastels and organizing an exhibition of thirty-five works. In both instances students played an active role in every stage of exhibition planning, from the

conceptualization of theme, selection of objects, research, and composition of labels to such matters as publicity, scheduling, and the development of education programs.

The results of their efforts are also manifest in this splendid book, which is being published on the occasion of the exhibition. *American Pastels* bears witness to the creative collaboration that can develop between curator and student and to the important contribution that can be made by younger scholars to the understanding of a major public collection.

We are indebted to Doreen Bolger, Marjorie Shelley, and the six Curatorial Studies II participants for their valuable work in "rediscovering" this fine collection of American pastels, which has received too little critical attention.

We would also like to acknowledge the enormous contribution of the faculty of the Institute of Fine Arts and the staff of the Museum who have guided the Museum Training and Curatorial Studies programs since their inception. They have done so out of a deep love and concern for works of art and an equally strong commitment to art history. Past directors of the program have included Hans Huth, A. Hyatt Mayor, Colin Eisler, Helmut Nickel, Sir John Pope-Hennessy, Ann Sutherland Harris, and Merribell Parsons; the program is currently under the direction of Marian Burleigh-Motley.

We are grateful to the Ford Foundation and the National Endowment for the Arts, which have made this program possible through their generosity.

Both of us have the pleasure of chairing the Joint Committee on Curatorial Studies, which governs the program.

Philippe de Montebello
Director
The Metropolitan Museum of Art

James R. McCredie
Director
Institute of Fine Arts

Acknowledgments

This publication and the exhibition it accompanies are the happy result of a Curatorial Studies II course for the Institute of Fine Arts, New York University, offered in the Department of American Paintings and Sculpture in the fall of 1983. Students in the class surveyed our collection of American pastels, compiled a check list of those acquired before 1983, selected the pastels featured in the exhibition, and researched and wrote the essays and entries included here. These students deserve tremendous acknowledgment for their enthusiasm and professionalism, not just during the few months that they spent on the project as a part of their course work, but also during the past six years, as they have continued to revise and expand their contributions. Indeed, they have all pursued degrees and careers in art history, many in the museum field: Mary Wayne Fritzsche (M.A., 1984) is now Manager of the Office of Education and Outreach at the Virginia Museum of Fine Arts, Richmond; Jacqueline Hazzi (M.A., 1984) is working on a Ph.D. in Islamic art at the Institute; Gail Stavitsky (M.A., 1978), also at the Institute, is working on a dissertation on the artist and collector Albert E. Gallatin and is also an Andrew W. Mellon Fellow at the Museum; Mary L. Sullivan (M.A., 1985) is Manager of the Information Resources Department at the Virginia Museum of Fine Arts; Marc Vincent (M.A., 1984) is working on his Ph.D. at the University of Pennsylvania; and Elizabeth Wylie (M.A., 1987) is now Curator at the Danforth Museum in Framingham, Massachusetts.

The class owes a tremendous debt to Marjorie Shelley, Conservator in the Department of Paper Conservation, for her important role in both the course and in the development of this book. Ms. Shelley offered the students inspiring sessions on the conservation of works on paper and met repeatedly with them throughout the course of the project to examine and discuss each piece included in the exhibition. Her essay, which explores the materials and techniques employed by American pastelists, reflects her extensive research into the use and preservation of this delicate medium.

In compiling this book we have relied on the generosity and knowledge of many scholars, dealers, collectors, and donors, all of whom share our enthusiasm for American pastels: William Agee; Irving F. Burton; Bella Fishko, Forum Gallery; Susan Hobbs; Irma B. Jaffe, Fordham University; Mrs. Leonard Spencer Karp; Christopher Knight; Gail Levin; Paul Magriel; Marianne Martin, Boston University; Nancy McGary, Whitney Museum of American Art; August Mosca; Carolyn Nelson; Percy North; William O'Reilly, Salander-O'Reilly Galleries; Dr. Bernard Rabin; Sheldon Reich; Martica Sawin, Parsons School of Design; Bruce Weber, Norton Gallery and School of Art; Joy Weber; Virginia Zabriskie; and Judith Zilczer, Hirshhorn Museum and Sculpture Garden.

Helen Mules and Calvin Brown made our use of the Department of Drawings both easy and pleasant; David Keihl, Andrea Bayer, and Robert Luck welcomed us into the Department of Prints and Photo-

graphs; Lowery Sims and especially Ida Balboul of the Twentieth Century Department facilitated our study of the pastels under their aegis. Gail Cushman, Academic Programs, acted as our liaison with the Education Department. Within our department, the technicians—George Asimakis, Gary Burnett, Don Templeton, William Waelder, and Jason Weller—kindly moved, unframed, and reframed innumerable pastels innumerable times. Stephen Rubin was most helpful, and our Administrative Assistant, Nancy Gillette, patiently wordprocessed (and re-wordprocessed!) our unwieldy manuscript.

We are grateful to Colta Ives, Prints and Photographs; Laurence Kanter, Robert Lehmann Collection; and William Lieberman, Twentieth Century Art, for permitting us to include pastels from their departments. Linda Sylling was enormously supportive, both in developing a budget for the show and in seeking funds to mount it. The exhibition was made possible by a grant from Reliance Group Holdings, Inc., which has made a commitment to funding shows drawn exclusively from the Museum's collections. The National Endowment for the Arts and the William Cullen Bryant Fellows of The American Wing have contributed generously to the support of this publication, enabling us to complete an in-depth study of yet another area of the American collection.

I am grateful to Barbara Burn and Teresa Egan of the Editorial Department for their unflagging support of our project. Pamela T. Barr, editor of this catalogue, was both thorough and thoughtful in her efforts to improve our manuscript. Jean Wagner greatly clarified the bibliography, and Susan Bradford carefully compiled the index. Matthew Pimm guided the book through all stages of its production with diligence and sensitivity.

The authors owe a special debt to the institutions and private collectors who permitted us to use reproductions of their pastels as ancillary illustrations.

As always, I am grateful to John K. Howat, Chairman of the Departments of American Art, and Lewis I. Sharp, formerly Curator and Administrator of The American Wing and now Director of The Denver Art Museum, for their support and encouragement of my teaching and writing.

Doreen Bolger
*Curator, American Paintings and
Sculpture, and
Manager, The Henry R. Luce Center
for the Study of American Art*

American Pastels

American Pastels,

1880–1930:

Revival & Revitalization

Doreen Bolger, Mary Wayne Fritzsche, Jacqueline Hazzi, Gail Stavitsky, Mary L. Sullivan, Marc Vincent, and Elizabeth Wylie

The Revival of Secondary Mediums

The late nineteenth century in America witnessed revivals of many neglected mediums, techniques, and styles in painting, architecture, and the graphic arts. Artists who had been trained in the restrictive atmosphere of the American academies and inspired by the cosmopolitan tastes of American patrons went to Europe in great numbers for the first time and were dazzled by what they encountered in the studios and picture galleries there. In all disciplines, eclecticism was the watchword, as American artists returning from study abroad introduced European trends to their homeland. In architecture, the Shingle and the Stick styles took their places beside the Renaissance palazzo, while in the graphic arts, etching, lithography, and wood engraving found new importance as artistic, rather than merely reproductive, vehicles, and monotype emerged as a viable medium for experimentation. The Aesthetic movement and later the Arts and Crafts movement in Europe spurred American interest in art pottery and stained glass, while a rage for all things having to do with the Italian Renaissance sparked an interest in the practices of mural and true fresco painting, as well as in Italianate architecture. In studio painting, the traditionally esteemed medium of oil was joined, and in a few cases rivaled, by the secondary mediums of watercolor and pastel. As the American artist followed his European counterpart in moving out-of-doors to work and in finding his training among more forward-thinking masters, the academy, the traditional locus of the artist's life and education, was challenged.

Publications and organizations at home informed and nurtured the growing ranks of amateur and professional artists eager to experiment with untried mediums and techniques. *Art Age, Art Amateur, Art Interchange*, and later *Craftsman* carried announcements and reviews of exhibitions in this country, news from the art scene abroad, and "how-to" articles on everything from ecclesiastical embroidery to fixing pastel drawings.

Watercolor was the grande dame of the "genteel" mediums in nineteenth-century America. After mid-century, the medium grew in popularity, and in 1867 the American Society of Painters in Water Color, later called the American Watercolor Society, was formed.[1] In the 1870s and 1880s watercolor became a vehicle for experimentation, attracting younger, more daring artists, such as Thomas Eakins, Winslow Homer, John La Farge, J. Alden Weir, and J. Frank Currier. The year following the nation's centennial, 1877, was a banner year for the founding of associations devoted to the encouragement of revival mediums and for the artists who were attracted to their use. The New York Etching Club, the Tile Club, and the Society of Decorative Art were all established in that year.[2] The social activities of these clubs, especially the Tile Club, are well known, but they also had a serious purpose: the promotion and sale to American buyers of American works of art in less traditional mediums. Many artists belonged to several of these clubs at once, as well as to the National Academy of Design or its rival, the

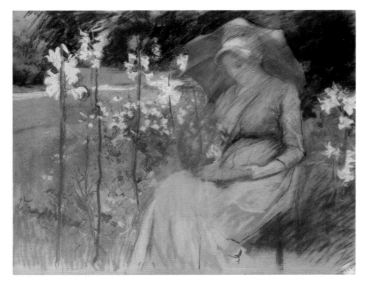

Fig. 1. Edwin Austin Abbey, *Woman in a Garden*, c. 1895, pastel and black chalk on cardboard, 21¹³⁄₁₆ × 27⅞ in., Yale University Art Gallery, New Haven, Conn.

Fig. 2. Cecilia Beaux, *Ethel Page Large*, pastel on paper, 16⅛ × 12 in., Mr. and Mrs. Raymond J. Horowitz

Society of American Artists. The annual exhibitions of all of these organizations were important and at times controversial events.[3]

In a perceptive appraisal of the appeal of the so-called lesser mediums to artists of the period, Mariana Griswold Van Rensselaer wrote in *Century Magazine* in 1884:

> The time is not long past when, if the average educated American spoke of pictures, he meant oil paintings alone; if of prints, steel engravings only. Art—true art, "high art"—was confined for him to these two methods; and he would not have understood that certain so-called minor branches, of whose existence he was dimly conscious, might properly be ranked beside them. . . . No painter, however great his mastery of oils, can do everything by their sole aid. . . . Great as has been our advance in oil painting within recent years, I think our most notable evidence of progress lies in the fact that these minor branches are no longer either unfamiliar or despised; that we have turned with eagerness to many methods of interpretation our fathers did not touch.[4]

Calling the move toward the use of secondary mediums "a vital effort," Van Rensselaer attributed their new appeal "to a wider wish for self-expression." Against the claim that in some of these mediums, particularly watercolor and pastel, the artist could do anything that he could do in oil, Van Rensselaer countered: "It is because they can do certain things that oil can *not* do so well that they have a real claim on his attention."[5] She was sounding the call for artist and public alike to be aware of a new impetus at work guiding American art, one of experimentation, of change, and of challenge, which would irrevocably alter the methods of artistic expression in this country.

Americans may have adopted the pastel medium so enthusiastically out of a strong desire to steer the direction of American art away from its conventional course, which was seen by the younger painters as stuffy, bombastic academicism. Pastel by its nature was one of the alternative mediums that could answer the needs of artists seeking new avenues of expression. Pastels were portable and lent themselves to the spontaneous capture of the moment; they could, as Mrs. Van Rensselaer put it, "fix such unsubstantial moods of nature."[6] Pastel had the wide range of color and vibrancy of oil but none of its

limitations: not the muddiness or gluey quality, not the problems caused by its slow-drying nature, nor the encumbrances necessary for its use—oil, turpentines, brushes, and rags. Thus, pastel was the perfect medium for the quick color sketch in the open air. Weir, Robert Blum, and John H. Twachtman all used pastels for this purpose, taking advantage of the clear, strong colors and the loose, painterly quality of the medium. American artists took their art out-of-doors and with the aid of pastels turned drawing into painting without a brush. It was with good reason that the French referred to the artist who used the medium as a *peintre en pastel*.

For some American artists pastel was the medium that freed them from academic restraints. Edwin Austin Abbey, an illustrator and a watercolorist, first used pastels in 1894. In *Woman in a Garden*, of about 1895 (fig. 1), he eschewed the highly finished treatment of his watercolors and exploited the sketchlike quality of the new medium.[7] Cecilia Beaux, upon her return in 1889 from several years' study in Europe, adopted the pastel medium as a means of overcoming what seems to have been a sort of "painter's block." She wrote in her autobiography that she experimented with pastels "as a means to an end," in order to strengthen her sense of color.[8] Pastel never came close to rivaling oil as a medium in Beaux's work, but she did use it for occasional portraits (fig. 2) and exhibited with the Society of Painters in Pastel in its final exhibition, in 1890.[9] Other artists, Twachtman and Weir among them, used pastels to lighten their palette. For Blum and Thomas W. Dewing, pastel was a color medium of preference that figures prominently in their work. J. Carroll Beckwith used pastel for broad color studies as well as to "touch" black-and-white drawings with color. Bryson Burroughs was another master of the delicate use of the medium for adding color highlights to black-and-white studies. It becomes clear that the uses of pastel during this period were as various as its colors.

M.L.S.

American Expatriates and the Use of Pastel: Whistler and Cassatt

Of the many American artists working abroad during the late nineteenth century, two in particular were important for their experimentation in pastel: James McNeill Whistler and Mary Cassatt.[10] Cassatt's pastels were created and exhibited within the international context of French Impressionism. While today they are accorded the esteem they deserve, they excited relatively little interest in America during the 1880s and 1890s. Rather, it was Whistler who exerted the greatest influence on his American contemporaries.

Whistler began his career as a realist, working closely with Gustave Courbet in Paris and then with Dante Gabriel Rossetti in London. During the 1870s he studied Japanese art and was inspired by non-Western artistic tradition. Consequently, his work moved away from straightforward representation toward a preoccupation with color, form, and pattern. Early in his career, he discovered that pastel was an ideal medium with which to investigate these formal concerns, and during his sojourn in Venice, from 1879 to 1880, he developed pastel to previously unknown dimensions (fig. 3).[11] In desperate need of money, Whistler accepted a commission from London's Fine Art Society to produce within a period of three months a series of twelve etchings of Venice (fig. 4).

In Venice, Whistler abandoned the figure studies in pastel that had occupied him previously and worked exclusively on landscapes and genre scenes depicting the city's architecture, ambience, and atmosphere. What makes the Venice pastels so remarkable is the nearly abstract treatment of subjects. Doors, windows, bridges, and canals are reduced to almost geometric shapes—a few simple lines of black pastel on paper of a subtle tone, heightened with touches of color, suffice to suggest a scene. The Venetian pastels reveal Whistler's renewed application of Japanese principles that he first explored in the 1860s—dreamy atmosphere, clear execution of line, and the presence of large voids. In Venice the aesthetic achievements of Whistler's oil *Falling Rocket*, 1877 (The Detroit Institute of Arts, Mich.), were translated to the pastel medium.

The Venetian pastels, though not numerous or prominent in Whistler's oeuvre, exerted considerable influence on both artists and the public. While still in Venice, Whistler came in contact with numerous American painters and critics, including Frank Duveneck and Otto Bacher. Whistler's pastels were avidly studied and admired by young art students, such as Robert Blum and John H. Twachtman, who, on their return to America, became proponents of his new pastel technique. When Whistler's seemingly unfinished pastels were exhibited at the Fine Art Society in January 1881, viewers were forced to

reevaluate their notions about aesthetics.[12] By displaying art that obviously described the artist's working process, that subjectively revealed the artist's hand, and that defied the traditional Western artistic vocabulary, Whistler redefined the role and nature of art—it was something to be seen, not as a means to an end, but as an end in itself.

In France, where Mary Cassatt spent her career, the pastel rarely achieved such modern and revolutionary overtones. Deeply rooted in the art of the eighteenth century, pastel was revived in the 1850s, along with other so-called secondary mediums, by

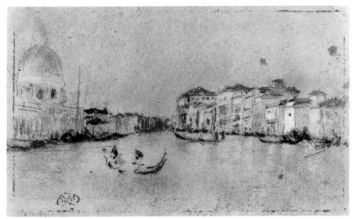

Fig. 3. James McNeill Whistler, *The Grand Canal, Venice*, 1879, pastel on tan paper, 17.4 × 27.0 cm., Freer Gallery of Art, Smithsonian Institution, Washington, D.C.

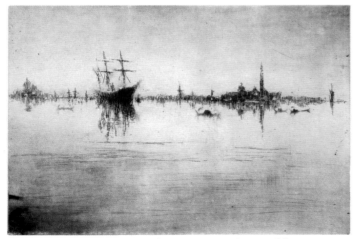

Fig. 4. James McNeill Whistler, *Nocturne*, 1879, etching, 8 × 11⅝ in. (plate); 8⅞ × 12⅜ in. (sheet). The Metropolitan Museum of Art, New York, Gift of Felix M. Warburg and his family, 1941. This etching, one of the first Whistler did for the London Fine Art Society, appeared as number 4 in *Venice: Twelve Etchings*.

Jean-François Millet (fig. 5) and painters of the Barbizon School. In the 1870s and 1880s the Impressionists considered pastel and oil as equally important means of expression. For some, such as Edgar Degas (fig. 6), pastel was a major aspect of their work; for others, such as Edouard Manet, it was used only occasionally, more frequently toward the end of their lives. Indeed, it was with the Impressionists, and not with the academic artists, that pastel first achieved popularity, for it readily expressed their quickness of touch, spontaneity, and vigor of treatment. Along with the rediscovery of pastel as an artistic medium went a renewed appreciation and reevaluation of the great eighteenth-century French pastelists whose art had fallen out of favor: François Boucher, Antoine Watteau, Jean-Baptiste-Siméon Chardin, and Maurice-Quentin de La Tour. Jules and Edmond de Goncourt revived an interest in these artists with their publication of *L'Art du dix-huitième siècle* (1859–75). The public and artists alike once more delighted in the light-hearted, anecdotal, and pleasant scenes of the Rococo age.

In 1872, at the height of this renewed interest in pastels, Cassatt arrived in Paris, where she worked briefly in the studio of Charles Chaplin before traveling to Italy and later to Spain in order to study the works of the old masters. Upon returning to France, she was soon drawn to the Impressionists. Degas invited her to participate in the group's fourth exhibition, held in 1879. Cassatt formed a close friendship with the master, who exerted a tremendous influence on her pastels. In fact it was Degas's work in pastel that had first attracted Cassatt. She had noticed one of his pastels on display in a gallery window on the boulevard Haussmann, and, as she later recollected, "I used to go and flatten my nose against that window and absorb all that I could of his art. It changed my life. I saw art then as I wanted to see it."[13]

Cassatt's own pastels reflect Degas's style and technique of the 1870s and 1880s. Like Degas, she was concerned not so much with color and the effect of light, but with composition and line. Both Degas and Cassatt demonstrate the Impressionists' awareness of Japanese prints, which were admired for their novel compositions and abstract patterns formed by contours. Cassatt also emulated Degas's pastel technique: she placed the pastel under steam, turning it into a paste that was easily manipulated and brushed on the paper or canvas. The result was a painterly surface, evident in *Mother Feeding Child*, a pastel of 1898 (p. 52). Later, Cassatt imitated Degas's technique

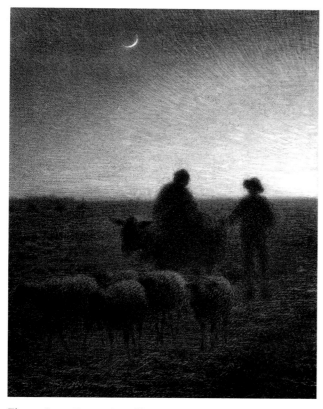

Fig. 5. Jean-François Millet, *Twilight*, c. 1866, Conté crayon and pastel on wove paper, 20 × 15¼ in., Museum of Fine Arts, Boston, Mass., Gift of Quincy Adams Shaw through Quincy A. Shaw, Jr., and Mrs. Marian Shaw Haughton, 1917

Fig. 6. Edgar Degas, *Woman Combing Her Hair*, c. 1888, pastel on light green wove paper (now discolored), mounted on original pulpboard, 24⅛ × 18⅛ in., The Metropolitan Museum of Art, New York, Gift of Mr. and Mrs. Nate B. Springold, 1956

of applying layer after layer of pastel on the paper or canvas, giving the work a rich, dense quality, as seen in the 1914 pastel *Mother and Child* (p. 58).

Although Cassatt was influential in the formation of American collections, particularly that of Mr. and Mrs. H. O. Havemeyer, her own work was not as central to the development of American art. Her painting style did not inspire imitators, nor did it produce a wave of mother-and-child depictions by other artists.

Whistler and Cassatt represent an interesting contrast in artistic philosophy and outlook. Whistler responded independently to new and challenging modes of pictorial art; Cassatt was consistent in her outlook, remaining faithful to the Impressionist mode once she made it her own. Whistler's contacts with American artists were few and far between, yet his influence was enormous. His philosophy, life style, and notoriety made him a revered figure in American art circles. It was to him that American artists looked for guidance and confirmation of their own ideas. Cassatt, on the other hand, did not actively seek public attention and did not move in artistic circles other than that of the French Impressionists. Unlike Whistler, she did not write or lecture about her work or philosophize about the state of the arts in society. In the development of pastel in America, it was Whistler who played the more active role. While Cassatt's pastels were exhibited often in Paris, they remained less well known in the United States.

M.V.

Fig. 7. Cover from the catalogue of the first exhibition of the Society of Painters in Pastel, March 1884, New York Public Library

The Society of Painters in Pastel and the
International Revival of the Medium

> A new medium, by the way—or rather an old one revived—is coming into vogue among some of the American Society artists. I speak of pastel painting. It is an open secret that Chase, Blum, [Frederick] Dielman, and half a dozen others are to give a special exhibition in pastels next spring.[14]

This article in the January 1883 issue of *Art Amateur* heralded the arrival of the Society of Painters in Pastel, founded in 1882 by William Merritt Chase, Robert Blum, J. Carroll Beckwith, H. Bolton Jones, and Edwin H. Blashfield.[15] In March 1884 the society held its first exhibition, at 290 Fifth Avenue in New York (fig. 7). From the outset, two distinct stylistic trends were in evidence among the works of the artists exhibiting with the society, and sometimes even in the work of a single artist.[16] Some produced pastels that were clearly drawings. Sketchy in treatment and informal in subject, their works exploited the blank ground of the paper as a crucial element of the composition. These artists were inspired by Whistler; some had met him in Venice and all were familiar with his pastels. They preferred to use the medium to create experimental compositions, which appeared to be informal drawings rather than finished exhibition pieces. John H. Twachtman, who met Whistler in Venice in 1880, followed the Anglo-American in his predilection for toned paper, a subtly restrained palette, and fine, almost wispy lines. One critic even maintained that had his pastels been signed with a Whistlerian butterfly, "it would have seemed all right."[17] Twachtman imparted this approach to his friend J. Alden Weir, most of whose pastels, usually landscape subjects, resemble Twachtman's. Weir's pastels are unequivocally drawings; working on colored paper, he made pencil guidelines and then added touches of color with delicate, broken strokes.

Other American pastelists, most notably Chase, attempted more ambitious pastels that rivaled their oils in size, degree of finish, and bravura treatment. The critic Mariana Griswold Van Rensselaer labeled these artists "followers of de Nittis," associating them with the Italian painter Giuseppe de Nittis, a friend of Edgar Degas's and an artist whose work enjoyed tremendous popularity among American painters in the 1880s.[18] Most of Chase's pastels date to that decade, but he continued to work in the medium after 1890, often with spectacular results in such pastels as *Hall at Shinnecock*, 1893 (fig. 8), in which he succumbed to the roughened surface facture of Impressionism and the canvas support has become visible between bold strokes of brilliantly colored pastel. Chase played a pivotal role in the pastel revival, both through his own work in the medium and through his participation in the Society of Painters in Pastel.[19] Moreover, though he does not seem to have offered specific instruction in pastel, a number of his students—including John Marin, Georgia O'Keeffe, and Joseph Stella—became leading practitioners of the medium during the early years of the twentieth century.

Few pastelists were totally consistent in their approach to the medium and it is this diversity that makes pastels of the period so fascinating. Blum, who drew small Whistlerian landscapes like *The*

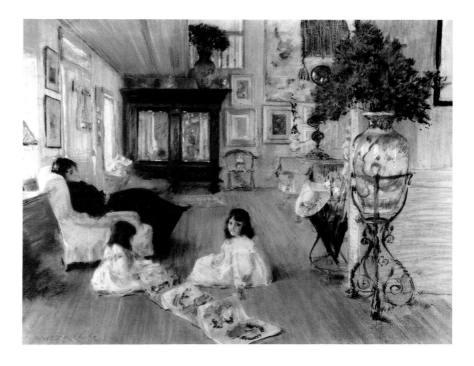

Fig. 8. William Merritt Chase,
Hall at Shinnecock, 1893, pastel on
light blue prepared canvas, 32×41 in.,
Terra Museum of American Art,
Chicago, Ill., Daniel J. Terra Collection

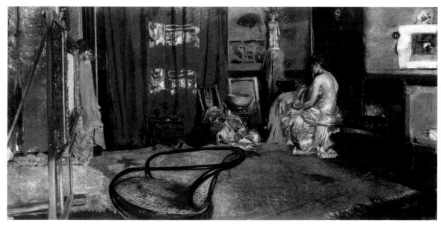

Fig. 9. Robert Blum, *Studio of Robert Blum*,
c. 1883, pastel on paper, 28×53¼ in.,
Cincinnati Art Museum, Ohio,
Gift of Mrs. Henrietta Haller, 1905

Cherry Trees, 1891 (p. 72), occasionally undertook more elaborate pastels, such as *Studio of Robert Blum*, of about 1883 (fig. 9). Childe Hassam, while studying in Paris, produced *Au Grand Prix de Paris*, 1887 (fig. 10), which in scale and treatment relates to his contemporaneous oils; upon his return to America he created *Poppies, Isles of Shoals*, 1890 (fig. 11), a pastel that must have been inspired, at least in part, by Whistler and his American followers. Even Weir sometimes chose a more ambitious format and more finished treatment for his pastel work; *The Window*

Seat, 1889 (fig. 12), could—and did—stand on its own as an exhibition piece when it was featured in the 1890 show of the Society of Painters in Pastel.

The pastels of some of these and of other American painters were brought before the public in a series of exhibitions organized by the Society of Painters in Pastel. By the opening of its first exhibition, on March 17, 1884, pastel was enjoying growing popularity. The inaugural exhibition included works by members Beckwith, Blashfield, Blum (by now the designated president of the

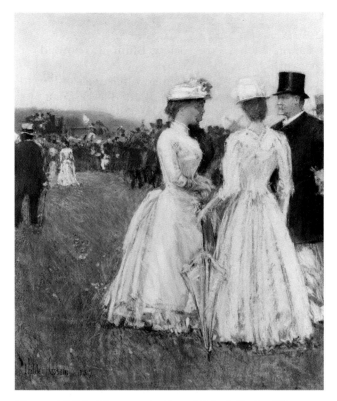

Fig. 10. Childe Hassam, *Au Grand Prix de Paris*, 1887, pastel on paper, 18 × 12 in., Corcoran Gallery of Art, Washington, D.C.

society), Chase, Jones, Francis Miller, and Charles Ulrich. A total of sixty-four works by seven members and nine guest contributors were shown.[20] Included were studies and finished works, portraits and landscapes, and Whistlerian "schemes" and "impressions." The critics were, for the most part, complimentary. While regretfully noting the lack of a distinctly American subject matter among the exhibits, the reviewer for *Art Amateur* praised the technical facility displayed in the entries and admitted that pastel would no longer be known solely as "the parent of certain wooly and faded portraits haunting the deserted upper rooms of country-houses."[21] A *New York Times* critic concurred that pastel's former obscurity was undeserved and rejoiced in the medium's recent rediscovery:

> In Europe more than in America have pastels and their kindred, colored crayons, labored under the contempt of artists and amateurs. In this country the art may be considered not to exist; in Europe it has been the stock in trade of inferior male and female workers in portrait. But it has happened recently that artists of the very highest quality have thought it worth while to demonstrate that pastels do not deserve the contempt in which they are held, but have qualities very attractive to the painter who uses them intelligently, and that they are capable

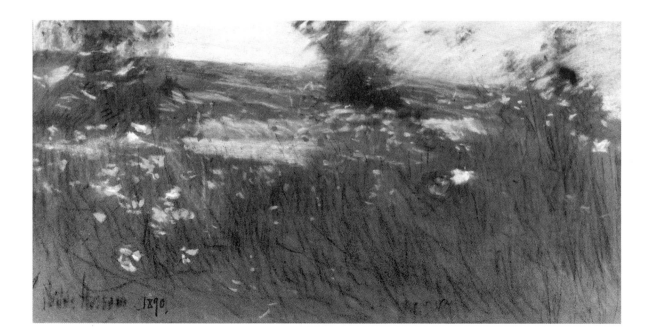

certainly of as much expression as etching and possibly of as much as watercolors. They have shown that it was the talents not the materials which seemed contemptible in the ordinary pastel portrait or landscape. . . . Just as etching needed certain men of genius to raise it from the bog of amateurishness in which it floundered, so pastels required such chosen talents as J. F. Millet, Whistler, and de Nittis to convince the world that good pictures could be made in a material which might be called "colored charcoals," to express its main characteristics of color, dryness, friability and ability to blend.[22]

Pastel had shed the dreary associations that had long clung to it. The critic for *Art Interchange* immediately associated the medium with the avant-garde: " 'Impressionism' is here seen at its sanest and best, and those who are susceptible to the charms of cleverness and dash can find much to delight them in this first effort to acquaint the general public with the possibilities of pastel."[23]

Despite the good notices for most of the participants, sales were few. On the closing day of the exhibit, a disappointed Beckwith wrote in his diary: "How blue we all are on the result of the pastel show."[24] Poor admission receipts and meager sales forced members to cover expenses out of their own

pockets. No exhibition was held in 1885, perhaps because of these financial difficulties and the fact that the president of the society, Blum, was abroad for part of the year.[25]

The society remained publicly inactive until its second exhibition opened in May 1888 at H. Wunderlich & Co. in New York.[26] The club's four-year hiatus from the exhibition scene was noted by the reviewer for the *New York Times*, whose quip that since the first exhibition "all the members who were not made officers declined to pay their dues" may have contained a grain of truth.[27] Absent from the original membership were Blashfield, Jones, Miller, and Ulrich. Joining the remaining members were Kenyon Cox, who exhibited two portrait sketches; John La Farge, who was represented by two studies and a finished piece; Twachtman, who showed some Venetian studies as well as several Dutch subjects—a total of eleven entries; and Weir, who sent three pastels. Blum was conspicuous in sending the largest number of works, thirty-one, and Chase exhibited six, two of which were loaned by private collectors. Beckwith showed two pieces. In all, fifteen exhibitors displayed a total of sixty-seven works.[28] Roughly half the exhibits were for sale, with prices ranging from thirty to two hundred dollars. Again, reviews were favorable. The critic for *Art Amateur*, perhaps implying a comparison between the society's 1888 exhibition and the mammoth annuals of the American

OPPOSITE
Fig. 11. Childe Hassam, *Poppies, Isles of Shoals*, 1890, pastel on brown paper, 7¼ × 13¾ in., Mr. and Mrs. Raymond J. Horowitz

RIGHT
Fig. 12. J. Alden Weir, *The Window Seat*, 1889, pastel and graphite pencil on paper, 13¼ × 17½ in., private collection

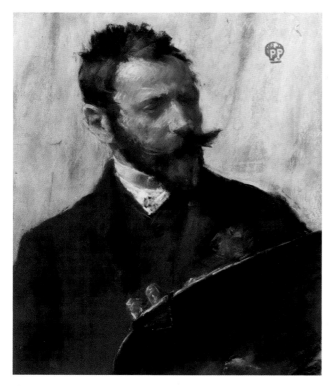

Fig. 13. William Merritt Chase, *Self-Portrait*, c. 1884, pastel on pumice paper, 17¼ × 13½ in., Mr. and Mrs. Raymond J. Horowitz. The stamp of the Society of Painters in Pastel appears in the upper right corner.

Watercolor Society, wrote: "For its size, it was one of the most interesting displays of the year; the comparative novelty of the medium and the brilliancy and variety of the effects produced with it attracted hosts of visitors, and it may be said that it was, in every way, an artistic success."[29] In what may have been an oblique comment on the outstanding quality of the works shown, the critic noted that only one flower piece was among the works exhibited at the pastel society. (The annual of the American Watercolor Society admitted works by amateurs, often flower still lifes, and the position of amateurs within that organization was a sensitive issue.)[30]

A study of works discussed in reviews of the first and second pastel society exhibitions reveals that the influential painterly style of de Nittis, dominant in 1884, had been superseded in the second show by the more delicate, "suggestive" styles of Blum and Twachtman. Different subjects also became popular: the second exhibition contained fewer portraits and more landscapes.[31] These trends toward a less formal, more experimental treatment and less conventional subject matter did not go unnoticed by the

press. The reviewer for *Art Interchange* commented on the exhibitors' creative use of tinted papers and colored mats to achieve unusual effects.[32] The critic for the *New York Tribune* applauded the less-finished appearance of the entries and praised Blum for his use of "the language of suggestion."[33] Strict realism, which this writer called "imitation," could be had by the use of photography. "Imitation of one kind or another," he noted,

> has been the bane of nearly all the graphic arts, of oil painting as well as etching, and it is pleasant to find artists asserting their individuality in the treatment of their subjects, selecting the points which seem to them essential and leaving something to the imagination.[34]

Admission and sales receipts for the second exhibition are not known, but one writer's comment that the exhibit "appealed to amateurs rather than to the general public" suggests that the returns were modest.[35] Nevertheless, the launching of a third pastel exhibit the following year is testimony to at least a modicum of success for the 1888 display.

The third exhibition of the Society of Painters in Pastel opened on April 20, 1889, at 278 Fifth Avenue, formerly Haseltine Galleries.[36] Eleven members—Blum, Chase, Weir, Twachtman, Beckwith, and La Farge, among them—were joined by such guest contributors as Caroline T. Hecker, a student of Chase's, and Walter L. Palmer, both of whom had shown works in the two previous exhibits.[37] The critic for *Art Amateur* commented:

> When . . . the Society of Painters in Pastel held its first public exhibition, it may have been a question whether the public would take kindly to the brilliant colors, the facile execution, the somewhat Impressionistic aims natural to the method and shown in most of the exhibits. The public, however, or that part of it which is really interested in art and which sets the rest in motion, was very agreeably affected, and this little coterie acquired at once a standing which is even yet denied to certain other associations of artists of more numerous membership and longer in existence. Its third exhibition . . . seems a timely and sensible bid for greater popularity.[38]

The writer went on to praise most of the work in the show but criticized the pictures that were "too highly

finished, too obviously reproducing effects better suited to oils." Echoing this preference for a spontaneous and fresh use of the medium was the critic for the *New York Tribune*, who wrote:

> It is art for art's sake which they offer, and it would be idle to ask too much, ungracious not to accord full appreciation to the rare sensitiveness to eye and facility of hand illustrated in their work. This exhibition differs from most of the others which we have in that it shows work which, with very few exceptions, seems to have been done out of genuine love for the doing . . . the laboring endeavor of the perfunctory task is very rarely felt.[39]

The fourth exhibition of the Society of Painters in Pastel, which took place at H. Wunderlich & Co. in May 1890, saw one crucial absence and two important additions to its roster of exhibitors. Blum had been commissioned by *Scribner's* to illustrate Sir Edwin Arnold's "Japonica" and, having left America for a three-year trip to Japan, did not participate in the show. Joining the veteran exhibitors were two young Americans who had recently returned from study abroad: Hassam, a new participant who contributed three works, and Cecilia Beaux, who displayed a portrait. The exhibition was the largest ever mounted by the society, with eighty-nine works by twenty artists. Despite this, the group was still, as the critic for *Art Amateur* noted, "the smallest of the artistic societies."[40] The usual core of members contributed pastels, with Twachtman leading Beckwith, Chase, Weir, and Irving Ramsey Wiles, by now a regular member of the group, in the number of contributions.[41] As usual, the critical notices were generally good, though the reviewer for *Art Amateur* lamented "the recklessness with which the stamp of the Society—the vivid, vermilion 'P. P.'—was stuck on many of these pale grayish studies, a high note for which they had evidently not been prepared, and which was somewhat disastrous to some of them."[42] The society's stamp appears prominently against the brilliant yellow background of Chase's *Self-Portrait* of about 1884 (fig. 13).

The fourth exhibition of the Society of Painters in Pastel proved to be its last. One reason for the demise of the society was that, with a few exceptions of loyal members and invited guests, its membership drifted in and out of active participation. Its roster included ambitious artists with demanding careers; when more important commitments, such as commissions for works in oil, required their attention, the pastel society took second place. Failure to exhibit with the society in a given year did not have the same ramifications as failure to exhibit, say, in the annual exhibition of the National Academy of Design or of the Society of American Artists. A regular exhibitor's absence from the pastel annual might be noted, but failure to contribute to at least one of the larger seasonal exhibitions was a more serious issue and detrimental to an artist's career— critically and perhaps financially. This difference was surely one of the aspects that made the pastel society so attractive to its members, and in the long run so short-lived.

At the end of his review of the 1890 exhibition of the Society of Painters in Pastel, the critic for *Art Amateur* commented that "the exhibition, as a whole, was so clever that the absence even of Mr. Blum, the President, was scarcely perceived."[43] But the writer underestimated the power of Blum's position within the society. His sojourn in Japan was surely the deathblow to the organization in which he was the driving force. When Blum returned to New York he was in delicate health, and mural commissions occupied him until his death in 1903. Chase, Blum's logical successor as leader of the group, was too busy with teaching and other activities to take the reins, and so the Society of Painters in Pastel simply ceased to exist. Nevertheless, pastel had secured a position within the work of American artists, both as an experimental tool and as a legitimate medium for exhibition. Pastels were exhibited more often in one-man shows and in the major annuals; the New York Water Color Club permitted pastels in its shows, at least intermittently, until 1913.[44] Pastels had not, however, become as desirable to American collectors as the Society of Painters in Pastel had hoped. As the critic for the *Sun* stressed in his review of the society's final exhibition, the medium's inability to establish its popularity with American collectors was not reflective of the quality of the works produced by American pastelists. On the contrary, he asserted that American pastels "would not be overlooked anywhere in Paris. The chief trouble," he wrote, "is that our public does not yet take pastel painting seriously enough; if, indeed, it can be said to take any American painting as seriously as it should."[45]

The influence of the Society of Painters in Pastel on artistic trends was far-reaching. Artists in Paris formed the Société des Pastellistes in 1885, one year after the American society's first exhibition. Their

inaugural show, at Galerie Georges Petit, included a retrospective of masters of the medium—Rosalba Carriera, Maurice-Quentin de La Tour, and Jean-Etienne Liotard—as well as works by such nineteenth-century French artists as Giuseppe de Nittis, Jean-François Millet, and Albert Besnard.[46] Most members of the society had studied at the Ecole des Beaux-Arts, and most had connections with Edgar Degas. Although he never exhibited with the group, Degas exerted an influence on the modern use of the pastel medium in France.[47] Stylistically, the members' work effected a compromise between academicism and modernism.[48] Regular participants in the annuals of the society were Jean-Charles Cazin, Emile Lévy, Léon Lhermitte, Pierre Puvis de Chavannes, Paul Helleu, and Besnard. Critical notices varied from year to year, but the popularity of the medium was such that more than once the society was represented in its own pavilion at the Paris Exposition.[49] The Société des Pastellistes held annual exhibitions for at least ten years before disappearing from the French art scene.

In England, the London Pastel Society held its first exhibition in 1888, the year of the delayed second exhibit of its American counterpart.[50] Sir John Coutts Lindsay, the owner of Grosvenor Gallery and the organizer of the society, led a group of "men of the newer school and of the more modern ways of thought."[51] As the critic for the Artist noted, "The Academy and other similar institutions were almost unrepresented. This is perhaps less extraordinary than might at first appear, for the academic sympathies are not as a rule with new developments, and are apt to be checked by innovations."[52] The first exhibition included a number of Whistler's Venetian pastels and works by members of the Société des Pastellistes. As with the French group, Degas's influence was in evidence among the works of the British pastelists, many of whom had studied in Paris. Prominent among the members were William Rothenstein and Phillip Wilson Steer, both of whom knew Whistler and Degas. Many members of the London Pastel Society also belonged to the New English Art Club, founded in reaction to the stodginess of the Royal Academy. (This is a parallel to the common membership of the Society of Painters in Pastel and the Society of American Artists, which had been founded in protest of the conservative policies of the National Academy of Design.) In comparison to those of the American pastel group, the exhibitions of the London organization were huge: 375 works were hung in the

society's third exhibition, in 1890. But like the American Society of Painters in Pastel, the London Pastel Society appears to have depended entirely on its president for organizational support. Lindsay was forced for financial reasons to close Grosvenor Gallery in 1890 and the society ceased exhibiting.

Throughout the 1890s in England, Hercules Brabazon, Edwin Austin Abbey, and others continued to exhibit pastels.[53] The new Pastel Society was organized in 1898 by Abbey, the expatriate American George H. Boughton, and the British artists Walter Crane, Edward Scott, Sir James Linton, and Rothenstein. Its first exhibition was held the following year at the Gallery of the Royal Institute of Painters in Water-Color, Piccadilly. R. A. M. Stevenson, writing for Art Journal, noted that the exhibitors made up a diverse group, "men and women, Britons and foreigners, academicians, and anti-academicians, decorative artists and naturalists," while the quality of the work shown ranged "from the artistic to the stupidly laborious."[54] Like the writer for Art Amateur, who in 1889 had criticized some of the exhibitors in the annual of the American Society of Painters in Pastel for trying to reproduce the effects of oil, Stevenson chided several of the British pastelists for the same fault. "Too many men . . . use pastel in a dull, laborious manner," he wrote. "It has, in their hands, the density of oil paint without its lustre, depth, richness, and the imposing vigour and volume of its impasto."[55]

The Pastel Society continued to exhibit well into the second half of this century, moving its exhibition quarters to the Royal Institute after its second show, in 1900. The society's annuals at the turn of the century were distinguished by a mix of foreign and native exhibitors and by the inclusion of works in other mediums—chalk, pencil, even gold point.[56] Drawings by Auguste Rodin, chalk studies by Thomas Gainsborough, or pastels by Edgar Degas might be found hanging near a study for a Salon oil by the French academician Charles Cottet or a flower still life by the British artist Arthur Tomson. As time went on, English entries were compared unfavorably with the work of the invited foreign guests. In 1904 the reviewer for Art Journal complained that "if the home exhibits had been as good as the foreign, the show would have compared favourably with its predecessors."[57] Three years later, expressing what was by now a familiar lament, Frank Rinder, writing in Art Journal about the 1907 exhibition, objected to the misuse of the pastel medium in the hands of the Pastel Society exhibitors: "Many

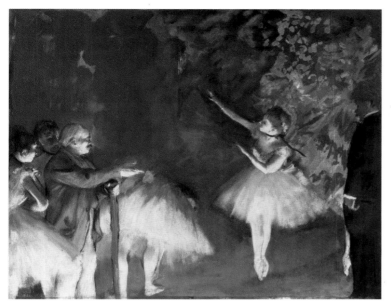

Fig. 14. Edgar Degas, *Ballet Rehearsal*, 1876–77, gouache and pastel over monotype on paper, 21¾ × 26¾ in., The Nelson-Atkins Museum of Art, Kansas City, Mo., Kenneth A. and Helen F. Spencer Foundation Fund

exhibitors attempt to gain effects only to be compassed in oils, abandon forthright freedom, slightness, subtlety, for elaborate realism, which in the end must be rather flimsy."[58] Portrait sketches in black chalk by John Singer Sargent and work by the late Sir Edward Burne-Jones were given prominence in the 1907 annual, as they were in Rinder's article, while regular exhibitors earned scant mention. In his review of the 1908 exhibition, Rinder again focused on the artists' failure to exploit the inherent qualities of the pastel medium:

> The present show is more serious, and less important. Pastel has to the full the advantage . . . of adaptability to widely-differing ideas of expression, but that very advantage is a danger, and the amount of indefinite work in the galleries is greatly in excess of that which is a real response to the invitation of pastel. Freshness and spontaneity are lost in labour which appears to aim at copying the facture of oil painting, and colour design, a special opportunity of the medium, is too much neglected.[59]

It seems that despite the progress made by the secondary mediums, the old hierarchy still held sway. Pastel, like pen and ink, chalk, and charcoal, was suited to spontaneous studies and sketches. Used for

this purpose, its color gave it an advantage over other sketching mediums, and its use became increasingly widespread. The pastel societies in America and Europe had indeed succeeded in reviving an interest in the medium among not only artists but the public as well.

M.L.S.

The Widening Exhibition of Pastels

The exhibition of pastels was not limited to the annual shows of pastel societies. The use of the medium by artists and its appreciation by the public were both fostered by the inclusion of pastels in innumerable exhibitions of American and European works at home and abroad. Among the most important of these were the early displays of Impressionist art in America. The first public American showing of an Impressionist picture—notably, a gouache and pastel over monotype—seems to have occurred as early as 1878, when Edgar Degas's *Ballet Rehearsal*, 1876–77 (fig. 14), was exhibited at the American Watercolor Society.[60] Given wide and generally favorable attention, this modest work hinted at the natural association of pastel and Impressionism.[61] For Americans, a relationship with the new school and the change it implied was reinforced by the major show *Exhibition of Paintings in*

Oil and Pastels by the Impressionists of Paris, held in 1886 at the American Art Association and then at the National Academy of Design. French Impressionist works had been exhibited occasionally in New York and Boston, but this display fully exposed the new style to the public for the first time.[62]

The accompanying catalogue, with an introduction by Théodore Duret, explained the movement and quoted art critics who had already attempted to define it. Newspapers and art periodicals devoted much attention to the exhibition, and though the descriptions and analyses of Impressionism differed, coverage was generally favorable.[63] Among many who recognized the singular importance of the show, Luther Hamilton, the reviewer for *Cosmopolitan*, welcomed Impressionism as "a glorious protest against everlasting commonplace" and praised the artists' "break with tradition."[64] The exhibition was a triumph: American artists were profoundly influenced by what they saw, the public came to learn, and collectors made significant purchases.[65] In response to this acclaim the exhibition, augmented by twenty-one additional works and accompanied by a new catalogue, was continued for another month, at the National Academy. The movement was given added stature the following year when a second show—*Exhibition of Celebrated Paintings by Great French Masters*—was held at the academy. It included works by the Impressionists as well as by the Barbizon painters Théodore Rousseau and Jules Dupré, the Realist Gustave Courbet, and the Romantic Eugène Delacroix.

The exhibition of 1886 not only presented Impressionism and its tenets to the public, but it also elevated pastel to a new status. Out of the 289 works selected by Durand-Ruel for display, 73 were pastels and watercolors.[66] The pastels by Degas, Jean-Louis Forain, Pierre-Auguste Renoir, Camille Pissarro, and others were perceived as important works of art by the critics and by the artists. The show was praised by Luther Hamilton as "one of the most important artistic events that ever took place in this country."[67] A writer for *Art Amateur* noted the particular compatibility of pastel with the aesthetic and technique of Impressionism and observed that several paintings were "made to look as much like pastels as possible."[68] In fact, pastel's pure and soft colors, blurred lines, matte finish, and sketchy quality were well suited to render the effects produced by the Impressionists' paintings.

Many of the young American artists who matured during the later decades of the nineteenth century had already been exposed to Impressionism while studying in Europe. Few remained immune to the movement, which changed the artist's palette and affected the technique and aim of painting. Even the most convinced, however, were unwilling to adopt all of its tenets. Borrowing from Impressionism mainly its technique, they searched for a personal style. Many American artists, influenced by the large number of pastels in the Impressionist exhibition, now turned their attention to this medium as an ideal tool for experimentation. The crisp and sharply outlined forms, finely detailed compositions, dark colors, and smooth finish of academic art were left behind as American artists adopted the new medium to express the aesthetic aims of Impressionism. They started treating their pastels as major works to be exhibited in their one-man shows as well as in annuals and international expositions. Of these young artists, J. Alden Weir and John H. Twachtman, later to become leading exponents of American Impressionism, turned seriously to pastel within a year of the Impressionist exhibition; within two years, one-third of their first combined public showing was pastels.[69] The comments and reviews by art writers and critics also reflected increasing understanding and appreciation of the work of these artists and of the qualities of pastel. When Weir's drawings and etchings were exhibited at H. Wunderlich & Co. in 1895, the reviewer for the *Evening Post* observed that these "fragmentary scraps contain more real art than could be found in many a huge canvas."[70] This perceptive comment shows how a more positive attitude toward intimate, less highly finished works had emerged during the preceding decade. Roger Riordan, writing in *Art Amateur* about the exhibition of Impressionist works in 1886, observed that a painting by Alfred Sisley or Pissarro was not "what we are in the habit of regarding as a finished picture; but then it is not hard to remember when, to many American critics, the works by [the Barbizon painters] Diaz and Rousseau looked rough and incomplete."[71]

After the sketchlike appearance of pastels and paintings gained wider acceptance, writers sought precedents for this quality in an established historical tradition. By 1892 *Art Amateur* was explaining to its readers that the Impressionists' assembling of pigments was similar to the methods used by the English watercolorists and the French pastelists of the previous century.[72] In the same vein, William A. Coffin, discussing William Merritt Chase's work, reminded his readers in 1894 that the medium was

"a favorite mode of expression in the hands of the painters of the time of Louis XV."[73] In a series of articles in 1895 and 1896, *Art Amateur* again turned its attention to pastel, detailing its technique as well as its advantages.[74]

Meanwhile, exhibitions that featured pastels repeatedly brought the medium before the American public. Pastels were a highlight of the March 1889 exhibition of Whistler's work at H. Wunderlich & Co., his first major exhibition in America.[75] Whistler's influence on American artists had been acknowledged during the first exhibition of the Society of Painters in Pastel, in 1884.[76] Although he was often mislabeled an Impressionist by contemporary writers, Whistler's highly individual style—with its soft color harmonies, understated elegance, and economy of line—offered an alternative to the exuberance of French Impressionism.[77] As early as the 1880s his approach was adopted by many American painters, including Weir and Twachtman, and he had a lasting influence on their work. Whistler's death in 1903 prompted a major retrospective, which included pastels, at the Boston Museum of Fine Arts in 1904; a one-man show that featured his pastels at The Metropolitan Museum of Art in 1910 (fig. 15); and the publication throughout the decade of a number of books and articles discussing his pastels. His continued influence is evident in pastels such as John Marin's *Venice*, 1907 (p. 95).

With the ferment in artistic activity during the late nineteenth century and the increasing popularity of pastel, works in this medium began to appear with greater frequency in New York auction sales and dealers' galleries. In 1887 Moore's auction galleries conducted an exhibition and sale of Chase's paintings and pastels. H. Wunderlich & Co. presented *Atmospheric Notes in Pastel* by George Hitchcock in 1890, and exhibited pastels by Twachtman in 1891, by Weir in 1895, by Kenneth Frazier in 1897 and 1899, and by J. Carroll Beckwith in 1898 and 1900. In 1895 Knoedler exhibited paintings, pastels, and etchings by Mary Cassatt. Pastels were also among the works shown by Chase at Fifth Avenue Art Galleries in 1891, by Childe Hassam at the American Art Association in 1896, by Weir at Boussod-Valadon in 1897, by Twachtman at Durand-Ruel Galleries in 1901, and by Cassatt at Durand-Ruel in 1903. Also, in 1897 the New York Water Color Club announced in the *American Art Annual* that "original water-colors and pastels never exhibited before were received."[78]

Exhibitions dedicated to watercolors were initi-

Fig. 15. Photograph of an exhibition of pastels and paintings by James McNeill Whistler that was held at The Metropolitan Museum of Art, New York, from March to May 1910.

ated under the sponsorship of the American Watercolor Society in New York in 1868, the New York Water Color Club in 1890, and the Philadelphia Water Color Club in 1904. Other art organizations welcomed works on paper at their annual shows; these included the Boston Art Club, inaugurated in 1845, and the Art Club of Philadelphia, founded in 1891. Watercolor technique had been influenced by pastel and the two mediums had become closely linked, so that pastels were often shown in watercolor exhibitions.[79] "The two arts have, as to the effects aimed at, much in common," claimed a writer for *Art Amateur* in 1890, "and some artists show a disposition to blend their techniques, so that it is not always possible to say, at a glance, whether a certain picture is in pastel or in watercolor."[80]

The check lists of these various groups differed in their methods of specifying and ranking mediums. Around the turn of the century some annual exhibitions underwent significant changes in their inclusion and listing of mediums. In 1894 the Boston Art Club expanded the designation of its exhibitions from *Water Colors* to *Water Colors, etc.*, likely as a result of the increasing proportion and range of other included mediums, such as pastel. Many added a reference to pastels in their titles. In 1895 the title of the annual at the Art Institute of Chicago was changed from *Water Colors* to *Water Colors and Pastels*, the exhibition space was more than doubled, and more detailed information about the medium of

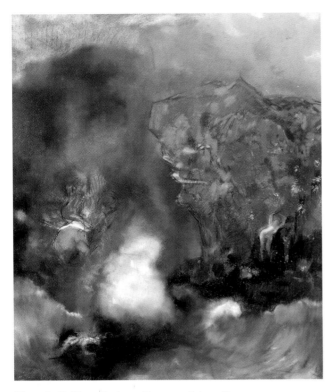

Fig. 16. Odilon Redon, *Roger and Angelica*, c. 1910, pastel on paper, mounted on canvas, 36½ × 28¾ in., The Museum of Modern Art, New York, Lillie P. Bliss Collection, 1934

each entry was provided. Beginning in 1902 the range of mediums at Chicago again expanded to include, among others, colored chalk, charcoal, tempera, color etching, and color woodblock print; nevertheless, pastels continued to rank second in number only to watercolors, with Hugh Breckenridge, Thomas P. Anshutz, and Birge Harrison, all prominent teachers, among the most frequent contributors of works in pastel.[81] From the outset of its annuals, in 1904, the Philadelphia Water Color Club used the title *Water Colors, etc.* The New York Water Color Club's yearly shows were entitled *Paintings in Water Color and Pastel*, and the Art Club of Philadelphia's, *Water Colors and Pastels*. In 1909 a review of the New York Water Color Club's annual asserted, "This club will doubtless add the words 'and Pastel' to its name, if the members continue to contribute so largely as at this exhibition pictures in that interesting medium. All things go in waves, and the pastel wave inundated this water-color show."[82] At the American Watercolor Society's annuals no medium other than watercolor was specified,

though both pastels and black-and-white drawings were often shown. In 1915 both the Philadelphia Water Color Club and the Boston Art Club began to specify in their check lists the mediums of individual exhibits, and the range of mediums at both clubs was impressive.[83] Judging from a review of the 1911 Philadelphia annual, which discussed earlier exhibitions, this interest in various mediums had begun years before:

> The attraction of the display was largely due to the unusually comprehensive scope of work shown and the introduction of several novel features. In reality it comprised a series of exhibitions of work in almost every medium save oil color and sculpture, numbering at least 1500 pieces and including water colors, pastels, lithographs, monotypes, illustrations, etchings and miniatures.[84]

Despite the dramatic increase in the variety of mediums included in the Philadelphia show, through 1917 the number of pastels still ranked second only to watercolors, but began to dwindle steadily in relative importance thereafter.

Because so many American artists studied and traveled abroad, exhibitions of pastels in Europe and the European attitude toward pastel were extremely important. In contrast to most American annuals, those in Europe were international rather than national in scope, generally included oils along with works on paper,[85] and usually specified the medium of each work in their check lists. From the outset, in check lists for the exhibitions of the Société des Artistes Indépendants, founded in Paris in 1884, entries in all mediums were interspersed, with entry numbers assigned alphabetically by artist. Significantly, this format radically contradicted that of the catalogues for the Exposition Annuelle des Beaux-Arts of the Société des Artistes Français. Until 1938, the catalogue for this Salon continued to list works hierarchically under such headings as "Peinture," "Dessins, Cartons, etc.," "Sculpture," "Architecture," "Gravure," and "Lithographie," with pastels included under "Dessins, Cartons, etc." rather than "Peinture."

In check lists for the first two exhibitions of the Salon d'Automne, held in 1903 and 1904, mediums were also categorized, with pastels exhibited along with watercolors. The following year, however, the format was changed and works in all mediums were combined in a single list. As at the Salon des Indépendants, works were listed alphabetically by

artist, and entries by a single artist were not necessarily arranged by medium, but more often by theme, with mediums interspersed. Pastels were regularly exhibited at the Salons d'Automne: in 1905, there were pastels by Edouard Manet, André Derain, Odilon Redon, Emile-Antoine Bourdelle, Jacques Villon, and Walter Sickert; in 1906, by Paul Gauguin, Redon, and Nathalie Goncharova; in 1907, by Berthe Morisot, Georges Rouault, Redon, and Eva Gonzales; in 1908, by Adolphe Monticelli and Hans von Marées; in 1909, by Siebe Ten Cate and Paul Ranson; and in 1911, by Jacques Villon, Wilhelm Lehmbruck, and Konrad Starke. Thereafter, the number of pastel entries by acknowledged masters decreased.

At Galeries Durand-Ruel one-man exhibitions of Redon's work in 1906 and 1910 featured twenty-three and fourteen pastels, respectively.[86] Pastels by Cassatt could be seen there in 1908 and 1914.[87] At Galerie Bernheim-Jeune several one-man shows included pastels—four by Sickert in 1907; at least nine by Edouard Vuillard in 1908; eleven by Manet in 1910; and two by Henri-Edmond Cross in 1914. A group show there in 1909 displayed sixteen pastels by Degas, thirty-five by Ker Xavier Roussel, and seven by Vuillard, with watercolors by Cézanne, Cross, and Paul Signac. At the exhibition *Divisionistes Italiens* at Serre de l'Alma in 1907, four pastels by Gaetano Previati and one by Giovanni Segantini were shown. Other major European artists working in pastel between 1900 and 1915 included the Orphist Frank Kupka; the Italian Futurists Giacomo Balla, Umberto Boccioni, and Gino Severini; and the German Expressionists Ernst Ludwig Kirchner, Franz Marc, and Otto Mueller.[88]

The status of pastel in the exhibitions of the Berlin Secession, a group that sponsored annuals like those in Paris, vacillated every year, far more so than in its Parisian counterparts. Not only did the medium's position waver hierarchically, but pastels were variously placed in painting and drawing categories.[89] In 1901 the Secession added to its spring annual a winter exhibition exclusively for secondary mediums. Whereas between 1899 and 1901 the spring exhibitions had averaged fourteen pastels by eight artists, the winter show of 1901–2 included sixty-nine pastels by twenty-six artists, with pastels outnumbering watercolors, a situation that did not occur in annual exhibitions of multiple mediums elsewhere in western Europe or America. From 1901 through 1913, when the winter annuals ceased, the exhibitions averaged forty pastels by

fifteen artists, with Ludwig von Hofmann and Max Liebermann, president of the Secession from its founding in 1898 until 1910, usually submitting large numbers of pastels. Between 1910 and 1913 other pastel contributors included Lovis Corinth, Liebermann's successor as president of the Secession, Signac, Lehmbruck, and Jules Pascin.[90]

American modernists who ventured to Italy, such as Marin, Arthur G. Dove, Abraham Walkowitz, Max Weber, Morton Schamberg, Charles Sheeler, and Joseph Stella, could have attended the important *Esposizione Internazionale d'Arte della Città di Venezia*, better known as the Venice Biennale. There, from the outset in 1895, the medium of each entry was designated. Works were listed by gallery, some national and some international, and were often segregated under the headings "Pitture" and "Bianco e nero," with pastels—on occasion even those with the same gallery—variously listed in either of these categories.[91]

Pastels were thus an important component in many exhibitions of American and European art. Playing a prominent role in early group displays of Impressionist art in America, pastels were also featured in one-man shows of such painters as Weir, Twachtman, Chase, and Whistler. The growing appreciation of pastel was also manifested by its inclusion in national exhibitions of works in secondary mediums initiated in America under the sponsorship of societies such as the Boston Art Club, the American Watercolor Society in New York, and the Philadelphia Water Color Club, or of a museum such as the Art Institute of Chicago. In Europe pastels by Redon (fig. 16) and others were regularly exhibited at the Paris Salons and with the Berlin Secession. Pastels, far from being confined to the annual shows of pastel societies, were highly visible in annuals, and in group and one-man shows at home and abroad.

<div style="text-align: right">M.W.F. / J.H. / G.S.</div>

Illustrators, the Eight, and Pastel

At the turn of the century, as pastel became increasingly popular among American artists, it played a more important role in illustration. By the late 1890s great technical strides had been made in this field, among them a nearly faultless system of halftone reproduction.[92] Devised by Frederic E. Ives for use by illustrated magazines, this process in-

volved making a photograph of the artist's illustration through a microscopically ruled screen. This screen broke up the tones into minute dots, which were translated into an image on the printed page in much the same way photographs are reproduced today. The result of this process was a much more accurate rendering of the artist's original work. It encouraged the use of more diverse and textural mediums than the ubiquitous pen and ink or watercolor. As a result, mediums employed by artists for illustration became increasingly complex and varied as technical refinements were made in the halftone-screen process. As the process developed, artists quickly learned what mediums or combinations of mediums lent themselves to faithful reproduction with the halftone screen. Pastel, with its elastic tonal range, was found by such illustrators as Everett Shinn, William Glackens, Jay Hambidge, André Castaigne, and Henry McCarter to be the perfect medium to add sparkle to their black-and-white illustrations. One author, in a review of Shinn's pastels, recognized the unique characteristics of the medium. "Pastel is one of the most charming of all vehicles. The possibilities of gradation of tone when it is employed [are] perhaps greater than any other medium."[93]

Since the late 1880s articles promoting the social reform movements of the time had appeared in many of the illustrated magazines.[94] Everett Shinn, a clever entrepreneur, certainly must have been aware of the public's interest in representations of the urban environment. Also realizing the innate charm of the pastel medium, Shinn made his appearance on the scene in 1899 as a "pastel painter," with two one-man pastel shows of New York scenes that attracted much positive attention from the press. "Mr. Shinn has done for New York what Raffaëlli has done for Paris and M. Fleury for Chicago," commented one writer in about 1901.[95] Pastel was clearly the medium that showcased Shinn's talents most effectively. Encouraged by his critical and financial success, his gallery, Boussod-Valadon, arranged for Shinn to take a trip to Paris in 1900 to produce pastels of that city. There he undoubtedly came into contact with the work of Edgar Degas, for the underlit faces of café singers, the backs of musicians' heads, the strong areas of color, and the peculiar spatial constructions of the French artist thereafter recurred consistently in Shinn's work.

William Glackens, like Shinn, was a student of Thomas P. Anshutz's at the Pennsylvania Academy of the Fine Arts and used pastel in his illustrations. As an illustrator, Glackens combined mediums to achieve certain effects (fig. 17). Most often he employed ink washes and charcoal for his illustrations, working with a very limited palette and utilizing pastel only minimally to add touches of color. After 1903, the year of his marriage and a formative trip to France, Glackens began to taper off his illustration work and turn more seriously to painting, developing an "almost lusty enjoyment of warm, swirling color."[96] He became well known for his vigorously colorful landscapes and beach scenes in pastel, executed much in the manner of Pierre-Auguste Renoir. Glackens also used pastel to make preliminary studies for his more elaborate oil paintings, formulating not only the compositional arrangements but the color schemes as well.[97]

Arthur B. Davies, though not an illustrator himself, took advantage of the quick application and

Fig. 17. William Glackens, *Seated Woman*, c. 1902, ink wash, charcoal, and pastel on paper, 18⅝ × 14¾ in., Mr. and Mrs. Raymond J. Horowitz

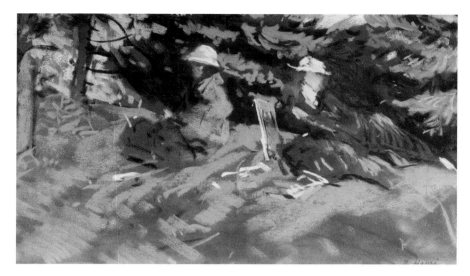

Fig. 18. Robert Henri, *The Sketchers in the Woods*, c. 1918, pastel on paper, 12⅜ × 19½ in., Rita and Daniel Fraad, Jr.

direct color of pastel to create more personal works. Davies evidently found the medium perfectly suited to study and experimentation. Although his pastels, both landscapes and figure studies, were rarely exhibited during his lifetime, his work in the medium was known and appreciated. As one writer commented:

> Mr. Davies in his drawings, of colored crayon on colored paper, is the Degas of America. . . . In front of most of these drawings a trained eye sees life, and life handled with the latest intelligence. Sees woman drawn as she has seldom been drawn. Sees a color-nerve strung to the last intimate harmony. Sees a touch on paper as delicate as melting light.[98]

The importance of pastel as a study medium cannot be overlooked in considering Davies's aesthetic. When viewing his pastels, particularly the nude studies, one is struck by their relative adherence to reality in contrast to his highly stylized oil paintings, which were criticized for being esoteric, introspective, meaningless, and vague. "His abundant gifts for drawing, coloring, designing, while they stamp him as the artist born as well as trained, are at the service of a potent imagination, an individual imagination."[99] It is precisely the painter's imagination that we see when confronted with Davies's oil paintings. His pastel studies may thus be

seen as anchors to reality, which inform him as he "develops his subject like a musician building up a symphony."[100]

In 1906, when that bastion of tradition, the National Academy of Design, merged with its once liberal offshoot, the Society of American Artists, progressive artists were left without a place to exhibit their work. Led by the revolutionary spirit of Robert Henri, artists who would not or could not hang their work at the academy banded together to formulate their own exhibition policies and show their work in a more liberal atmosphere. At a meeting of a group of fellow artists at the Players Club in 1906, Henri, himself a pastelist (fig. 18), proposed the establishment of an organization devoted to the exhibition of drawings, watercolors, and prints. The list of prospective members included artists who would later be designated as the Eight, those who were associated with the group of Impressionist-inspired American painters known as the Ten, as well as the illustrators Albert Sterner and William T. Smedley.[101]

The plan, which was never realized, represented a desire on the part of these artists to hold serious exhibitions of their work in the so-called minor arts. In 1907, spurred on by an increasingly vehement feud with the National Academy and its arbitrary policies, Henri spearheaded plans for a rival exhibition of the work of eight progressive artists. The members of the Eight were Henri, John Sloan, Ernest Lawson, Maurice B. Prendergast, George

Luks, Davies, Shinn, and Glackens. Although their 1908 exhibition consisted entirely of oil paintings, it was conceived in the spirit of revolution against tradition that had marked the plans outlined at the Players Club in 1906, and eventually led to full acceptance of pastel and other secondary mediums as viable and worthy of serious exhibition.

E.W.

The Pastellists, 1910–15

After the final exhibition of the Society of Painters in Pastel, in 1890, pastels continued to be shown in various annual exhibitions, but no single American organization was devoted exclusively to promoting and displaying works in the medium. In 1910 a group of interested New York artists formed a new organization, the Pastellists, which held four exhibitions before its demise in 1915. During this brief period of activity, the president of the Pastellists was Leon Dabo, a painter best remembered for his Whistlerian landscapes, and its secretary-treasurer was Elmer MacRae, a painter who helped organize the Armory Show. Unlike the Society of Painters in Pastel, which struggled to find acceptance for the medium, the Pastellists seems to have grown out of pastel's widespread popularity, not only with artists, but also with the general public. Artists simply needed a way to bring their pastel work before critics and collectors. While their exhibitions could hardly be described as innovative or revolutionary, the Pastellists did bring the medium to the attention of younger artists, many of whom made pastel an important feature of their work over the next decade.

Information about the Pastellists and their activities remains somewhat inconclusive. It appears that only the catalogues for the first and fourth exhibitions have survived; the dates and location of the third exhibition, held in 1912 or 1913, are unknown. While reviews of the other exhibitions often list participants, not all of them were necessarily members. (For example, works by James McNeill Whistler and Mary Cassatt were shown in the first exhibition; the former had died years earlier and the latter, then residing in France, is unlikely to have been a member.) Typically, the exhibitors were artists who had achieved prominence at or after the turn of the century—Jerome Myers (fig. 19), William Glackens, George Bellows, Walt Kuhn, and Walter Pach. There were, however, a few

Fig. 19. Jerome Myers, *Self-Portrait*, c. 1915, pastel on brown paper, 15⅜ × 12½ in., Mr. and Mrs. Arthur G. Altschul

artists, such as Everett Shinn, who had long since established reputations as pastelists. Of the artists who had shown their work with the Society of Painters in Pastel, only J. Alden Weir chose to exhibit with the Pastellists, though several of his contemporaries, Thomas W. Dewing among them, showed with the group.

The first exhibition of the Pastellists seems to have been the most important—it certainly inspired the most comment. Held at Folsom Galleries from January 10 to 25, 1911, it featured sixty-seven works by at least twenty-three artists.[102] A detailed account of the exhibition—its hanging, opening, and some of the daily visitors—is recorded in MacRae's diary.[103] On several occasions MacRae reported "good day" and "big attendance" and noted the visits of such critics as Arthur Hoeber, James Huneker, Royal Cortissoz, and Albert E. Gallatin.[104] Gallatin hailed the new group of artists, who had "banded themselves together for the encouragement of this charming form of art," and praised their exhibition,

"which, on the whole, was admirable."[105] The critic for the *New York Times* concluded that the success of the exhibition "proves once more to an ever skeptical public that the message of genuine art can be conveyed by the simplest as well as by the most complicated means."[106] Following up on the exhibition's success, MacRae called a business meeting for the group on January 25, when the officers and the Board of Control, which apparently consisted of the portraitist Juliet Thompson, Shinn, and Myers, were made permanent for the next year.[107] MacRae soon began to collect membership fees from the artists, and a second business meeting was held on February 15, when members agreed on articles of incorporation for the group.[108]

The second exhibition of the Pastellists, held at Folsom Galleries, opened on December 9, 1911, and has been variously reported as closing on the twenty-first, twenty-third, and thirtieth of that month.[109] While it appears there were fewer participants in this show, there was one important addition—Robert Henri.[110] It was at this exhibition that the idea of the Armory Show was first discussed. Within a month, the Association of American Painters and Sculptors had been formed, and had elected MacRae secretary-treasurer. Among the first members were several artists who had been quite active in the Pastellists—Dabo, Davies, Glackens, and Myers, to name a few.[111] Ironically, the Pastellists' third exhibition, which was probably held in 1912 or 1913, may have been overshadowed by the Armory Show, which opened in February 1913.[112] MacRae devoted much of his time to many details of the landmark show, and it seems likely that he was no longer able to provide the Pastellists with the leadership they needed to mount and publicize a major exhibition.

The final exhibition of the Pastellists took place at the National Arts Club from February 5 to March 7, 1914.[113] Several significant changes were made in the format of the show: no works by deceased artists were shown, and watercolors as well as pastels were accepted for exhibition.[114] It seems there were fewer exhibitors, but many of the better-known pastelists— Glackens, MacRae, Shinn, and Weir—continued to participate.[115] In 1915 the group was described as "inactive" and by the following year it was no longer listed in the *American Art Annual*'s comprehensive listing of art organizations, suggesting that it, like so many groups, had simply outlived its usefulness.[116] Another factor also may have come into play: in 1915 the American Watercolor Society revoked its 1913 decision to exclude pastels from its annual exhibi- tion, thus opening an important forum to pastelists and perhaps making the need for a separate annual less compelling.[117]

D.B.

Pastel and the American Modernists

In the early twentieth century, leading American and English art periodicals carried a number of articles championing pastel.[118] Their typically defensive tone was projected in "Pastel—Its Value and Present Position," published in *Magazine of Art* in 1900. The author summarized what he presumed to be the prevailing negative belief that pastel "is not supposed to be befitted for serious efforts and does not, in the estimation of artists and picture collectors, rank anywhere near the level occupied by oil and water- colour painting." He then argued that the medium "deserves a place to itself and recognition as an independent art with a technique of its own that cannot be said to belong to any of its successful rivals."[119]

In this and other articles, avoidance of pastel was further attributed to its fragility, femininity, and impermanence. The pastels of recognized French masters—Rosalba Carriera, Maurice-Quentin de La Tour, Jean-Baptiste-Siméon Chardin, Antoine Watteau, François Boucher, Jean-Baptiste Greuze, Jean-Baptiste Perroneau, Jean-Etienne Liotard, and Jean-François Millet—and of the Americans James McNeill Whistler, Eastman Johnson, Robert Blum, and Chase, were cited to refute these charges. Their work was used to illustrate pastel's distinctive advantages, such as "spontaneity and freedom of method . . . directness and simplicity . . . brilliancy and delicate variety."[120] Also celebrated were the medium's atmospheric qualities, softness, respon- siveness, purity and range of color, unreflecting texture, freshness (or permanence) of pigment— even after 150 years—and the variety of support materials on which it could be used. With increased confidence, publications advocating pastel stressed its practical advantages: its accessibility in hundreds of ready-to-use, colorfast pigments, and its capacity for manipulation relative to other mediums, es- pecially oil.

The work of the leading modernist practitioners of pastel exemplifies its versatility as a medium for both the painter and the draftsman, one that can serve as both an experimental vehicle for the exploration of abstraction and an instrument for

the depiction of representational imagery. Most of these artists began their studies with the leading American pastelists of the previous generation, such as William Merritt Chase, Hugh Breckenridge, Thomas P. Anshutz, and Birge Harrison, from whom they likely gleaned techniques for using and even making pastels.

At the turn of the century, William Merritt Chase, a highly influential proponent of modern art, rightfully claimed to have taught more art students than any other teacher in America. He returned from his studies abroad in 1878 to teach at the Art Students League, and by 1897 he had been an instructor at several of the major art schools in the country, including his own in New York.[121] Chase's students at the Pennsylvania Academy of the Fine Arts included John Marin from 1899 to 1901, Carles from 1900 to 1907, and Sheeler and Schamberg from 1903 to 1906. Among his pupils in New York

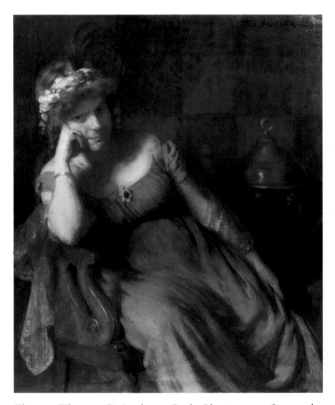

Fig. 20. Thomas P. Anshutz, *Becky Sharp*, c. 1906, pastel on canvas, 42½ × 34 in., Pennsylvania Academy of the Fine Arts, Philadelphia, Joseph E. Temple Fund

art schools were Hartley from 1893 to 1900, Stella from 1900 to 1902, Dickinson from 1906 to 1910, and O'Keeffe from 1907 to 1908.[122] One of Chase's earliest pupils and a fellow exhibitor with the Society of Painters in Pastel was Irving Ramsey Wiles, who remarked, "It was his delight in pastel that opened our eyes to the medium. Up to then no one handled pastel in so painter-like a manner."[123]

Two other prominent pastelists, Thomas P. Anshutz and Hugh Breckenridge, were also instructors at the Pennsylvania Academy. Anshutz (fig. 20), who took up pastel at the age of forty-one as the result of a year of study abroad, from 1892 to 1893, reportedly commented in 1899: "It didn't make much matter what medium one used or what one chose to portray so long as one was learning to paint."[124] According to the same source, pastels and watercolors seemed as numerous as oils in Anshutz's studio at the time.[125] Between 1904 and 1906 Anshutz and his former student H. Lyman Säyen fabricated their own pastels at Säyen's home. They later repeated the practice in Europe in 1910, when they used a paint mill to mix pigments, and experimented with new, brilliant colors—colors until then not in common use.[126] Anshutz fostered the stylistic independence that would result in the modernists' varied responses to European trends and their equally varied applications of the pastel medium.

Breckenridge, who was as celebrated for his pastels as for his oils, may have been involved in Anshutz's pastel-making experiments in Philadelphia;[127] like Anshutz, he exhibited his pastels regularly in annual exhibitions of secondary mediums in Philadelphia and elsewhere. In about 1899 Breckenridge wrote a one-page document, "Making Pastel Sticks," which was evidently a class handout. Not only does this demonstrate Breckenridge's promotion of the medium among his students, but it also conveys the nature of pastel's appeal for him and his experimental approach to it. "What you need in making pastels, is what you need in painting your picture—*Experiment*," he asserted. Artists were encouraged to experiment with the variable amounts of gum required as a binder for different pigments, bearing in mind the degree of softness or hardness desired for the stick. He recommended making pastels in pure pigments, advocating eleven specific permanent ones, and he marveled that "with these colors you can make a million tints."[128]

Birge Harrison, the supervisor of the Art Students League's Woodstock Summer School, was

also an accomplished pastelist who exhibited his work frequently. The school's philosophy, as stated by Harrison in 1910, echoed that of the Pennsylvania Academy under Anshutz: "The strongest effort is made by the school to cultivate and foster the individuality of its students . . . at liberty to choose their own medium, whether it be oils, water colors, pastels or tempera; and no rigid formula in regard to technique is enforced, each selecting the style which best suits his temperament."[129] In 1909 and 1915 Harrison wrote two analyses of the pastel medium that bespeak substantial growth in his technical command of and confidence in pastel during the intervening years.[130]

Between 1905 and 1915 most of the modernists who used or would use pastel, except O'Keeffe, traveled abroad. Most studied and worked in Paris, where they encountered European avant-garde stylistic currents and, most likely, pastels by prominent European artists, on view in large annual Salons and at leading commercial galleries. This exposure as well as other experiences abroad may have motivated or conditioned their use of pastel. In 1908 Weber and Säyen participated in a class led by Henri Matisse, who reportedly stressed the notion that a subject's colors should not simply be copied. Rather, a picture should possess an autonomous color scheme with harmonies that reflect those of the model.[131] Matisse's emphasis on nonmimetic color construction likely heightened Weber's and Säyen's appreciation of the formal qualities of color and possibly fueled their attraction to pigment-laden pastel. Odilon Redon paid a visit to the class, and its members frequented the salons of Leo and Gertrude Stein, spending hours examining portfolios of drawings by Pablo Picasso, which could have included pastels.[132] Hartley lived in Berlin from 1913 to 1915, when he had a one-man show at the home of leading German pastelist Max Liebermann, former president of the Berlin Secession and an artist whose work may have had some bearing on Hartley's later attraction to the medium.[133]

When modernists such as Marin, Weber, Dove, Carles, Walkowitz, and Hartley returned to America after exposure to European art in exhibitions and schools, they found a hospitable atmosphere for their work at Alfred Stieglitz's Little Galleries of the Photo-Secession, often called "291," where O'Keeffe later joined their circle. Not only was "291," as of 1908, the foremost American showcase for European modernism, but Stieglitz, a photographer himself,

seemed inclined toward works on paper, as manifested in the exhibitions held there. Between 1908 and 1911 he showed drawings by Auguste Rodin; lithographs, watercolors, drawings, and etchings by Matisse; color lithographs by Edouard Manet, Pierre-Auguste Renoir, Paul Cézanne, and Henri de Toulouse-Lautrec; and watercolors and drawings by Picasso. Beginning in January 1910 works in secondary mediums by European and American modernists were reproduced regularly in the gallery's official quarterly, *Camera Work*. Stieglitz purchased many of the works exhibited at "291" and, from the Armory Show, acquired *Reclining Woman*, 1911, a pastel figure study by Arthur B. Davies (p. 162).[134] Significantly, Stieglitz rejected the academic attitude toward the hierarchy of mediums:

> I do not see why photography, water colors, oils, sculptures, drawings, prints . . . are not of equal potential value. I can not see why one should differentiate between so-called "major" and "minor" media. I have refused so to differentiate in all the exhibitions that I have ever held. . . . It is the spirit of the thing that is important.[135]

With its small-scale intimacy, its consciously experimental thrust, and an orientation less commercial than that of other American galleries, "291" provided an environment conducive to the exhibition of works in secondary mediums, including pastel.[136] In fact, every year between 1910 and 1913, one-man exhibitions held at "291" by American modernists included pastels. In 1910 twenty pastels were grouped with forty-three watercolors and eight etchings by Marin. A show of drawings and paintings by Weber in 1911 included at least one pastel, the head of a young woman, and it was the only work that sold.[137] The following year, Dove's show, billed as his "first exhibition anywhere," consisted solely of pastels. In 1913, "291" showed drawings, pastels, and watercolors by Walkowitz, who in 1912 had helped Stieglitz mount an exhibition that included pastels by children.[138]

Building on Stieglitz's initiative, the Armory Show's organizers did much to advance the creation, exhibition, and marketability of works in minor mediums in America. In its official statement inviting artists to participate in the show, the Association of American Painters and Sculptors went out of its way to solicit entries in any medium:

The Association particularly desires to encourage all art work that is produced for the pleasure that the producer finds in carrying it out . . . the result of any self-expression in any medium that may come most naturally to the individual. For instance, a man may be a painter and amuse himself at woodcarving, which he might never intend to exhibit, and yet the woodcarving may be the most valuable as a natural expression of the artist's talent. You may come in contact with someone who is not a professional artist and yet produces original designs in needlework of art value.[139]

This nondiscriminatory policy was extended to the show's check list, in which mediums were not segregated.

Four of the Armory Show's instigators, Walt Kuhn, Elmer MacRae, Jerome Myers, and the association's president, Arthur B. Davies, were actively involved in the Pastellists.[140] After encountering Redon's paintings and pastels for the first time at The Hague in 1912, Kuhn wrote home, "We are going to feature Redon big (BIG!)."[141] Indeed with seventy-six works, including six pastels, in the Armory Show, Redon was by far the most prominently showcased artist. In all, thirty-six pastels were displayed, with examples by Davies, Childe Hassam, Kuhn, MacRae, Pierre Puvis de Chavannes, and Georges Rouault.[142]

With the Armory Show's success, a nucleus of commercial galleries rallied to the cause of avant-garde art in secondary mediums. N. E. Montross let Davies arrange several exhibitions featuring works by American modernists.[143] The first one, held in 1914, combined pastels by Stella, drawings by Kuhn, and watercolors by Davies, Schamberg, and Prendergast, with three oils by each of these artists and four by Sheeler.[144] A large show of Weber's work at Montross in 1915 included ten pastels.[145] Bourgeois Galleries, which opened in 1914, also showed pastels by Stella.[146]

Charles Daniel, who opened the Daniel Gallery in 1913, credited "291" as "the original impulse of my going into the modern art world."[147] Daniel frequented the exhibitions at "291," and purchased works by several American modernists, including Hartley, Marin, Weber, and Walkowitz.[148] Like Montross, he enjoyed exhibiting various mediums together, especially, according to one source, pastels by Dickinson, colored-pencil drawings by Sheeler, watercolors by Charles Demuth, and India-ink draw-

ings by Yasuo Kuniyoshi.[149] Daniel was Dickinson's exclusive dealer and he also financed Hartley's 1918–19 excursion to Taos, New Mexico, where he worked predominantly in pastel.[150]

Stieglitz helped to organize Anderson Galleries's 1916 *Forum Exhibition of Modern American Painters*, to which artists were asked to submit both paintings and drawings and to which Dove and Walkowitz contributed pastels.[151] Between 1921 and 1925, after the closing of "291," Anderson Galleries became a temporary showcase for Stieglitz and his coterie. Examples of O'Keeffe's pastels were first seen there in a 1922 group show and in one-man shows in 1923 and 1924. Stieglitz then opened, within Anderson Galleries, the Intimate Gallery, where pastels by Dove, O'Keeffe, and Peggy Bacon were shown between 1926 and 1929.[152]

The modernist pastels of Stella, Weber, Walkowitz, Dove, Dickinson, O'Keeffe, Hartley, Schamberg, Sheeler, and Carles reflect the versatility of the medium. Stella, a pupil of Chase's, executed pastels throughout his career. In 1913–14, inspired by his exposure to Fauvism and Futurism abroad, Stella used pastel as a colorful vehicle for advancing abstraction in his work. Yet he simultaneously maintained an interest in the use of pastel for representational subjects. Around 1920 his diverse pastel production encompassed industrial scenes (p. 105) and symbolical, organic motifs. Stella's application of pastel varied from the thick, painterly technique of the industrial works to the spare, delicate, precise treatment in many botanical studies inspired by visits to the New York Botanical Garden in the Bronx from 1919 to 1921 and from 1938 to 1946.

Impoverished after his years abroad, Max Weber reportedly took up pastel and numerous other secondary mediums because they were more affordable than oil. Between 1912 and 1916 pastel appears to have been the secondary medium Weber favored most. Many of his pastels of this period reflect Weber's interest in abstraction and the influence of such movements as Cubism and Futurism, and of such painters as Wassily Kandinsky. Weber's application of pastel, a blanketing of the medium over the full surface of the paper, strongly resembles his use of oil. The many passages of stumpwork are often accented with spirited staccato marks.

Abraham Walkowitz utilized a wide array of secondary mediums, including pastel, for his many works on paper. Between 1912 and 1917, years marking his close association with Stieglitz, Walko-

Fig. 21. Marsden Hartley, *New Mexico*, 1919, pastel on paper, 17 × 27½ in., University Gallery, University of Minnesota, Minneapolis, Bequest of Hudson Walker, from the Ione and Hudson Walker Collection

witz used pastel and other mediums as vehicles for an abstract art particularly inspired by Kandinsky's paintings and theories that drew analogies between music and art.

Another major pioneer of modern abstraction inspired by Kandinsky was Arthur G. Dove, for whom pastel also played a crucial role. He made his debut in 1912 at "291" with ten pastels that sparked critical attention because of their enchanting colors and nonillusionistic imagery. Dove continued to work largely in pastel through 1917 and briefly resumed use of the medium during the 1920s, creating such painterly pastels as *Tree Forms and Water* (p. 116).

Although he most likely was introduced to pastel as a pupil of Chase's and Harrison's, Preston Dickinson did not seriously turn to this medium until the late teens. Attracted to pastel because of its capacity for manipulation, Dickinson adapted it to his eclectic, synthetic style, in which he combined Western and Oriental mediums and qualities. His first major series of pastels, consisting of industrial scenes along the Harlem River, was executed in about 1922 (p. 134).

Georgia O'Keeffe, also a pupil of Chase's, may have been attracted to pastel in about 1914 through her enthusiastic encounters with Dove's work in this medium. She used pastel regularly from 1920 until about 1945 (p. 131). Ready workability and intense color appear to have been the attributes of pastel that most impressed her.

The colors and dryness of the landscape of New Mexico, where O'Keeffe resided after 1949, inspired a number of pastels. These aspects of the New Mexico terrain also prompted pastels by Hartley in 1918–19 (fig. 21) and by Marin in 1929, though both of them otherwise rarely used the medium. In their dry, matte quality, Hartley's pastels are well attuned to the parched hills they chiefly depict.[153] It has been suggested that the artist, feeling that the mood of the colors was not appropriate for oils, chose a spare application of pastel instead.[154] Whereas some modernists used pastel to advance abstraction in their work, Hartley's Taos pastels show, as Barbara Haskell noted, "a higher degree of naturalism than he had attempted since his student days" and "while pleasant enough as studies . . . display none of his expressive strength or abstract decorative skills."[155] It is not known whether Hartley considered these pastels as studies while he was producing them. When he returned to New York, he based a series of oils on them, capturing the chalky texture of the pastel with paint.[156] Hartley reportedly abandoned pastel because of its fragility. "He loved this delicate medium, but found it hard on his eyes, a fact which he lamented," wrote Elizabeth McCausland.[157] Nevertheless, he did employ the medium on occasion in

Fig. 22. Morton Schamberg, *Composition*, 1916, pastel on paper, 7¾ × 6 in., Françoise and Harvey Rambach, Courtesy of Salander-O'Reilly Galleries, New York

the 1930s for depicting Maine subjects and the Bavarian Alps, perhaps mindful of his early association with Liebermann or of his Taos mountain pastels.

Judging from signed, dated oils similar in motif, style, and size, we can date Morton L. Schamberg's earliest known pastels of park and theater scenes to about 1908 and 1909, when he was in Paris. Their hasty, impressionistic handling and small size suggest that they may have been done on the spot, perhaps as preliminary sketches for oils, and that portability and directness of application were factors in Schamberg's initial attraction to pastel. His painterly approach to the medium signals the strong rapport his pastels would continue to have with his oils.[158]

Schamberg's most extensive and aesthetically noteworthy use of pastel, in 1915 and 1916, coincided with his well-known oils based on machine forms, the culminating works of his short career.[159] The pastels (fig. 22) display considerable variety in

Fig. 23. Charles Sheeler, *Still Life with Peaches*, 1923, pastel on paper, 15⅝ × 11¼ in., Columbus Museum of Art, Ohio, Gift of Ferdinand Howald, 1931

handling and realize an expressive freedom not achieved in the more highly controlled machine oils. In many cases Schamberg's gestural handling and his blurring of the pastel into the paper create the sensation of rotating, vibrating machine belts and wheels, in contrast to the generally static appearance of the related oils and watercolors. In most of the pastels he used pencil to delineate the machine forms, then rubbed the pastel over the pencil lines to enhance the impression of motion. William Agee noted that their "color is intense and personal. The use of turquoise and pink in several, for example, is literally unique in the art of the time."[160]

Charles Sheeler was only briefly involved with pastel, in 1923 and 1924. His early enthusiasm for Chase's teaching[161] and his lifelong friendship with Schamberg, from their student days together at the Pennsylvania Academy,[162] make Sheeler's delayed adoption of the medium especially interesting. Moving from Philadelphia to New York in 1919, Sheeler may have encountered pastels stylistically sympathetic with his own concerns by Stella, O'Keeffe, and Dickinson. Sheeler's documented works in the medium consist of a few still lifes (fig. 23), a self-portrait,[163] and *Portrait of a Woman*, 1924 (New York art market), which, in comparison to his other works on paper, contains more freely manipulated and sharply faceted colors and shapes.[164] In all of Sheeler's pastels the execution is draftsmanly rather than painterly in effect, with individual forms carefully outlined.

The 1907 pastel portrait *Frances Metzger West* (fig. 24), which is decidedly derivative of Chase's style and technique, and two stylistically unrelated pastels of the mid-teens suggest that Arthur B. Carles turned to the medium at least occasionally early in his career.[165] He later explored it in depth for a series of brilliantly colored single female nudes in about 1929.[166] A subject of longstanding importance for his oils, his nudes in that medium increased in their intensity of color and degree of abstraction during the 1920s.[167] His adoption of pastel in this connection recalls the ventures of Weber and Stella into abstraction and many modernists' explorations of heightened color through the medium of pastel. Carles's pastel nudes are uniformly expansive in their application of the medium over the full support and in their rich synthesis of drawing and rubbing.

The modernists Carles, Säyen, Schamberg, Stella, Dove, Marin, Walkowitz, and Weber used pastel from the outset of their careers. Hartley,

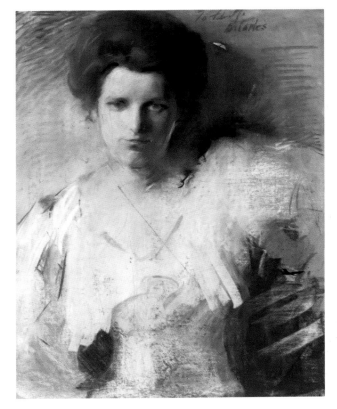

Fig. 24. Arthur B. Carles, *Frances Metzger West*, 1907, pastel on canvas, 24 × 19½ in., Pennsylvania Academy of the Fine Arts, Philadelphia

Sheeler, Dickinson, and O'Keeffe, in contrast, adopted the medium relatively late; therefore, their approach to it was conditioned by their earlier treatment of other mediums and by their already formulated aesthetics. After taking up pastel, some modernists—Stella, Walkowitz, Schamberg, and Dickinson—used the medium steadily for the duration of their careers; O'Keeffe used it for about twenty-five consecutive years. Dove was the only modernist for whom pastel assumed a dominant position, particularly between 1911 and 1917.

Marin, Walkowitz, Stella, Weber, and Carles developed eclectic pastel styles that were strongly influenced by European currents, whereas Dove and O'Keeffe made particularly personal and consistent use of the medium. Schamberg's and Dickinson's pastels straddle both camps. Notably, the eclectic group used pastel in mixed-media works, whereas Dove and O'Keeffe did not. Stella's and Dickinson's mixed-media pastels, in fact, outnumber their works done solely in pastel. Whatever their source of

inspiration, most of the modernists exhibited their pastels, which were designated variously as paintings, drawings, or pastels. Dove's and O'Keeffe's pastels, however, were uniformly painterly, and exhibition check lists suggest that the artists referred to them as paintings.[168]

Weber, Dove, Walkowitz, and O'Keeffe were affected by Kandinsky's synaesthetic theories, which encouraged their exploration of abstraction using pastel and other mediums. Weber in 1912 and Stella in 1913 and 1914 executed pastels more abstract in style than their contemporary works in other mediums. Weber, Dove, Schamberg, and Stella also experimented with nontraditional art materials. Novel supports, such as wood and newspaper, were utilized by Dove and Weber, respectively, in their pastels.

Perhaps related to the Precisionist stylistic tendency perceived in the work of many modernists in the late teens and early 1920s, Stella in 1917, O'Keeffe in 1921, Dickinson in 1922, and Sheeler in 1923 all began using pastel for smoothly finished still lifes. Thus pastel served variously, or simultaneously, as in Stella's case, as a vehicle for abstraction and representation. But, like their artistic predecessors, modernists were attracted to the medium's capacity for manipulation, directness of application, variety of rich, colorfast pigments, and versatility as a painterly or draftsmanly material. Modernist pastels certainly support the assertion of Richmond and Littlejohns in their 1927 manual *The Art of Painting in Pastel*: "There are practically no limits to its powers of artistic expression."[169]

M.W.F. / G.S.

NOTES:

1. Foster 1979 provides a short history of the society. A more extensive discussion of the subject appears in Kathleen Adair Foster, "Makers of the American Watercolor Movement, 1860–1890" (Ph.D. diss., Yale University, 1982).

2. For further information concerning organizations and periodicals during this period see Richard Guy Wilson, "Periods and Organizations," in Brooklyn Museum, *The American Renaissance, 1876–1917*, exhib. cat. (New York, 1979), pp. 63–70. For the Tile Club see W[illiam] Mackay Laffan, "The Tile Club at Work," *Scribner's Monthly* 17 (Jan. 1879), pp. 401–9; W[illiam] Mackay Laffan and Edward Strahan [Earl Shinn], "The Tile Club at Play," *Scribner's Monthly* 17 (Feb. 1879), pp. 464–78; idem, "The Tile Club Afloat," *Scribner's Monthly* 19 (Mar. 1880), pp. 641–71; W[illiam] Mackay Laffan, "The Tile Club Ashore," *Century Illustrated Monthly Magazine* 23 (Feb. 1882), pp. 481–98; J. B. Millet, "The Tile Club," in *Julian Alden Weir: An Appreciation of His Life and Works* (New

York, 1921), pp. 75–87; Lyman Allyn Museum, *A Catalogue of Work in Many Media by Men of the Tile Club*, exhib. cat., with an essay by Dorothy Weir Young [Mrs. Mahonri Sharp Young] (New London, Conn., 1945); Ronnie Rubin, "The Tile Club, 1877–1887" (M.A. thesis, New York University, 1967), the most complete treatment of the subject; and Mahonri Sharp Young, "The Tile Club Revisited," *American Art Journal* 2 (Fall 1970), pp. 81–91. On the etching revival see Rona Schneider, "The American Etching Revival: Its French Sources and Early Years," *American Art Journal* 14 (Fall 1982), pp. 40–65. On the Society of Decorative Art see MMA, *In Pursuit of Beauty: Americans and the Aesthetic Movement*, exhib. cat. by Doreen B. Burke et al. (New York, 1986), pp. 96–102, 218, 481–82.

3. For example, the jury for the American Watercolor Society's exhibition in New York in 1882 selected about 850 works and created a furor when it found room to hang only 650 (Foster 1979, p. 20).

4. Van Rensselaer 1884, p. 204.

5. Ibid., pp. 205, 209.

6. Ibid.

7. Yale University Art Gallery, *Edwin Austin Abbey*, exhib. cat. by Kathleen Adair Foster and Michael Quick (New Haven, 1974), p. 66.

8. Cecilia Beaux, *Background with Figures* (Boston/New York, 1930), p. 195.

9. *Art Amateur* 1890.

10. For an examination of American painters who remained in Europe for most of their lives see Dayton Art Institute, *American Expatriate Painters of the Late Nineteenth Century*, exhib. cat. by Michael Quick (Dayton, 1976).

11. Coe Kerr Gallery, *Americans in Venice, 1879–1913*, exhib. cat. by Donna Seldin (New York, 1983); and Fine Arts Museums of San Francisco, *Venice: The American View, 1860–1920*, exhib. cat. by Margaretta M. Lovell (San Francisco, 1984) provide an overview of the activities of various American artists in Venice, including Whistler. See also Otto H. Bacher, *With Whistler in Venice* (New York, 1908); and Getscher 1970.

12. Contemporary reviews of this pastel exhibit can be found in Getscher 1970.

13. Quoted in Wildenstein & Co., *A Loan Exhibition of Mary Cassatt for the Benefit of the Goddard Neighborhood Center*, exhib. cat. by Adelyn D. Breeskin (New York, 1947), p. 17.

14. Montezuma [pseud.], "My Note Book," *Art Amateur* 8 (Jan. 1883), p. 29.

15. J. Carroll Beckwith, diary, Nov. 18, 1882, National Academy of Design, New York, Archives. I am very grateful to Carolyn Nelson for drawing my attention to Beckwith's diaries and for generously sharing with me her unpublished M.A. thesis. Nelson 1983 and Pilgrim 1978 are the most informative sources on the origins and activities of the Society of Painters in Pastel. It should be noted that the society's name is variously reported as the Society of Painters in Pastel, the American Society of Painters in Pastel, and the Society of American Painters in Pastel.

16. Stebbins 1976, pp. 226–27, characterizes the two trends.

17. *Art Amateur* 1890.

18. Van Rensselaer 1884, p. 205, as quoted in Pilgrim 1978, p. 47. It was Dianne Pilgrim who first appreciated the importance of de Nittis's work for American painters.

19. University of Washington, *A Leading Spirit in American Art: William Merritt Chase, 1849–1916*, exhib. cat. by Ronald G. Pisano (Seattle, 1983), pp. 66–71.

20. The nine guest contributors were Charles H. Freeman, Jr., Kate H. Greatorex, Caroline T. Hecker, Francis C. Jones, S. G. McCutcheon, W. McEwen, John H. Niemeyer, Walter L. Palmer, and Ross Turner ([W. P. Moore Gallery], 290 Fifth Avenue, *Initial*

Exhibition of Painters in Pastel, exhib. cat. [New York, 1884]; copy in the New York Public Library).

21. "The Pastel Exhibition," *Art Amateur* 10 (May 1884), p. 123.

22. "The Painters in Pastel," *New York Times*, Mar. 17, 1884, p. 5.

23. "Open Questions," *Art Interchange* 12 (Mar. 27, 1884), p. 73.

24. Beckwith, diary, Mar. 29, 1884.

25. "Art Notes and News," *Art Interchange* 15 (Dec. 3, 1885), p. 152.

26. H. Wunderlich & Co., *Second Exhibition of the Painters in Pastel*, exhib. cat. (New York, 1888); copy in the New York Public Library.

27. "Professors of Pastels," *New York Times*, May 5, 1888, p. 4.

28. Other contributors to the second exhibition of the society were Lyle Carr, William A. Coffin, Herbert Denman, Caroline T. Hecker, Francis C. Jones, Walter L. Palmer, Irving Ramsey Wiles, and J. Louis Webb.

29. "The Pastel Exhibition," *Art Amateur* 19 (June 1888), pp. 3–4.

30. Foster 1979, p. 21.

31. Nelson 1983, p. 68.

32. "Art Notes," *Art Interchange* 20 (May 19, 1888), p. 161.

33. "The Pastel Club's Exhibition," *New York Tribune*, May 7, 1888, p. 6.

34. Ibid.

35. "Art News and Comments," *New York Tribune*, May 20, 1888, p. 10.

36. Catalogues of the third and fourth exhibitions of the Society of Painters in Pastel have not come to light, though at least one writer refers to a catalogue for the fourth exhibition, in 1890, in his review, "The Painters in Pastel," New York *Sun*, May 17, 1890, p. 6. The most complete information concerning the final two exhibitions of the society can be found in the reviews mentioned below.

37. Other exhibitors were Francis Day, George Hitchcock, Irving Ramsey Wiles, and Henry O. Walker ("The Pastel Exhibition," *Art Amateur* 21 [June 1889], p. 4).

38. Ibid.

39. "The Pastel Club, Third Exhibition," *New York Tribune*, Apr. 21, 1889, p. 7.

40. *Art Amateur* 1890.

41. Other contributors were Otto Bacher, Augusta Berg, Maria Brooks, Carlton T. Chapman, Francis Day, Charles Warren Eaton, Caroline T. Hecker, Benoni Irwin, Francis C. Jones, H. Bolton Jones, Walter L. Palmer, Edith Sackett, and Rosina Emmet Sherwood (ibid.).

42. Ibid.

43. Ibid.

44. "Annual Watercolor Show," *American Art News* 11 (Mar. 8, 1913), p. 2.

45. "The Painters in Pastel," p. 6.

46. Grand Palais, *Autour de Lévy-Dhurmer: visionnaires et intimistes en 1900*, exhib. cat. (Paris, 1973), p. 11. My assessment of the French and British pastel societies depends on Nelson 1983, which includes a careful examination of pastels in an international context.

47. Nelson 1983, p. 32.

48. Ibid., p. 33.

49. Ibid., p. 34.

50. Ibid., p. 35.

51. "Grosvenor Gallery," *Artist* 9 (Nov. 1, 1888), p. 332.

52. Ibid.

53. Lucas 1921, II, pp. 287–88.

54. R. A. M. Stevenson, "Exhibitions in London," *Art Journal* (London) 51 (Apr. 1899), p. 119.

55. Ibid.

56. "Some London Exhibitions," *Art Journal* (London) 53 (Aug. 1901), p. 254; and Frank Rinder, "Some London Exhibitions: The Pastellists, British Colonials, and Others," *Art Journal* (London) 54 (Aug. 1902), p. 263.

57. "London Exhibitions," *Art Journal* (London) 56 (Mar. 1904), p. 98.

58. Frank Rinder, "London Exhibitions," *Art Journal* (London) 59 (Aug. 1907), p. 247.

59. Frank Rinder, "Pastel Society," *Art Journal* (London) 60 (Aug. 1908), p. 246.

60. William H. Gerdts, *American Impressionism* (Seattle, 1980), p. 29. Gerdts adds that this Degas pastel already suggests "the role that the revival of pastel painting would have in the transmission and popularization of Impressionist aesthetics during the following decade."

61. "The Old Cabinet," *Century* 15 (Apr. 1878), pp. 888–89.

62. There had been two previous exhibitions in the United States that included French Impressionist works: one was presented at Mechanic's Hall in Boston in September 1883 as part of the International Exhibition of Art and Industry; the other was the Bartholdi *Pedestal Fund Art Loan Exhibition*, organized by William Merritt Chase and others and held at the National Academy of Design in December 1883.

63. For a full discussion of the exhibition and the reaction of the press see Hans Huth, "Impressionism Comes to America," *Gazette des Beaux-Arts* 19 (Apr. 1946), pp. 241–44; and H. Wayne Morgan, *New Muses: Art in American Culture, 1865–1920* (Norman, Okla., 1978), pp. 121–25.

64. Luther Hamilton, "The Work of the Paris Impressionists in New York," *Cosmopolitan* 1 (June 1886), p. 240.

65. Huth, "Impressionism Comes to America," p. 244.

66. The 289 entries were not all works by Impressionists; about 50 pictures by more academic artists, such as John Lewis Brown and Alfred-Philippe Roll, were also included. The pastels and watercolors were numbers 35 to 107.

67. Hamilton, "The Work of the Paris Impressionists in New York," p. 240.

68. "The Impressionist Exhibition," *Art Amateur* 14 (May 1886), p. 121.

69. For Weir's adoption of pastel see Burke 1983, p. 168; for Twachtman see Hale 1957, p. 259 n. 2.

70. "J. Alden Weir's Drawings," New York *Evening Post* [Feb. 1895], scrapbook, Family of the artist.

71. R[oger] R[iordan], "The Impressionist Exhibition: Second Notice," *Art Amateur* 15 (June 1886), p. 4.

72. "What Is Impressionism," *Art Amateur* 28 (Dec. 1892), p. 5.

73. William A. Coffin, "Portraits of Women," *Cosmopolitan* 18 (Nov. 1894), p. 8.

74. The articles in *Art Amateur* were "Painting in Pastel," 33 (Sept. 1895), p. 68; "The Elements of Pastel Painting," 34 (Mar. 1896), p. 88; and "Pennell on Pastel," 34 (Feb. 1896), p. 64.

75. The exhibition featured thirty-six watercolors, four pencil drawings, and twenty-two pastels.

76. Van Rensselaer 1884, p. 207; "The Painters in Pastel," *New York Times*, Mar. 17, 1884, p. 5.

77. Charles de Kay, "Whistler: The Head of the Impressionists," *Art Review* 1 (Nov. 1886), p. 6.

78. *American Art Annual* (1898), p. 284.

79. Stebbins 1976, p. 233.

80. "The New York Water-Color Club," *Art Amateur* 24 (Dec. 1890), p. 3.

81. At the Art Institute of Chicago, pastel continued to sustain its lead over all mediums except watercolor through 1920. In 1921 this annual became an international show of watercolor and tempera paintings only, a shift that was described as innovative in the foreword to the check list. In 1927, however, the Art Institute reversed its stance yet again and reincorporated pastel and other mediums into its international annuals.

82. Minna C. Smith, "New York Water-Colour Club Exhibition," *International Studio* 36 (Jan. 1909), p. xcvi.

83. The Philadelphia Water Color Club's 1915 annual included works in watercolor, pastel, oil, tempera, crayon, Crayola, pencil, colored pencil, chalk, charcoal, sepia, wash, India ink, etching, color etching, soft-ground etching, monotype, color monotype, aquatint, color aquatint, wood engraving, color wood engraving, stipple engraving, woodcut, wood-block print, color wood-block print, lithograph, color lithograph, drypoint, color drypoint, xylograph, and mixed mediums, noted with attention to the dominant medium; for example, pastel and pencil (cat. no. 1069) versus pencil and pastel (cat. no. 1072), both on p. 86 of the catalogue.

84. Alice T. Searle, "The Ninth Annual Exhibition of the Philadelphia Water Color Club," *International Studio* 45 (Jan. 1912), p. lxviii.

85. The Berlin Secession's winter annual, *Zeichende Künste*, did not include oils.

86. Gordon 1974, II, pp. 151–52, 407.

87. Frederick A. Sweet, *Miss Mary Cassatt, Impressionist from Pennsylvania* (Norman, Okla., 1966), p. 227.

88. Gordon 1974, II: Sickert, p. 188; Vuillard, p. 249; Manet, pp. 414–15; Cross, p. 848; 1909 group show, pp. 336–37; *Divisionistes Italiens*, pp. 221–22. According to Gordon, pastels by Picasso were shown at the Moderne Galerie, Munich: one in a 1910 group show, p. 424, and three, dating 1902, 1903, and 1904, in a 1913 one-man show, p. 664. Signac showed four pastels at the Berlin Secession's winter annual in 1911, p. 509. In 1904, pastels by Picasso were seen in group shows at Galerie B. Weill, Paris. For a general survey covering the use of pastel by twentieth-century European artists see Geneviève Monnier, *Le Métier de l'artiste: le pastel* (Paris, 1983), pp. 8, 66–83.

89. From the outset, the categories of mediums in the spring exhibition changed regularly; for example, from "Ölgemälde; Pastelle, Aquarelle und Zeichnungen; Plastik; Graphische Künste" in 1899; to "Ölgemälde, Pastelle, Aquarelle, Zeichnungen und Radierungen; Plastik" in 1900; to "Ölgemälde, Pastelle, Aquarelle etc.; Plastik" in 1901.

90. Gordon 1974, II, pp. 432, 508–9, 633–34.

91. For example, see the 1909 check list, "Sala 35—Napoli e altra regione," pp. 141–43, in which pastel entries nos. 4, 5, 13, and 14 are grouped under "Pitture," and nos. 30, 36, and 37 under "Bianco e nero."

92. For a complete survey of the genesis and refinement of photomechanical printing processes see Robert Taft, *Photography and the American Scene* (New York, 1938), esp. chap. 21, "Photography and the Pictorial Press." For an interesting investigation into halftone processes prior to the halftone screen see Phillip Dennis Cate, "Steinlen's Techniques for Photomechanical Reproduction," in Phillip Dennis Cate and Susan Gill, *Théophile-Alexandre Steinlen* (Salt Lake City, 1982).

93. Unidentified clipping, scrapbook, Everett Shinn Papers, Arch. Am. Art, microfilm D179, frame 194.

94. WMAA, *Turn of the Century America*, exhib. cat. by Patricia Hills (New York, 1977), p. 91.

95. Clipping from *Chicago Sunday Herald Record* [1901], scrapbook, Everett Shinn Papers, Arch. Am. Art, microfilm D179, frame 10.

96. Catherine Beach Ely, *The Modern Tendency in American Painting* (New York, 1925), p. 15.

97. See Janet Flint, *Drawings by William Glackens* (Washington, D.C., 1972), which contains reproductions of Glackens's pastel studies for paintings such as *Dream Ride* and *Nude with Apple*.

98. "Arthur B. Davies," *Art Collector* 9 (Dec. 15, 1898), p. 54.

99. James Huneker, *The Pathos of Distance* (New York, 1913), p. 115.

100. Ibid., p. 119.

101. Prospective members of the Players Club scheme were Arthur B. Davies, William Glackens, Childe Hassam, Robert Henri, Winslow Homer, Ernest Lawson, George Luks, Willard L. Metcalf, Maurice B. Prendergast, Robert Reid, Everett Shinn, John Sloan, William T. Smedley, Albert Sterner, and J. Alden Weir (William Innes Homer, *Robert Henri and His Circle* [Ithaca/London, 1969], p. 121).

102. Florence N. Levy, ed., *American Art Annual* 9 (1911), p. 210. Participating artists mentioned in reviews were George Bellows, George Bellows, Mary Helen Carlisle, Mary Cassatt, Colin Campbell Cooper, Paul Cornoyer, Leon Dabo, Thomas W. Dewing, William Glackens, Edward Kramer, Ernest Lawson, Jonas Lie, Elmer MacRae, Jerome Myers, Henry Reuterdahl, Everett Shinn, Albert Sterner, Gladys Thayer, Juliet Thompson, J. Alden Weir, James McNeill Whistler, and Henry C. White. List compiled from reviews: A. E. Gallatin, "The Pastellists," *Art and Progress* 2 (Mar. 1911), pp. 142–44; "First Exhibition of 'The Pastellists' Suggests the Revival of a Charming Form of Eighteenth Century Art," *New York Times*, Jan. 15, 1911, sec. 5, p. 15; and "Pastellists at Folsom's," *American Art News* 9 (Jan. 14, 1911), p. 6.

103. MacRae Diary, 1911. Unfortunately, only 1911 and 1913 of MacRae's diaries survive.

104. Ibid., Feb. 10–13, 1911.

105. Gallatin, "The Pastellists," pp. 142, 144.

106. "First Exhibition of 'The Pastellists' Suggests the Revival of a Charming Form of Eighteenth Century Art," p. 15.

107. MacRae Diary, Jan. 25, 1911; and Levy, *American Art Annual* 9, p. 210.

108. MacRae Diary, Feb. 1, 2, 15, 1911.

109. "Around the Galleries," *American Art News* 10 (Dec. 9, 1911), p. 6; Florence N. Levy, ed., *American Art Annual* 10 (1913), p. 151; and MacRae Diary, Sept. 26, 1911.

110. Henri seems to have agreed to exhibit with the group after meeting with MacRae (MacRae Diary, Dec. 2, 1911). Participants in the show (list compiled from reviews of the exhibition) were Marion Beckett, Bryson Burroughs, Mary Cassatt, Colin Campbell Cooper, Paul Cornoyer, Leon Dabo, Arthur B. Davies, William Glackens, Robert Henri, Edward Kramer, Ernest Lawson, Jonas Lie, Elmer MacRae, Jerome Myers, Henry Reuterdahl, Everett Shinn, Albert Sterner, Juliet Thompson, John H. Twachtman, J. Alden Weir, and Henry C. White ("News and Notes of the Art World: The Pastellists," *New York Times*, Dec. 17, 1911, sec. 5, p. 15; and "Pastellists at Folsom's," *American Art News* 10 (Dec. 16, 1911), p. 2.

111. Brown 1963, pp. 29–34; Jerome Myers, *An Artist in Manhattan* (New York [1940]), pp. 32–39; and "New Art Society Forms," *American Art News* 10 (Jan. 6, 1912), p. 3.

112. An exhibition of pastels by fourteen artists was held at Powell Gallery in February 1912. Participants included George Bellows, Gutzon Borglum, Leon Dabo, Arthur B. Davies, Walt Kuhn, George Luks, Elmer MacRae, Jerome Myers, Ivan Olinsky, Allen Tucker, and Max Weber ("Matters of Art," *New York Tribune*, Feb. 25, 1912, sec. 2, p. 7). It is possible that this exhibition was organized by the Pastellists, though the name of the group was not mentioned.

113. Florence N. Levy, ed., *American Art Annual* 11 (1914), p. 255.

114. "Art Notes," *New York Times*, Jan. 31, 1914, p. 10.

115. Participants were Marion Beckett, George Bellows, Fanny Wilcox Brown, Leon Dabo, Arthur B. Davies, Nathaniel Dolinsky,

Aileen Dresser, Vernon Ellis, Freedman, William Glackens, Anne Goldthwaite, Samuel Halpert, George Hart, Ernest Haskell, Childe Hassam, Edith Haworth, Eugene Higgins, Herminie Kleinert, Edward Kramer, Walt Kuhn, Mrs. C. R. Lamb, George Luks, Elmer MacRae, Charlotte Reinmann Meltzer, Leo Mielziner, Ethel Myers, Jerome Myers, Walter Pach, Telford Paulin, Maurice B. Prendergast, Mary C. Rogers, Everett Shinn, Carl Sprincorn, Joseph Stella, Albert Sterner, Juliet Thompson, and J. Alden Weir (National Arts Club, *Exhibition: Contemporary Art*, exhib. cat. [New York, 1914], nos. 140–223).

116. Florence N. Levy, ed., *American Art Annual* 12 (1915), p. 167.

117. Board of Control, American Watercolor Society, Minutes, Dec. 8, 1915, American Watercolor Society Papers, Arch. Am. Art, microfilm N68–9.

118. For example, between 1904 and 1907 *International Studio* devoted a series of ten articles to contemporary French pastelists, including Alfred-Philippe Roll, Gaston La Touche, Jean-François Raffaëlli, Henri Fantin-Latour, and Edmond-François Aman-Jean. The series was enhanced by brilliantly colored illustrations made possible by improved reproduction techniques at the turn of the century. Several recurring themes about pastel are explored in these articles. For example, in the essay on Fantin-Latour the author postulates a link between the medium and music, asserting that the "misty indefinite medium of pastel naturally attracted the music mad painter" (Bouyer 1904, p. 39), and likens pastel's dustlike quality and color range to those found on butterfly wings (ibid., pp. 43–44).

119. A. L. Baldry, "Pastel—Its Value and Present Position," *Magazine of Art* 24 (1900), p. 278.

120. Ibid.

121. For further information on Chase's teaching career see Ronald G. Pisano, *A Leading Spirit in American Art: William Merritt Chase, 1849–1916* (Seattle, 1983), pp. 85–145.

122. See Heckscher Museum, *The Students of William Merritt Chase*, exhib. cat. by Ronald G. Pisano (Huntington, N.Y., 1973).

123. MMA, *American Impressionist and Realist Paintings and Drawings*, exhib. cat. by Dianne Pilgrim (New York, 1973), p. 28.

124. Francis J. Ziegler, "An Unassuming Painter—Thomas P. Anshutz," *Brush and Pencil* 4 (Sept. 1899), p. 279.

125. Ibid. See also PAFA, *Thomas P. Anshutz*, exhib. cat. by Sandra Denney Heard (Philadelphia, 1973), pp. 13–14. See p. 14, fig. 5, for an example of Anshutz's pastels, which, with their loosely modeled forms and play of light, reflect the impact of Impressionism.

126. National Museum of American Art, *H. Lyman Säyen*, exhib. cat. by Adelyn D. Breeskin (Washington, D.C., 1970), pp. 17, 33. Säyen, a scientist and an artist, was Anshutz's student from 1899 to 1902.

127. Philadelphia Art Alliance, *Memorial Exhibition of the Work of Thomas Anshutz*, exhib. cat. by Helen W. Henderson (Philadelphia, 1942), unpaginated. On Breckenridge see Valley House Gallery, *The Paintings of Hugh H. Breckenridge (1870–1937)*, exhib. cat. by Margaret Vogel (Dallas, 1967); and National Collection of Fine Arts, Smithsonian Institution, *Pennsylvania Moderns*, exhib. cat., with a foreword by Adelyn D. Breeskin, and an essay by Joshua C. Taylor and Richard J. Boyle (Washington, D.C., 1975).

128. Hugh Breckenridge, "Making Pastel Sticks," MS., c. 1899, Hugh Breckenridge Papers, Arch. Am. Art, microfilm 1907, frame 481. In the document, Breckenridge recommends an 1899 edition of Charles Martel's translation of M. E. Chevreul's *De la loi du contraste simultané des couleurs, et de l'assortiment des objets colorés, considéré d'après cette loi* (Paris, 1839). Therefore, the document must date from 1899 or later, but probably not much later, given the frequency with which new editions of Martel's translation appeared during the late nineteenth century.

129. Birge Harrison, "The Woodstock School of Landscape Painting," *Art and Progress* 1 (Sept. 1910), p. 322. See also Harrison 1909, esp. pp. 107–9; and Harrison 1915, pp. 154–57. Harrison was a pupil of Carolus-Duran's and Cabanel's in Paris. He was a distinguished landscape painter who was influenced by the Barbizon School. For further information see L. Mechlin, "Birge Harrison's Paintings," *Art and Progress* 3 (Nov. 1911), pp. 379–83; and Vassar College Art Gallery, *Woodstock: An American Art Colony, 1902–1977*, exhib. cat. (Poughkeepsie, N.Y., 1977), unpaginated.

130. Harrison 1909, esp. pp. 107–9; and Harrison 1915.

131. Alfred H. Barr, Jr., *Matisse: His Art and His Public* (New York, 1951), p. 57.

132. Max Weber, "The Matisse Class," Max Weber Papers, Arch. Am. Art, microfilm NY59–6, frames 159, 161.

133. McCausland 1952, p. 27.

134. The pastel by Davies was entry no. 927 and was purchased by Stieglitz for sixty-five dollars (Brown 1963, p. 235).

135. From "Writings and Conversations of Alfred Stieglitz," in *Twice a Year*, ed. Dorothy Norman (1947), excerpted in *Readings on American Art since 1900*, ed. Barbara Rose (New York/Washington, D.C., 1968), p. 48.

136. "Photo-Secession Notes," *Camera Work* 30 (Apr. 1910), p. 47, states, for example: "In considering the exhibitions it should be remembered that the Little Gallery is nothing more than a laboratory, an experimental station, and must not be looked upon as an Art Gallery in the ordinary sense of that term."

137. Homer 1977, p. 136, identifies the pastel's subject, and p. 282 n. 31, adds that Mrs. Agnes Meyer purchased it for five hundred dollars, enough to support Weber for a year.

138. A review of the 1912 exhibition of children's art is reprinted in *Camera Work* 39 (July 1912), p. 48.

139. Quoted in Brown 1963, p. 64.

140. At a show of the Pastellists in Dec. 1911, Walt Kuhn, Elmer MacRae, Jerome Myers, and Henry Fitch Taylor met, according to the minutes of the Association of American Painters and Sculptors, "to discuss the possibilities of organizing a society for the purpose of exhibiting works of progressive and live painters, both American and foreign—favoring such work usually neglected by current shows and instructive to the public" (ibid., pp. 30–31).

141. Ibid., p. 56.

142. Ibid., pp. 217–302, especially the annotated check list.

143. Ibid., p. 210.

144. Gordon 1974, II, p. 800.

145. Ibid., pp. 899–900.

146. Jaffe 1970, pp. 182–84.

147. Quoted in "What '291' Means to Me," *Camera Work* 47 (Jan. 1915), p. 33.

148. Elizabeth McCausland, "The Daniel Gallery and Modern American Art," *Magazine of Art* 44 (Nov. 1951), pp. 281–82.

149. Ibid., p. 284.

150. McCausland 1952, pp. 8, 74.

151. WMAA at Philip Morris, *The Forum Exhibition: Selections and Additions*, exhib. cat. by Anne Harrell (New York, 1983), p. 5.

152. See Sue Davidson Lowe, *Stieglitz: A Memoir/A Biography* (New York, 1982), pp. 433–34, for a complete listing of these shows.

153. An example of Hartley's Taos pastels appears in WMAA 1980, p. 57, fig. 52.

154. Ibid., p. 12.

155. Ibid., p. 8.

156. Ibid., p. 60.

157. McCausland 1952, p. 8.

158. A comparison between virtually all of his known pastels and

contemporary oils supports this view. Salander-O'Reilly 1982 illustrates all known pastels and almost all known oils by him. After this essay was written, a new catalogue on Schamberg's use of pastel was published (Salander-O'Reilly Galleries, *Morton Livingston Schamberg (1881–1918): The Machine Pastels*, exhib. cat. by William Agee [New York, 1986]).

159. In its revolving circular motifs, a pastel entitled *Landscape*, c. 1913 (Salander-O'Reilly 1982, no. 47), forecasts the gear and wheel forms and the gestural handling of the medium in Schamberg's machine pastels (see, for example, ibid., nos. 48, 51, 55).

160. Ibid., p. 11.

161. See Constance Rourke, *Charles Sheeler: Artist in the American Tradition* (New York, 1938), pp. 16–22.

162. From 1906 to 1909 Sheeler and Schamberg shared a studio in Philadelphia, and from 1910 to 1918 they rented a farmhouse near Doylestown for weekend excursions.

163. National Museum of American Art, *Charles Sheeler*, exhib. cat. (Washington, D.C., 1968), reproduces two pastel still lifes by Sheeler, figs. 29 and 30, and *Self-Portrait*, fig. 37.

164. See Museum of Art, Pennsylvania State University, *Charles Sheeler: The Works on Paper*, exhib. cat. by John P. Driscoll (University Park, Pa., 1974), *Portrait of a Woman*, cat. no. 22, pl. XII.

165. See PAFA, *Arthur B. Carles, 1882–1952: Painting with Color*, exhib. cat. by Barbara A. Wolanin (Philadelphia, 1983): *Frances Metzger West*, 1907, cat. no. 10, p. 18; *Flowers II*, 1914, cat. no. 37, p. 60; and *Dorizat*, c. 1915, cat. no. 38, p. 63.

166. Examples include *Sleeping Nude, Cubist Nude*, and *Nude on a Couch*, all c. 1929, and *Blue Lady*, c. 1932; illustrated in ibid., nos. 70, 71, 72, and 83, respectively.

167. Philadelphia Museum of Art, *Philadelphia: Three Centuries of American Art*, exhib. cat. by Anne d'Harnoncourt (Philadelphia, 1976), p. 532, no. 452.

168. At the Newark Museum (1930), Stella's pastels were categorized as drawings; at Knoedler (1942), as paintings; at Bourgeois Galleries (1920), as both. In her annual shows at Intimate Gallery and subsequently at Stieglitz's An American Place, O'Keeffe generally included between one and four pastels along with twenty-five to forty oils. In some years, check lists placed her pastel exhibits nondiscriminately among the paintings; in others, the pastels were distinguished by medium. See WMAA Papers, Arch. Am. Art, microfilm N679, frames 73–187.

169. Richmond 1927, p. v.

American Pastels

of the Late Nineteenth & Early Twentieth Centuries: Materials & Techniques

Marjorie Shelley

By the time the art of pastel reached American shores in the eighteenth century, at the height of its popularity, the technique had long been known in Europe. Of early American practice, little more survives than the pastels of such artists as Henrietta Johnson and John Singleton Copley, and the endearing portraits of various unidentified limners. Professional American artists did, however, have close ties to Europe at this time. Those working in pastel most likely sought out treatises on the subject, such as *Elements of Painting with Crayons* (London, 1772), by the English pastelist John Russell, in order to learn the basics of the medium, for no significant literature on the subject was written in this country until the late nineteenth century.

Virtually on the heels of its introduction to America, the art of pastel was to fall from favor. Internationally, taste and aesthetic sensibilities had changed, and by the end of the eighteenth century pastel was widely disparaged and discredited as suitable for only frivolous subject matter and vulgar sentimentality. Although pastel was never out of favor with the French Romantic painters, such as Eugène Delacroix, Jean-François Millet, and Alexandre Decamps, few artists elsewhere in Europe or in America executed major works in the medium during the first half of the nineteenth century. Reflecting current trends, instruction manuals addressed to the amateur refrained from providing information on pastel and focused instead on the newly fashionable art of watercolor painting.

Toward the end of the nineteenth century the practice of pastel experienced a rebirth, which began in Europe and was followed in the late 1870s and early 1880s in America. Various events stimulated this renewed enthusiasm for the medium. Among them was the first Impressionist exhibition in Paris, in 1874, which included pastels by Edgar Degas, Claude Monet, Pierre-Auguste Renoir, and Berthe Morisot. For American artists the impetus can be traced to an awareness of the work of Millet and Giuseppe de Nittis, and particularly to the wide-ranging influence of James McNeill Whistler, who produced numerous pastels during a fourteen-month sojourn in Venice that began in 1879. As pastel became increasingly popular in America, two divergent styles were to emerge: the expansive, robust, and richly colored work associated with William Merritt Chase and Robert Blum; and a more delicate, linear style characteristic of Whistler, John H. Twachtman, and J. Alden Weir.

As has been so often noted in the literature, pastel was particularly suited for Impressionist imagery. The range of the palette, from the most muted tones to the brightest, was ideal for conveying the new, intimate subject matter: sun-filled interiors, the ephemeral effects of light on water or landscape, and delicately lighted portraits. Also contributing to the revival of pastel was the availability of ready-to-use colors, which were easily portable and did not need to dry and were thus perfect for plein-air work, a pursuit that now had many enthusiastic practitioners.

Underlying these salient explanations, however, are several factors allied to the physical nature of pastel, which in a rather more subtle manner

contributed to the appeal the medium held for artists of this era. Because it is dry color in stick form applied directly to the support, pastel is ideal for sketching, a part of the working process that previously had been concealed but was now elevated to a new level of acceptance, particularly as interest declined in rendering highly finished pastel "paintings." By virtue of its direct application and its availability in a vast range of colors, pastel was also a perfect means of translating the popular chromatic theories of Michel-Eugène Chevreul (*De la loi du contraste simultané des couleurs, et de l'assortiment des objets colorés, considéré d'après cette loi*, 1839), Ogden Rood (*Modern Chromatics*, 1879), and others into practice. The graphic strokes and daubs of the crayon made immediately possible additive mixing, successive and simultaneous contrasts, and the juxtaposition of opposing colors. The draftsmanly handling this encouraged complemented the recently available plethora of brightly colored papers of varied textures and types—supports that were, in fact, far better suited to the dry, opaque nature of pastel than to watercolor, ink, or oil. Pastel does not appear to have been a subject in treatises on color, yet brief passages in Charles Blanc's highly influential *Grammaire des arts du dessin* (1880) and in the well-known *L'Art du dix-huitième siècle* (1880) by Edmond and Jules de Goncourt reveal a new appreciation for the medium. In these volumes, works by the great French masters of the previous century were discussed in terms of the graphic and coloristic possibilities that were at issue in contemporary aesthetics. The Goncourts described Jean-Baptiste-Siméon Chardin as boldly uniting the most contradictory tints without mixing or fusing, applying them side by side, and emphatically opposing them; while Blanc praised Maurice-Quentin de La Tour for his masterful juxtaposition of tints, which are not physically blended but appear to merge.[1] Other appealing aspects of pastel that meshed with the aesthetic concerns of the late nineteenth century are its velvety airiness and brilliance and its nonyellowing property. These qualities were attractive to artists who had turned away from the tight brushwork and deeply saturated colors of the past several decades in search of a light-filled, high-keyed palette.

The techniques and materials employed by late nineteenth-century pastelists were essentially the same as those of the previous century, but the Industrial Revolution brought some changes and modifications in traditional practices and tools. These included the use of unusual supports, syn-

thetic pigments, and new types of fixatives and surface treatments. Although the medium itself had hardly been altered in composition, it and the various recently introduced ancillary materials were enthusiastically received because they were easily adapted to the stylistic and artistic goals emerging at the time. Pastelists no longer sought to imitate oil painting, as had been the practice one hundred years earlier, but now placed greater emphasis on draftsmanly handling and dramatic effects gained through the juxtaposition of colors.

Medium: Pigments, Fillers, and Binders

Pastel is made up of three components: pigment, filler, and binder. From the sixteenth century, when the use of pastel was first recorded, to the present day, the manufacturing process has remained largely unaltered. The two dry substances are ground, a cohesive binder is added, and the composite paste is formed into a stick-shaped implement that is then allowed to dry. In technical and historical literature from the seventeenth century through the twentieth, the term *pastel* generally has referred to either the work of art or the medium itself, whereas *crayon* or *pastel crayon* has denoted the tool with which the work was executed. *Crayon* appears to have evolved from the French *craie*, which means "chalk." Because of its appearance and because it too is a direct-line medium, chalk has often been confused with pastel and used as a synonym for it. Pastel, in turn, has often been erroneously called colored chalk.

Pigments

With few exceptions, the pigments used for pastel are the same as those found in the watercolor or oil palette. Because of the differences in vehicle, however, they each have distinctive optical properties and, therefore, particular handling requirements. The jewellike transparency of watercolor results from light passing through the colored washes to an opaque white paper substrate, from which it is refracted to the viewer's eye. The rich, tone-enhancing glazes of oil painting function in a similar manner. In order to maximize these effects, the nineteenth-century artist was encouraged to purchase and use only the finest unadulterated colors and to layer rather than mix them in his work, so

that the spectral purity of the pigments would be preserved and the final effect would not be muddied. Unlike oil or watercolor, premixed dry pastel colors are not always composed of a single pigment but are often a combination of two or more pigments and variable amounts of a white base. This mélange of pigments and filler does not, however, impair the optical clarity of the work of art. Brilliance and depth of tone in pastel do not depend on transparency and refraction or on the brightness of the substrate, but rather on light being diffusely reflected or scattered off the irregularly shaped powdered particles that form an opaque layer, obscuring the support (fig. 25).

In addition to producing particular colors, mixtures of pigments are often required to form pastels with suitable textural qualities—crayons that are neither too hard to adhere to the support nor too crumbly to grasp. Some pigments are not useful at all because of certain chemical or physical properties, such as their lack of covering power. Over the course of time, various mineral and organic colors have been introduced to the pastel palette—chrome colors and zinc oxide in the nineteenth century, and cadmium red and titanium white in the twentieth— while others used in earlier years have become obsolete (gallstone), or were found to be transient (madder) or poisonous (lead colors) and were therefore abandoned.

The most notable change in pastel occurred in the second half of the nineteenth century, when colors formed of synthetic dyes were developed. Especially brilliant in hue, the coal-tar, or aniline, colors produced in the 1870s were short-lived; most would quickly lose their splendor when exposed to sunlight, while others would fade within a few years. It is impossible to know just how widespread their use was, since one cannot determine by eye alone if certain muted colors, made fashionable at that time by Pierre Puvis de Chavannes and Maurice Denis, were intended or if they are simply the faded remains of aniline pastels or other fugitive organics, such as carmine or crimson lake, which were still in use. Degas is said to have avoided them, using only the rich, colorfast palette that he obtained from a friend, the artist Jules Chialiva.[2]

Synthetic pigments undoubtedly enjoyed popularity, for from their inception until the 1940s, pastel literature was replete with warnings to the artist to resist these dazzling but fleeting colors. Reflecting the prevailing interest in America and abroad on the action of light on color, the American magazine *Art*

Fig. 25. This scanning electron micrograph of pastel magnified five hundred times shows its irregularly shaped particles and masses of powder. The physical structure of pastel reflects light diffusely, contributing to the characteristic velvety texture of the medium.

Amateur warned its readers as early as the 1890s about the hazards of these pastels.[3] A few years later, the serious artist might have become aware of their impermanence in *Letters to a Painter on the Theory and Practice of Painting* (1907), a translation of a series of articles intended for an American audience but originally published in the *Münchener Allgemeine Zeitung* in 1903–4. The author, Wilhelm Ostwald, a German color and optics theorist, condemned coal-tar pastels and provided instructions for testing colorfastness.[4] One of the artists determined to enlighten both students and colleagues to their dangers was Birge Harrison, an American landscapist and teacher who practiced in the early decades of this century. Familiar with the fabrication of pastel from his own experiments, Harrison expressed anger at the commercial colormen who produced cheap and ephemeral dyes made by infusing chalk with color.[5] This particular technique was probably not commonplace, but the eventual scarcity and expense of certain high-quality mineral colors, such as sienna, and the range of wonderfully brilliant hues that could be produced artificially contributed to the growth of the synthetic-pigment industry. Nonetheless, concern with the stability of aniline colors undoubtedly rekindled the age-old concern with lightfastness, prompting many artists to make their own pastels, while commercial colormen more vigorously emphasized the permanence, true or false, of their products.

Fillers

The other dry component of pastel is the filler, or base, a finely ground, white, inert mineral substance. The filler serves several purposes. Because it is white, its combination with the pigment or pigment mixture reduces the chromatic strength of the pure color, producing soft, pale, pastel tints that enable the artist to broaden and refine his palette. In 1772, John Russell, the author of one of the few early treatises on the subject written by an artist, described his pastel box as consisting of twenty gradations for each color.[6] Over a century later, in 1885, a pastel instruction book noted that five hundred colors were available in a particular set, providing every conceivable hue and tint that the artist required.[7] From the late 1880s through the early 1890s, *Art Amateur* repeatedly advised its readers to enlarge their collections of crayons.[8] The colors not already in the pastel box had to be purchased, as they could not be produced by blending.

Another function of the filler is to give body, or substance, to the crayon by contributing cohesiveness, thereby allowing the pigment to be handled as a tool and to be applied directly to the support. The filler also gives the stick the proper consistency, so that it will powder rather than flake when drawn across the surface of the support. As it is a finely pulverized substance, the filler also provides covering power, or opacity, which causes the pastel to obscure the surface on which it is superimposed and enhances its power to reflect light.

Until the second half of the nineteenth century the choice of the filler type was determined by the properties of the pigment. Colors that tended to crumble required the addition of plaster of Paris; colors that were suitable as is might be blended with tobacco pipe clay; while others that were too soft could be combined with alabaster or ground shell. As time went on, new ideas and technologies, many developed as a result of the Industrial Revolution, brought changes in the kinds of bases used in making pastels. Of the traditional fillers, chalk remained popular through most of the nineteenth century and into the twentieth. A variety of new inert substances were introduced in the late 1800s, including oxides of bismuth and sulfate, and the magnesium earths. Combinations of calcium sulfate and chalk were also frequently used, but they were supplanted some years later by kaolin, lithopone, and zinc, and after 1929, by titanium white. The most noteworthy change in the base component, which has streamlined the production of pastel, occurred in this century. The time-honored but complex system of balancing the properties of the filler with those of the pigment has been supplanted by the use of a universal filler made from a combination of various inert substances, including clay, silica, and aluminum. Although formulas differ among colormen, these new bases may be used with all pigments; only the amount used will vary, according to the desired gradations of the color.[9]

Binders

The third component of the pastel mixture is the binder, a weakly cohesive gum, or size, which serves simply to hold together the pulverized pigment and the filler so that they may be rolled into a soft, semihard, or hard stick. It does not enable the pastel powder to adhere to the paper, a function dependent upon the support itself. Until the late nineteenth century the binder was selected on the basis of the properties of the pigment and filler. So complex was the matter of balancing the type and proportion of each component that over the course of time countless binders were utilized in attempts to produce a serviceable pastel. These included vegetable gums (arabic, tragacanth), proteinaceous sizes (parchment size, rabbit-skin glue), and various household liquids (alewort, fig juice, honey, and crystallized sugar water, among others).

Many of these substances yielded a fairly hard crayon, which was desirable for the relatively linear compositions of the seventeenth century, but as aesthetic sensibilities changed, binders that produced a softer crayon gradually came to be preferred. By the late nineteenth century most of these materials presumably had been dispensed with, since the few artists' handbooks that bothered to describe the fabrication of pastel crayons specified only gum tragacanth as a suitable binder. In the early decades of the twentieth century, when studio preparation of pastel was popular, gum tragacanth, gum arabic, dextrin, starch, and certain adhesive fillers, such as whiting and kaolin, were cited in the literature.[10] Gum tragacanth is occasionally employed today, but the binders currently favored are methyl cellulose and other cellulose gums, which produce a very soft crayon. These clear synthetic adhesives are less vulnerable to mold growth than were the organic substances used in the past.

The amount of binder used in forming a pastel is the bare minimum needed to surround the particles. If too much of the adhesive substance is present, the particles will compact, making the crayon hard and dense, which will prevent the powder from readily falling away from the stick as it is drawn across the support. Too much binder also diminishes the brightness of the color, for when pigment and filler are completely enveloped by this substance, the particles coalesce and fewer surfaces are available from which light can be reflected. More light is thus absorbed or transmitted through the pastel layer, and the colors appear dark and saturated. In addition, the presence of a high proportion of binder will eventually cast a yellow tonality over the work of art, because organic resins, gums, and glues oxidize and darken as they age. Indeed, it is the absence of a gradually darkening medium in pastel, more than the chemistry or lightfastness of the pigments, that allows the colors to retain their freshness over time. Undoubtedly, this nonyellowing property must have had particular appeal for pastelists of the late nineteenth century, for it ensured that the brilliant effects of light and color, so crucial to their work, would be preserved.

Fabricating the Crayon

Despite the various changes that have occurred in the ingredients used to compose the pastel crayon, the method of fabrication has remained essentially the same, though it has evolved from a handmade process to a mechanized one. The earliest method, described in 1574 by Petrus Gregorius in the *Syntaxeon artis mirabilus* and practiced for centuries thereafter, involved kneading the pulverized substances into a smooth, moist paste that was formed into cylindrical sticks either by rolling it between the hands or two boards, or by pressing it into a chalk stone with narrow furrows. These early pastels were made to be the "length of a finger and the thickness of a goose quill," with a point so sharp that the artist could draw a hair.[11] By the early years of the twentieth century fabrication entailed squeezing the paste from a syringe through a nozzle. More recently, pastels have been formed by applying pressure to a cylindrical mold containing the paste or by extruding it from a nozzle and cutting the compressed mass into the required lengths while it is still soft.[12] Whereas the firm, narrow shape of the early pastel crayon was well suited to produce a

draftsmanly composition, changes in technique and a taste for bravura in pastel "painting" during the eighteenth century led to the evolution of thicker and softer crayons, which were either cylindrical or squared off. Aside from a cone-shaped pastel, which was described in a treatise of 1890 by the French artist Karl-Robert as suitable for achieving both broad color effects and delicate strokes,[13] the traditional stick shape has found little competition.

The preparation of pastel was theoretically simple, but in the eighteenth century the seemingly innumerable formulas, the juggling of fillers and binders, the requisite knowledge and skill, and the element of unpredictability that attended its manufacture must have discouraged fabrication in the studio while encouraging production by professional colormen. By mid-century most artists seem to have used commercially made pastels, and it had become commonplace in both Europe and America for pastels to be procured from foreign makers. Among the extant documents that record such transactions is a letter of 1762 from John Singleton Copley to the well-known Swiss pastelist Jean-Etienne Liotard, ordering "one sett of Crayons of the very best kind such as You recommend [for] liveliness of colour and Justness of tints. In a word let em be a sett of the very best that can be got."[14] As commercially prepared colors became increasingly available, artists' books ceased to give recipes for their fabrication, as had been customary in earlier times. Some information was still offered—not out of necessity but because of general dissatisfaction with ready-made products. Authorities of the day expressed irritation with commercial pastels, noting that "it is very rare to find a set of such crayons as may be called good."[15] The reason the handbooks offered for enumerating the various substances and describing the particular purposes they served was merely to enable the artist to improve upon what was available in the shops.

By the mid-nineteenth century, if an artists' handbook presented any information on the preparation and composition of pastel, the subject was often treated derisively. Henry Murray, author of *The Art of Painting and Drawing in Coloured Crayons*, published in England by the colormen Winsor & Newton in 1850 (and still in print in 1890), stated in his otherwise complete discourse that it was necessary for the artist to know the composition of his crayons only so "that he may be thus aided . . . in the superposition and harmonizing of his tints; and enabled . . . to form any tints which may not be found in the usual gradations. . . . To instruct the

artist in the manufacture of his colors . . . would be a manifest absurdity."[16] Explaining the many complications involved in fabrication, Murray concluded that crayons made by the artist would be inferior to any he could purchase. Although Murray recommended certain colors, he did not endorse a particular brand. Ironically, the subject of the volume notwithstanding, the publisher included only two advertisements for pastel crayons and none for supports, despite the extensive notices for other artists' materials produced or sold by Winsor & Newton.

John G. Chapman's *American Drawing Book: A Manual for the Amateur*, which appeared in several editions between 1847 and 1864, was probably the first technical manual published in the United States that provided information on pastels. The artist-writer did not offer any guidelines on the fabrication of crayons, but like many of his English predecessors, Chapman considered those from Switzerland the best.[17] Some years later, the American art supplier Henry Leidel, who was in the business of importing pastels and was also the author of *The Art of Pastel Painting as Taught by Raphael Mengs* (1885), claimed that German crayons were superior, and those from France, unsatisfactory.[18] He criticized pastels that were made in a mold and dried by heating, and found them inferior to those that were hand-rolled and air-dried, but he did not mention how the pastelist might make his own colors.[19] No pastels are known to have been made in America at this time, and those that were available appear to have been commercially manufactured abroad.

With the passage of time and the growing concern with the quality and lightfastness of pastels, a different attitude emerged. Indeed, the exaltation of handcrafted objects and natural materials, and the rejection of machine production, which had such a profound influence on the decorative arts of the late nineteenth century—beginning with the Aesthetic movement and evolving into Arts and Crafts—eventually had an impact on the studio preparation of artists' materials. Many books and magazine articles were written on the subject in the early years of the twentieth century. Among pastelists, the emerging interest in fabricating crayons was largely a reaction to commercial pastels made with fugitive aniline dyes. Wilhelm Ostwald complained in *Letters to a Painter* that the arbitrary names of factory-produced pastels did not reflect actual ingredients and that they were impermanent and of poor quality. Many artists appear to have made their own pastels during this era, including Hugh Breckenridge, the

New England landscapist F. Mortimer Lamb, Birge Harrison, and Thomas P. Anshutz.[20] Arthur G. Dove is known to have ground his own colors for oil paint, and he may have fabricated his own pastels as well.[21] Throughout the early decades of this century and into the 1930s, information about the studio manufacture of pastels, commonplace in the early eighteenth century, once again became available in the many handbooks published at this time, such as Max Doerner's *Materials of the Artist and Their Use in Painting* (1934).

Handling

From the middle of the eighteenth century on, as the preparation of pastel became more the business of commercial colormen rather than of artists, most instruction books dealt primarily with matters of handling. Giving play to the graphic, or linear, possibilities of pastel was to be avoided; the colors must be blended and smoothed into one another so that the work appeared as if rendered with a brush. In 1772, John Russell instructed readers of his *Elements of Painting with Crayons* to blend the colors "beginning with the strongest light on the forehead . . . uniting with the next tint, which must continue until the whole is sweetened together."[22] With similar intentions, Benjamin West criticized the young John Singleton Copley for painting pastels that were "too liney," the fault of "there being so much neetness in the lines. . . . Endeavouring at great Correctness in one's outline," West opined, "is apt to produce a Poverty in the look of one's work."[23]

Although materials were discussed in greater detail and the reader was given more alternatives in technique, such as methods of fixing or of preparing the support, instruction books of the late nineteenth century were not appreciably different in matters of handling from those of the eighteenth century, and, as in the manner of most artists' handbooks, these practices were presented as largely inflexible. One was to begin laying in the colors at the top of the composition and work downward, from the background to the drapery; for the portrait, one was to render the hair first, but save the face for last in order to prevent injury from falling pastel dust. Information on the correct colors for details was also specified: for the nostrils and eyebrows, for the skin of a peach or the bark of a tree. The warmest tones and shadows were to be applied first, followed by the cool half-tints, and, finally, the clear highlights.

Shading could be done by hatching, or with a paper or leather stump—the pastelist's most important tool.

Henry Leidel, standing astride the more painterly manner of the past and the new, more draftsmanly mode, informed his readers in *The Art of Pastel Painting* that colors were to be placed side by side, as they are in a mosaic, yet, as in the style of the eighteenth century, there were to be no hard edges.[24] Other than for fine details, even the crayons themselves were not to be cut or pointed, for color was to be applied in broad, painterly passages. "The breadth of the stump is the rule—the point of the crayon is the exception" was the dictum the novice was to follow.[25] Pastels were to be rubbed gently on the paper, one over another, and blended into form with the fingers, a stump, a cotton bat, or the palm of the hand if the area was large. It was by this means that a particular delicacy and softness were achieved.

Late-nineteenth-century instruction was distinguished by a new emphasis on the underdrawing. Whereas in earlier times pastel was worked as if applied with a brush and all indications of the preliminary outline were concealed beneath a high finish, there was now greater interest in rendering transparent effects and in revealing the working process by allowing the graphic stroke and the hue and texture of the support to remain visible through the later stages of coloring and blending. This became an increasingly popular technique among professional artists, as can be seen in many of the works in this exhibition, including Thomas W. Dewing's *Evening Dress* (p. 62), J. Carroll Beckwith's *Veronese Print* (p. 65), J. Alden Weir's *Boats* (p. 66), and John H. Twachtman's *Landscape* (p. 71). Gradually, this approach made its way into the instructional literature.[26] Most of the handbooks, including Leidel's, presented guidelines for executing the preliminary sketch. In the eighteenth century, black chalk, charcoal, and pastel had been used to outline the subject; by the late nineteenth, suggestions for red chalk, charcoal, and Conté crayon (a slightly greasy, fabricated chalk that was introduced in the early 1800s) were common. Charcoal and Conté had both enjoyed great popularity among artists during the first half of the nineteenth century, when pastel was in its dormancy, and they were now recommended for landscape, a new subject for the pastelist. In portraiture and still life, the amateur was advised to avoid shades of black, and to execute the underdrawing in colors close to the final palette. Among the hues most frequently recommended for

the preliminary outline in portraits was orpiment, known popularly as king's yellow, a brilliant lemon color but a highly poisonous pigment containing arsenic.

Despite the desire for more transparent, graphic treatment on the one hand, and the traditional taste for richly modulated, painterly compositions on the other, pastel, for all its apparent simplicity, presented the practitioner with a number of technical constraints. Mediums with a liquid vehicle, such as oil or watercolor, enable the artist to apply a fresh color over a dry one. Because pastel is powdery and does not form a continuous, cohesive film, making corrections, mixing colors, building up layers, and rendering transparent effects can be accomplished only with the lightest touch. Heavy-handedness will cause previous work to flake or powder off the surface or be pushed aside as the new color is applied. Everett Shinn's *Julie Bonbon* (p. 102) reveals a virtuoso layering of thick coats of pastel, but in other, heavily laden compositions, color has not held so tenaciously, as, for example, in Mary Cassatt's *Mother and Child* (p. 154), which is flaking in the flesh tones. Colors too vigorously worked can compress the pastel, so that it no longer conveys the softness and immediacy of touch so characteristic of the medium. Injudicious layering may also impair the spectral brilliance of the tones.

The blending of colors presents the most significant limitation of the pastel medium. When colors are rubbed too hard, the particles become compressed and appear dull and muddied. This optical effect results from an increased amount of light being absorbed from the illuminating source and a reduction in the number of reflecting surfaces. Throughout the literature on pastel practice, in both the eighteenth and nineteenth centuries, the striving artist was continually warned not to blend the colors too much, for this would only reduce the tints to tameness and insipidity.[27] Thus, in addition to a light touch, good work also required that one have a large assortment of fine pastel crayons of every shade and hue needed, since two colors could not be combined to produce a third without sacrificing their integrity and brightness. The artist working in a painterly manner had to apply colors in small tonal gradations to achieve his chromatic effects, a technique that necessitated the vast number of closely spaced tints available in the pastel box. Colors were modified on the support, if necessary, by blending into adjacent colors at their extremities. This technique is characteristically seen in traditional handling, as in the

softly blended and smoothed surfaces of Copley's *Mr. Ebenezer Storer* (p. 159), or in certain works by Cassatt, such as *Mother Feeding Child* (p. 52). In both of these compositions the variations in skin tones, which range from grays and greens to pinks and yellows, are subtly and invisibly blended. This painterly manner was still practiced in the late nineteenth century—as seen, for example, in *Mrs. Edward Clark Potter* by Daniel Chester French (p. 195)—and was never entirely abandoned in the twentieth, as revealed in the works of Joseph Stella, Georgia O'Keeffe, and Arthur G. Dove (pp. 105, 131, 189). However, it was the inherent stroke of the crayon and the apparent speed of execution that aroused the great enthusiasm, initiated by the Goncourt brothers and by Charles Blanc during the Impressionist era, for the work of Jean-Baptiste-Siméon Chardin and Maurice-Quentin de La Tour. These artists did not so much paint as draw with the pastel crayon—the mode of handling that was to become popular with the revival of the medium. Indeed, it was precisely because the colors were not mixed on the palette that pastel was to earn praise as "a most suitable tool for the modern method."[28]

For the circle of European and American artists working in the Impressionist manner, the handling of pastel involved new considerations. Rather than the high finish gained by blending and smoothing, pastel was applied in broken strokes or in masses of tone with contrasting and complementary colors juxtaposed against one another or on a strongly colored support. In Cassatt's *Mother Playing with Her Child* (p. 152) both painterly and draftsmanly techniques are combined. Lines of color are blended and fused to form the face and hands; elsewhere, in the drapery and the background, rapid zigzag hatchings and short, open strokes are forcefully applied over patches of color. This bold handling is taken further in *Mother and Child* (p. 151), in which all the elements of the composition, and the highlights and shadows are formed of disparate strokes of brilliant color. In the far simpler *Evening Dress* by Dewing (p. 62), the face of the model appears at first to be rendered in smoothly modulated hues, but is, in fact, built up with a restricted palette of closely spaced lines of yellow, pink, and white, and the body and gown are rendered in an even more limited color range against a strongly contrasting, dark brown support (fig. 26).

As interest in rendering a pastel painting declined, the striving pastelist was encouraged to

Fig. 26. The face of the woman in *The Evening Dress* by Thomas W. Dewing shows how the artist achieved seemingly blended effects in the skin tones with discreet, closely spaced strokes of pastel (enlarged detail).

execute freer, more spontaneous compositions. This was to be accomplished by both color placement and directness of stroke. Leidel explained that "if the colors are laid in their proper places with the proper degree of strength, then there is but little work for the finger to do. The less the colors are worked upon the more fresh and transparent they will be."[29] The purpose of "putting the proper tints in the proper places," the reader was told in one of the rare references to additive mixing in the instructional literature, "was to optically produce any color not found in the pastel palette."[30]

The change in taste was accompanied by a growing disdain for blended and stumped pastels. In 1889 certain works in the third exhibition of the Society of Painters in Pastel were criticized for attempting to reproduce the effects of oil.[31] Years later, in 1931, a review of a Pastel Society exhibition in London harshly berated the works of Howard Russell Butler (p. 150) because they appeared to have

been painted with a liquid.[32] Indeed, from the final years of the nineteenth century through the 1930s, commentary in handbooks and reviews generally held that the inherent brittle and dry nature of the pastel crayon should be respected: overblending, rubbing, and too much use of the stump or the finger were to be avoided. One was to "work only as long as you know what to do; not an instant longer."[33] A pastel that looked belabored was a contradiction of the essential nature of the medium. Rather than blending colors one into another, the successful pastelist had to rely on the relationships between them. Manuals on technique, such as *The Art of Painting in Pastel* by L. Richmond and J. Little-johns (1927), *The Art of Pastel* by Anna Airy (1930), *A Manual on Pastel Painting* by L. A. Doust (1933), and *Pastel Painting* by Gladys Rockmore Davis (1943), as well as many others published at this time, emphasized this means of handling.

Rendering transparency was another important issue confronting the pastelist. In actuality this is not physically possible, for any finely pulverized substance, such as pastel, is opaque and will obscure the substrate on which it is applied. As it is not held in a liquid vehicle, it cannot be used as a glaze. Producing the illusion of transparency, therefore, requires that the artist utilize other techniques. Russell recommended that "one begin with colors as dark and as rich as possible, for any attempt at glazing or scumbling would cause tints below to work up from underneath and render the attempt abortive."[34] With the growing emphasis on draftsmanly handling in the late nineteenth century, several new means of conveying this effect evolved. One that gained great appeal and may be said to be a hallmark of pastels of this era was building up a work with sketchy, open strokes and discrete areas of color, which allowed reserve passages in the support and a sense of the working process to remain in evidence. This technique was used by such artists as Twachtman and Whistler. Complementing this new approach, pastel was increasingly worked with other graphic mediums: in William Glackens's *Shop Girls* (p. 90), pastel was layered over watercolor; in Everett Shinn's *Circus* (p. 100), pastel was applied over monotype; in Preston Dickinson's *Water Gate* (p. 134), pastel was used with charcoal and India ink; and in *The Red Barn* by Arthur B. Davies (p. 163), pastel was used with graphite pencil.

Significantly, it was at this time, when the artist was turning away from traditional modes of han-

dling, that the use of the terms *pastel drawing* and *pastel painting* were first brought into question. In a review of the work of the Society of Painters in Pastel in 1884, the critic Mariana Griswold Van Rensselaer described the medium as "a sort of dry painting" and noted that "it is a question among artists whether pastel should be called a process of drawing or of painting."[35] References to pastel compositions as drawings rather than paintings were, nonetheless, to become more common as works emphasizing the linear possibilities of pastel, such as those of Whistler and Dewing, became increasingly familiar. New works by these artists not only gave play to the draftsmanly aspect of pastel and raised the sketch to the rank of a finished painting, but they also reinterpreted and reorganized traditional color relationships. Unlike the meticulous and seamless finish of the eighteenth-century pastel, with its smooth brushlike handling, the visible stroke and the support on which it was applied were now regarded as an integral part of the work itself, and the subject was often no more than a pretext for the execution.

Supports

The interest in varying the textural properties of pastel was complemented in the final decades of the nineteenth century by the use of diverse supports with pronounced surface qualities. In the eighteenth century the support had been perceived as merely a carrier that provided mechanical tenacity for the pastel powder; both the grain and the color of the substrate were intentionally obscured as the artist sanded and smoothed all irregularities and then applied a thick layer of pastel, as seen in James Sharples's work (pp. 213–16). Now the support was often chosen expressly for its textural and tonal properties. With the industrialization of paper making and the introduction of brilliant aniline dyes, a new interest also arose after the middle of the century, even among watercolorists, in the use of colored sheets and the complementary or contrasting effects produced on them by the pastel. In *The Art of Painting and Drawing in Coloured Crayons*, one of the most widely read pastel manuals of the day, Henry Murray noted that the role of the paper was to "bear out the color of the crayons." The beauty of the work "depended upon the paper being yet perceptible through the ultimate finish," a technique Murray also described as a successful means of

imitating the transparency of oil painting.[36] Instructors during the 1890s, an era in which pastel had become particularly popular among American artists and amateurs, suggested that the artist choose paper of a shade approximating the general tone of the sketch, for "a fleeting effect may be rapidly secured in that manner."[37] Although not necessarily executed on papers close in tone to that of the pastel composition, such effects and an enthusiasm for colored substrates are seen in most of the pastels done in the late nineteenth century. Colored papers intended for commercial purposes, as well as those made especially for the artist, are seen in works throughout the period: the cheap laminated green cardboard of Cassatt's *Woman on a Bench* (p. 155) and the brown machine-made wrapping paper of Edwin Austin Abbey's *Dirge of the Three Queens* (p. 61), for example. Information about traditional practices, such as the mounting of vellum on a strainer, was still available, but this preliminary preparation was no longer a requirement or aesthetically important: even a simple sheet of paper was now acceptable.

Advice to the amateur was taking a new turn. Following the model of pastelists working in Europe, aspiring artists were encouraged to experiment with commercially available materials, such as cartridge and charcoal papers. Commentators explained that unlike the surfaces of the past, "here and there little specks of paper would show through. They are to be left. The same occurs with watercolor. These little accidents add charm and variety. It should be the same in pastel."[38] Indeed, textured papers, which were often also colored, had great appeal, and examples from the late nineteenth century abound, such as the rough-surfaced gray-brown sheets discovered by James McNeill Whistler in a Venetian warehouse (p. 49); the long-fibered dyed Japanese tissues of Arthur B. Davies (pp. 79, 83); the blotting paper of Joseph Stella's *Landscape* (p. 108); and the clearly visible grain of the laid paper of Max Weber's *Lecture at the Metropolitan* (p. 127). In later years, pastelists were enticed by other substrates as well: the gessoed panel of William Merritt Chase's *At the Toilette* (private collection, Philadelphia); the very popular, yet ordinary, artists' illustration board of William Glackens's *Shop Girls* (p. 90); the coarse weave linen of Arthur G. Dove's *Cow* (p. 110) and the roughly planed plywood plank of his *Tree Forms and Water* (p. 116).

Paralleling the new popularity of rough-textured supports was the introduction of abrasive papers made expressly for use with pastel. These were among the most distinctive supports for art work that emerged in the second half of the nineteenth century. It was claimed that these sheets offered mechanical adhesion for the particles, but because of their surface uniformity they did not exercise any textural effect on the design layer. One of the earliest abrasive papers to be patented was *papier pumicif*, by 1850.[39] It was made by sprinkling finely ground pumice, often dyed blue—which has proven to be especially fugitive—onto an adhesive-coated wood-pulp paper or cardboard. At the time of their introduction, these sparkling sheets were commended as "assisting in the labors of the artist."[40] Although these papers were especially favored by amateurs (as was commercial sandpaper by American folk artists), John H. Twachtman appears to have used them frequently (*Landscape*, fig. 27), as did Elmer MacRae (*Schooner at Dock*, p. 202), and Chase, on occasion (*Self-Portrait*, fig. 13). Twachtman's *Landscape*, which contains broad reserve passages, has yellowed from a combination of poor materials and exposure to light, but the protected margins reveal that the original tone of the sheet was blue.

Many variations of this type of support were manufactured in the latter part of the century, including buff, blue, and gray pastel canvases that had a pumice ground and required mounting on a stretcher, as used by Chase for *Hall at Shinnecock* (fig. 8). Also popular were Winsor & Newton's velour paper, which had a flocked surface but appeared to be rubbed vellum, and the finely ground wood-fiber-coated paper on which Robert Blum executed his *Cherry Trees* (p. 72). This support, which originally was blue-gray and would have given the composition a silvery, cool tonality, has faded drastically. Despite the easy handling and alluring texture of these papers and canvases, appreciation of them among professional artists waned by the early decades of the twentieth century. Birge Harrison criticized the "myriad of protruding points from which the powder promptly falls away upon the first really serious shaking or beating";[41] various writers of pastel manuals concurred, noting that the surfaces were unsympathetic and the weak tenacity required the use of a fixative.

Fixatives

Throughout the history of pastel numerous colorless elixers have been devised to hold it in place without altering its hue or destroying its velvety texture.

These substances have included isinglass, brandy, sugar candy, gelatin, shellac, casein, and countless other decoctions applied in a variety of inventive techniques, ranging from complete immersion of the work in a liquid solution to brush coating, spraying, or steaming the composition. Even in the eighteenth and nineteenth centuries, when it was difficult at best to procure large sheets of clear glass to cover a framed pastel, and hence alternatives for protecting the surface were few, the use of fixatives was always a subject of controversy. Although these substances stabilize the inherently powdery medium by penetrating it and giving it some measure of solidity, they also darken and dull the tones, an optical effect caused by the saturation of color and the consequent reduction of its brilliance.

Despite this limitation, the need for protection existed, and when a fixative was used, it was applied as a final coating over the finished work of art. It was not until the latter part of the nineteenth century that these adhesive solutions were introduced as part of the working process. Following the innovative work of Edgar Degas, the range of handling possibilities for pastel expanded greatly. Among the techniques popularized by Degas was the use of a fixative as a barrier between successive layers of pastel, which allowed colors to be superimposed without muddying their tone or disrupting the surface. Utilizing this process in *Margot in Orange Dress* (fig. 28), Mary Cassatt was able to apply thick strokes of soft pastel over broad passages of color. Not only have the colors retained their purity and strength, but the ridges of powder yielded a rich texture that enhances the play of light on the surface. Such techniques, which allowed for freer handling and more interplay of colors at different physical levels of the composition, were ideal for producing additive color effects and were especially appreciated at the end of the century, when interest in chromatic theory became widespread.

Another notable technique developed in the 1870s by Degas and also practiced by Cassatt was combining scraped pastel powder with size or fixative. This allowed the artist to mix colors on the palette and apply the resulting paste with a brush or knife. With these tools a variety of textural effects could be produced, ranging from smooth passages with a compact, gouachelike quality to impasto, sgraffito, or the imprint of a stiff brush. Close inspection of such works often reveals cracking caused on drying, or tiny air bubbles that resulted from the incomplete mixing of the substances (see,

Fig. 27. The pumice paper used as a support by John H. Twachtman in *Landscape* was made by sprinkling finely ground and dyed pumice onto an adhesive-coated paper (enlarged detail).

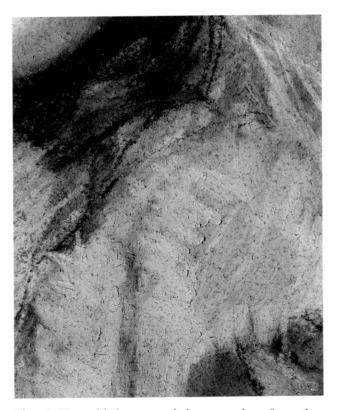

Fig. 28. To enable her to apply heavy strokes of pastel without disrupting lower layers of color in *Margot in Orange Dress* Mary Cassatt applied fixative to selected passages of the composition (enlarged detail).

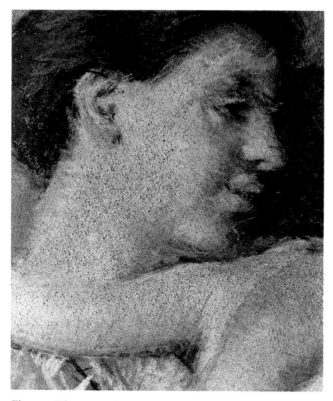

Fig. 29. The granular texture evident in this close-up of *Mother and Child* by Mary Cassatt resulted from the incomplete mixing of pastel powder with a liquid. This paste, formed by exposing the dry pastel to steam, is only weakly attached to the support, resulting in some flaking near the outer corner of the eye.

for example, Degas, *Dancer on Stage*, MMA). Combining pastel with a liquid or exposing it to steam, techniques both artists occasionally employed, sometimes resulted in a grainy texture, owing to the coalescing of the pastel particles, as seen in Cassatt's *Mother and Child* (fig. 29). These technical innovations undoubtedly provoked the revival of gouache as an independent medium, but they did not in the long run gain widespread popularity.

By the beginning of the twentieth century the art of pastel was still considered a secondary medium, but far more artists than ever before were utilizing it. Its brilliance and nonyellowing character were enthusiastically welcomed, particularly as dissatisfaction

grew with the mediocre quality of the industrially made oil colors and varnishes that were available. Both draftsmanly and painterly handling, which had enjoyed succeeding waves of popularity, depending upon academic restraints and public taste, were now acknowledged equally. The range of subject matter, having expanded from portraits, landscape, and still life in the eighteenth century to include plein-air landscape and genre scenes in the nineteenth, now also embraced abstract imagery. Despite the renewed appreciation of pastel for its suitability for executing rapid, impressionistic sketches, it never achieved the importance of chalk and charcoal for preparatory work. As in the past, its rich, brilliant palette was favored for finished compositions. Interest burgeoned in developing pastel's textural possibilities by varying the pressure of application of the crayon and by emphasizing the diverse supports to which it could be applied.

Works in pastel of the last hundred years are often subject to more severe conservation problems than those of earlier eras. The pastel colors themselves are in many instances stable, and the presence of a fixative has not necessarily interfered with the integrity of the work; however, the substrates manufactured since the middle of the nineteenth century are frequently composed of short-fibered, machine-made papers of nonpurified wood-pulp stock, dyed with fugitive, synthetic colors. Thus, not only are there dangers inherent in the structure of the supporting material itself, but these weaknesses generally have been exacerbated by prolonged exposure to light from years of continuous display and from the uncontrolled vagaries of heat, dryness, or excessive moisture in the environment where they have been hung. Fading, yellowing, and embrittlement of the support are some of the common problems encountered in these pastels. Mounting and framing with poor-quality or inappropriate materials, such as cardboard and wooden shingles (the latter, commonplace for folk art), will contribute to this precarious condition. Mold growth, foxing, and staining from condensation, common afflictions of pastel, are often provoked by humidity and a lack of air space between the work of art and the inside surface of the glazing. Some of these problems can be corrected, but many of them will worsen unless constant care is taken to control environmental factors, such as light, temperature, and relative humidity levels, all of which have a profound effect on the appearance and well-being of these works. The inherent fragility of the pastel medium accounts

for its freshness of color and velvety texture, but it is also its greatest weakness. This cannot be remedied by any fixative; thus, these compositions must be framed with materials of the best quality, and must not be subject to excessive movement or handling in order to prevent disruption of their delicate and powdery surfaces.

NOTES:

This material is adapted from a longer work in progress, "Painting in the Dry Manner: A Technical History of the Art of Pastel."

1. Edmond and Jules de Goncourt, *L'Art du dix-huitième siècle*, 3d ed. (Paris, 1880), pp. 151–52; and Charles Blanc, *Grammaire des arts du dessin* (Paris, 1880), p. 588.

2. Ernest Rouart, "Degas," *Le Point* 2 (Feb. 1937), p. 22.

3. "Pastel Queries," *Art Amateur* 25 (Nov. 1891), p. 128.

4. Wilhelm Ostwald, *Letters to a Painter on the Theory and Practice of Painting* (Boston, 1907), pp. 23–27, 35–43.

5. Harrison 1915, p. 155.

6. John Russell, *Elements of Painting with Crayons* (London, 1772; 2d ed. 1777), p. 43.

7. Leidel 1885, p. 10.

8. For example: E. M. Heller, "Painting in Pastels I," *Art Amateur* 25 (Nov. 1891), p. 138; and E. M. Heller, "Pastel Painting," *Art Amateur* 26 (May 1892), p. 159.

9. Françoise Flieder, "The Study of the Conservation of Pastels," in *Science and Technology in the Service of Conservation* (London: International Institute for Conservation of Historic and Artistic Works, 1982), p. 72.

10. James Watrous, *The Craft of Old Master Drawings* (Madison, Wis., 1967), p. 161, no. 34.

11. William Salmon, *Polygraphice; or, The Arts of Drawing, Limning, Painting, and c.* (London, 1672; 1685), p. 5.

12. Ostwald, *Letters*, p. 25. This is also discussed by Max Doerner, *The Materials of the Artist and Their Use in Painting* (London, 1934); and Ralph Mayer, *The Painter's Craft: An Introduction to Artists' Materials* (New York, 1948), pp. 175–77. According to Geneviève Monnier (*Pastels: From the Sixteenth to the Twentieth Century* [New York, 1984], p. 117), this is the technique currently used by LeFranc & Bourgeois, artists' colormen in Paris.

13. Karl-Robert [Georges Meusnier], *Le Pastel: traité pratique et complet* (Paris, 1890), p. 27.

14. John Singleton Copley, letter to Jean-Etienne Liotard, Sept.

30, 1762, in Massachusetts Historical Society, *The Letters and Papers of John Singleton Copley and Henry Pelham, 1739–1776* (Boston, 1914), p. 26.

15. Robert Dossie, *Handmaid to the Arts* (London, 1758), p. 196.

16. Henry Murray, *The Art of Painting and Drawing in Coloured Crayons* (London, 1850), p. 13.

17. John G. Chapman, *The American Drawing Book: A Manual for the Amateur* (New York, 1847), p. 252.

18. Leidel 1885, p. 13.

19. Ibid.

20. Hugh Breckenridge, "Making Pastel Sticks," MS., c. 1899, Hugh Breckenridge Papers, Arch. Am. Art, microfilm 1907, frame 481; Ely 1921, p. 201; Harrison 1915, p. 156; and Philadelphia Art Alliance, *Memorial Exhibition of the Work of Thomas Anshutz*, exhib. cat. by Helen W. Henderson (Philadelphia, 1942), unpaginated.

21. Arthur G. Dove, letter to Elizabeth McCausland, Arch. Am. Art, microfilm D384B, frames 146–51.

22. Quoted in See 1920, p. 166.

23. Benjamin West, letter to John Singleton Copley, August 4, 1766, in Massachusetts Historical Society, *Letters and Papers of Copley and Pelham*, p. 44.

24. Leidel 1885, p. 15.

25. Murray, *Art of Painting*, p. 29.

26. Ibid., p. 51; Heller, "Painting in Pastels I," p. 138; and E. M. Heller, "Notes on Pastel," *Art Amateur* 30 (May 1894), p. 159.

27. Leidel 1885, p. 15.

28. Ely 1921, p. 202.

29. Leidel 1885, p. 17.

30. Ibid.

31. "The Pastel Exhibition," *Art Amateur* 21 (June 1889), p. 4.

32. "The Pastel Society and the Pencil Society at the Burlington Galleries," *Apollo* 13 (Feb. 1931), p. 135.

33. Heller, "Pastel Painting," p. 158.

34. Russell, *Elements of Painting*, pp. 19–20.

35. Van Rensselaer 1884, p. 205.

36. Murray, *Art of Painting*, pp. 26, 46.

37. Harper Pennington, "Talks with Artists," *Art Amateur* 26 (Dec. 1892), p. 9.

38. Heller, "Notes on Pastel," p. 159.

39. E. J. Labarre, *Dictionary and Encyclopaedia of Paper and Paper-Making*, 2d ed. (Amsterdam, 1952), p. 273.

40. Murray, *Art of Painting*, pp. 26, 28.

41. Harrison 1915, p. 156.

Catalogue

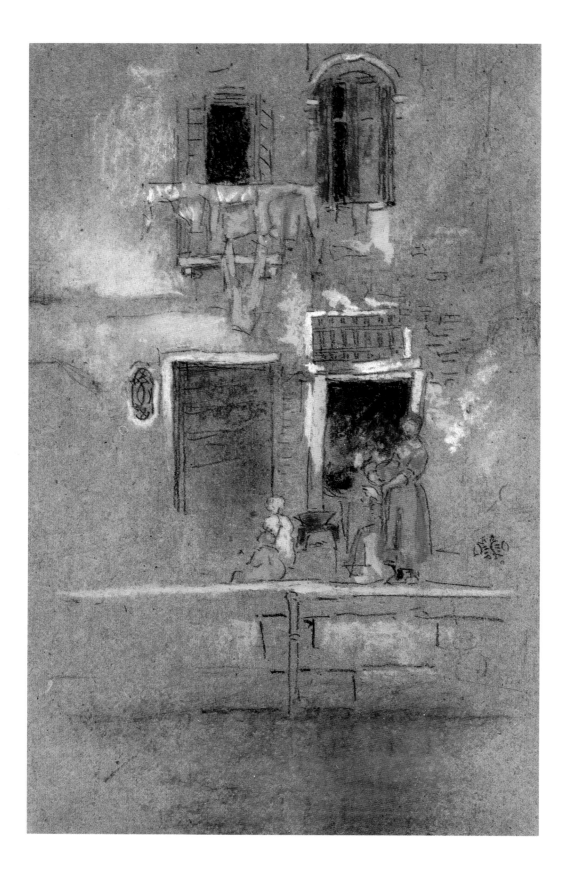

James McNeill Whistler
1834–1903

Bead Stringing, Venice, about 1880
(probably *Note in Pink and Brown*)

Pastel on gray-brown wove paper, 11¾ × 7¼ in.
At right: [butterfly monogram]
Harris Brisbane Dick Fund, 1917 (17.97.5)

By the time he left London for Venice in the fall of 1879, James McNeill Whistler had been using pastel for more than a decade. Unlike his etchings, many of which were picturesque genre scenes, especially along the Thames, the pastels of the late 1860s and 1870s were usually figure studies of women, shown either nude or dressed in Greek clothing. The work of the British artist Albert Moore, whom Whistler first met in 1865, was influential in the development of his pastel technique. Moore encouraged Whistler to use pastels to develop both a sense of color and a spontaneous style.[1] Like Moore, Whistler would first delineate the figure's outline in pastel and fill in the details later. These early pastels, as well as those made in Venice, played an important role in Whistler's definition of art. By dedicating himself to such modest works, Whistler proclaimed their legitimacy. The very act of working in pastel and in other secondary mediums enabled him to explore mood, atmosphere, and composition in a very free and distinctive manner.

Whistler arrived in Venice in September 1879 and remained there for fourteen months. Although he had been commissioned by the London Fine Art Society to execute a series of twelve etchings, he produced many more, as well as about one hundred pastels.[2] As in London, Whistler avoided obvious landmarks to depict less familiar themes; he ignored Venice's architectural splendors and focused his attention on crumbling buildings, courtyards, tiny streets, doorways, beggars, and other mundane subjects. Indeed, the Venetian pastels contain few recognizable references to that city. A certain universality was thus achieved; freed from subject matter, Whistler concentrated his efforts on more formal aspects, such as color, line, and shadow.

If the treatment of subject matter in these works is consistent, their style is not. At first, Whistler's pastels were heavily blended and somewhat muddy, with colors hardly distinguishable from one another. Later on, however, they were characterized by much bolder, clearer colors, each separated from the other by sharp lines. *Bead Stringing, Venice* seems to belong to the latter category, and if one assumes that Whistler improved upon his technique with the passage of time, it was probably made late during his stay in Venice. Typically, the outlines of the buildings, windows, doors, and people are drawn in black pastel, with only a few touches of vivid purple and yellow pastel added here and there. The only spot where the pastels have been blended is in the building's faint reflection on the water.

Whistler worked rapidly with pastels and was very economical in his strokes, drawing only what was essential. Although the pastel appears to be spontaneous and free-spirited, the composition was carefully considered before the first stroke of black touched the paper. Like Edgar Degas and Mary Cassatt, Whistler trained his mind and hand by constantly drawing the same subjects, thereby perfecting his design. While some of his pastels were

Fig. 30. One of *Three Pages of Thumb Note Sketches of the Venice Pastels Lithographed by the Author* in T. R. Way, *Memories of James McNeill Whistler, the Artist* (London, 1912)

finished on the spot, others were drawn only in outline at the site and finished later in the studio.

The novelty of the Venetian works also resided in the artist's deliberate use of brown paper, which he had found in an old, abandoned warehouse in Venice and decided to use as a support for his pastels. He emphasized the color of the paper and its strong unifying tone by leaving much of it visible rather than covering it over with pastel. Whistler's use of colored paper and his respect for the integrity of the pastel, demonstrated by a lack of rubbing and blending, are reminiscent of the style of Jean-Antoine Watteau, the eighteenth-century French artist whose work Whistler had studied at the Louvre during his student days in Paris.[3]

On January 19, 1881, two months after returning to London, Whistler exhibited his Venetian pastels at the Fine Art Society. *Bead Stringing, Venice* was probably included in the highly acclaimed show. Judging from the thumbnail sketches (fig. 30) that T. R. Way made as a record of the exhibition, it

appears to be number 26 in the catalogue, where it is entitled *Note in Pink and Brown*.[4] Whistler, anticipating an increase in his popularity on account of the exhibition's success, wrote to his brother's wife:

> The pastels you know Nellie, I verily believe will be irresistable [*sic*] to buyers—. . . I assure you the people—painter fellows—here, who have seen them are quite startled at their brilliancy. . . for the pastels . . . are, and remain even in my present depression, lovely. Just think fifty—complete beauties—and something so new in Art that every body's mouth will I feel pretty soon water—.[5]

The press did not share Whistler's enthusiasm. Critics could not understand the unfinished quality of the pastels, their insignificant and seemingly trivial subject matter, and the use of the brown paper. The exhibition of Sir John Everett Millais's work in the room adjoining Whistler's exhibit provided a striking contrast between two philosophies of art. The *Weekly Times* noted that leaving the Millais exhibit to go into Whistler's display of "vague and unutterable daubs is too great a descent from the sublime to the ridiculous."[6] Millais himself, however, called the pastels "magnificent, fine—very cheeky—but fine."[7] The reaction of the general public was favorable as well, and most of the pastels were sold at high prices.

Whistler also proved to be an innovator in the design of the exhibition itself. He believed that the artist's responsibility did not end with the completion of the work, but included its proper exhibition as well. Accordingly, Whistler placed unfinished and finished pastels next to one another, designed their frames, and painted and decorated the exhibition room in green, gold, and yellow. He even designed the invitations.

After returning to London, Whistler abandoned the kind of pastels he had done in Venice and went back to his more traditional figure studies of women. Nevertheless, he had started a movement toward freedom and spontaneity in drawing. Many artists followed his lead and traveled to Venice, also drawn by that city's fabled light and scenery. John Singer Sargent, Robert Blum, Maurice B. Prendergast, and later John Marin were only a few of the many Americans who captured the city's marvels and enjoyed its artistic milieu.

M.V.

NOTES:

1. For a recent evaluation of Albert Moore's work see Minneapolis Institute of Arts, *The Victorian High Renaissance*, exhib. cat. (Minneapolis, 1978), pp. 129–55, esp. 131–32 for the Moore-Whistler connection.

2. Getscher 1970, p. 101.

3. A discussion of the influence of Watteau on Whistler's art can be found in Freer Gallery of Art, *James McNeill Whistler at the Freer Gallery of Art*, exhib. cat. by David Park Curry (Washington, D.C., 1984), pp. 35–51.

4. Getscher 1970, pp. 285–86.

5. Quoted in Stanford University Museum and Art Gallery, and the Galleries of the Claremont Colleges, *Whistler: Themes and Variations*, exhib. cat. (Stanford/Claremont, 1978), p. 39.

6. Quoted in Getscher 1970, p. 220.

7. Quoted in E. R. and J. Pennell, *The Life of James McNeill Whistler*, 2 vols. (London/Philadelphia, 1908), I, p. 293.

REFERENCES: E. L. Cary, *The Works of James McNeill Whistler* (1907), p. 198, no. 274 // T. R. Way, *Memories of James McNeill Whistler, the Artist* (1912), ill. following p. 52, no. 26 // M. F. MacDonald, University of Glasgow, letter, Oct. 30, 1972, Dept. Archives // Pilgrim 1978, ill. p. 46.

EXHIBITED: Fine Art Society, London, 1881, *Venetian Pastels: James McNeill Whistler*, no. 26, as Note in Pink and Brown (probably this pastel) // Palais de l'Ecole des Beaux-Arts, Paris, 1905, *Exposition des oeuvres de James McNeill Whistler*, no. 149, as En enfilant des perles // MOMA, 1932–33, *American Painting and Sculpture, 1862–1932*, no. 116, as Bead Stringers // Wildenstein & Co., New York, and Philadelphia Museum of Art, 1971, *From Realism to Symbolism: Whistler and His World*, entry by K. Jánszky, no. 32 // MMA, 1972, *Drawings, Watercolors, Prints, and Paintings by James Abbott McNeill Whistler* (no cat.) // Fine Arts Museums of San Francisco, 1984, *Venice: The American View, 1860–1920*, entry by M. M. Lovell and M. Simpson, no. 96, p. 146.

EX COLL.: Harris Brisbane Dick estate

MARY CASSATT
1844–1926
Mother Feeding Child, 1898

Pastel on wove paper (now discolored), mounted on
canvas, 25½ × 32 in.
Signed at lower left: Mary Cassatt
From the Collection of James Stillman,
Gift of Dr. Ernest G. Stillman, 1922 (22.16.22)

Mary Cassatt was an extremely versatile artist who
produced oil paintings, prints, aquatints, and pastels.
Although her first pastels, which date from 1868, are
simple in nature and depict somewhat trite subjects,
they demonstrate her attraction to pastel and its
artistic possibilities.

Cassatt worked largely in oil until 1879, when
she turned seriously to pastel, using it with great
brilliance and virtuosity. Her pastels of the 1880s and
1890s are composed like her oil paintings: they are
big and bold, and the human figure takes up most of
the surface. After 1890, like her contemporaries
Edgar Degas, James McNeill Whistler, and Berthe
Morisot, Cassatt was influenced by the Japanese
prints of Hokusai and Hiroshige, characterized by
irregular spatial arrangements and flat, linear pat-
terns. This *japonisme* can be seen in *Mother Feeding
Child*, especially in the way the table is cropped at the
lower left.

Mother Feeding Child is characteristic of Cassatt's
accomplished pastel work of the 1890s in the
attention to pattern, as seen, for example, in the
printed decoration on the baby's dress, and in the
repetition of curvilinear shapes in both figures and
in the plate and covered dish on the tabletop. The
pastel is also remarkable in its sensitive representa-
tion of the intertwined hands of the models. Atten-
tion to the special bond between mother and child
was characteristic of Cassatt's work during this
period.

Cassatt's use of the pastel medium was undoubt-
edly influenced by her close friend Degas. His
insistence on precise draftsmanship and refined
composition is particularly evident in this pastel.
Unlike other Impressionists, such as Claude Monet
and Camille Pissarro, both Degas and Cassatt
stressed the primacy of line and form over color and
atmosphere. Cassatt's pastel technique was also sim-
ilar to Degas's: the pastel was applied in thick strokes
and was blended into a very fine texture and
sometimes into the paper itself.

The eighteenth-century French artist Maurice-
Quentin de La Tour was also an important influence
on Cassatt. She often visited the Musée de La Tour
at St. Quentin and studied the master's exquisite and
delicate pastels, which were drawn with precision
and clarity. De La Tour's preference for a painterly
pastel application, typical of the period, is reflected
in *Mother Feeding Child*, particularly in the head of
the mother. Indeed, if one looks at examples of
the French master's pastels, such as *Mlle de Zuylen*
or *Mme de Pompadour*, both at the museum at
St. Quentin, one notices not only a similarity of style
but also a similar facial composition—a three-
quarter view of the head, with fine, delicate features,
attentive eyes, and tied-back hair.

The Museum's pastel is one of the many mother-
and-child scenes that Cassatt depicted. This repeti-
tion of subject was perhaps inspired by Degas, who
also limited his work to particular themes, such as
ballerinas and bathing women. "It is essential to do
the same subject over again, ten times, a hundred
times. Nothing in art must seem to be chance, not
even movement," Degas once wrote.[1] Practical rea-
sons as well may have dictated Cassatt's choice of
subject. The world of men was essentially off-limits,
both socially and professionally. It was considered
improper for a woman of her social position to visit
bars and cafés unescorted, and male models were
not readily available to women artists. So Cassatt
turned to a world of young children, mothers, family
members, and friends. Ironically, she herself never
married and had no children.

It is perhaps the serious yet pleasing depiction
of children and mothers that made Cassatt's work so
appealing to American art collectors of the day,
including James Stillman, a New Yorker who pur-
chased this work directly from the artist. Patrons like
Mr. Stillman were important to Cassatt's career,
as they commissioned a great number of her works.

M.V.

NOTE:

1. Quoted in E. John Bullard, *Mary Cassatt: Oils and Pastels* (New
York, 1972), pp. 15–16.

REFERENCES: A. Hoeber, *Century Magazine* 57 (Mar. 1899), ill.
p. 741 // C. Mauclair, *Art décoratif* 47 (Aug. 1902), frontispiece //
A. Ségard, *Un Peintre des enfants et des mères: Mary Cassatt* (1913),
p. 123, ill. p. 85 // Breeskin 1970, p. 129, ill. no. 282 // F. Getlein,
Mary Cassatt—Paintings and Graphics (1980), p. 110, color ill. //
G. Pollock, *Mary Cassatt* (1980), p. 113, ill. no. 45.

EX COLLS.: James Stillman, Paris and New York; his son,
Dr. Ernest G. Stillman

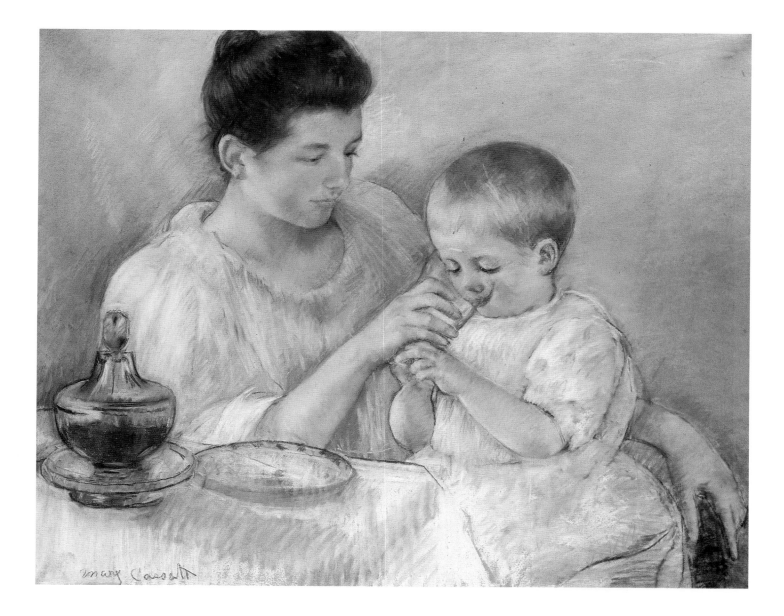

MARY CASSATT
Gardner and Ellen Mary Cassatt, 1899

Pastel on wove paper (now discolored),
originally on a strainer, 28¼ × 23½ in.
Signed at lower right: Mary Cassatt
Gift of Mrs. Gardner Cassatt, 1957 (57.182)

By the late 1890s Mary Cassatt was working in pastel much more frequently than in oil. When she left France in the fall of 1898 for a visit to her native United States, she took only her pastel equipment, and her work during her stay in America consisted mainly of pastels. The trip was an important event for Cassatt, as she was able to renew contact with old friends, such as Mr. and Mrs. H. O. Havemeyer and Mr. and Mrs. James Stillman, important art collectors and patrons who purchased many works of art from the French Impressionists on Cassatt's advice.

Cassatt's own lack of recognition in the United States, even as late as the turn of the century, is reflected in a notice that appeared in the *Philadelphia Ledger* to announce her arrival: "Mary Cassatt, sister of Mr. Cassatt, president of the Pennsylvania Railroad, returned from Europe yesterday. She has been studying painting in France and owns the smallest Pekingese dog in the world."[1] In Pennsylvania, she stayed with her brother Gardner, who lived just outside Philadelphia. While there, Cassatt made this pastel portrait of two of his children, Gardner, Jr., and Ellen Mary. The portrait is unusual in Cassatt's oeuvre because it depicts an adolescent boy and girl without an adult. Cassatt rarely portrayed men or members of both sexes together. Although she also made pastels of the children of Mr. and Mrs. Gardiner Green Hammond of Boston, Cassatt preferred to execute portraits of family members, and she rarely accepted commissions from strangers. To make a proper portrait, Cassatt felt that she had to have something in common with the sitters—a shared bond, heritage, or social milieu—and this could be achieved only with close friends or with family. This pastel shows how successful she was in capturing the essence of sitters she knew well. The boy's face is stern and responsible, while the girl's is more ambiguous—a little worried, perhaps, and puzzled. Yet one senses that she is snug and comfortable on her brother's lap, encircled by his right arm. It is this sort of psychological perception that won Cassatt the greatest acclaim at home and abroad.

Gardner and Ellen Mary Cassatt demonstrates the simplification and streamlining that characterized Cassatt's work at this time. Compared to *Mother Feeding Child* (p. 52), the portrait is stark and devoid of detail. The clothing is plain and simple, with no decorative patterns; props and accessories have been eliminated; the sitters have been enlarged and brought closer together; and the color scheme is somber and uncomplicated, composed primarily of restrained greens and browns. All these features enable the viewer to concentrate on the sitters' faces and not on their surroundings.

M.V.

NOTE:

1. Quoted in E. John Bullard, *Mary Cassatt: Oils and Pastels* (New York, 1972), p. 17.

REFERENCES: S. Preston, *Apollo,* n.s. 83 (Apr. 1966), p. 303 // Breeskin 1970, p. 135, ill. no. 302 // E. Wilson, *American Painter in Paris: A Life of Mary Cassatt* (1971), p. 161 // E. J. Bullard, *Mary Cassatt: Oils and Pastels* (1972), p. 64, ill. pl. 22 // G. Pollock, *Mary Cassatt* (1980), p. 114, ill. no. 46.

EXHIBITED: Philadelphia Museum of Art, 1960, *Mary Cassatt,* as Master Gardner Cassatt and Miss Ellen Mary Cassatt // M. Knoedler & Co., New York, 1966, *The Paintings of Mary Cassatt: A Benefit for the Development of the National Collection of Fine Arts, Smithsonian Institution, Washington, D.C.,* pl. 31.

EX COLLS.: brother of the artist, J. Gardner Cassatt (d. 1911); his wife, Mrs. J. Gardner Cassatt; her daughter-in-law, Mrs. J. Gardner Cassatt, Villanova, Pa.

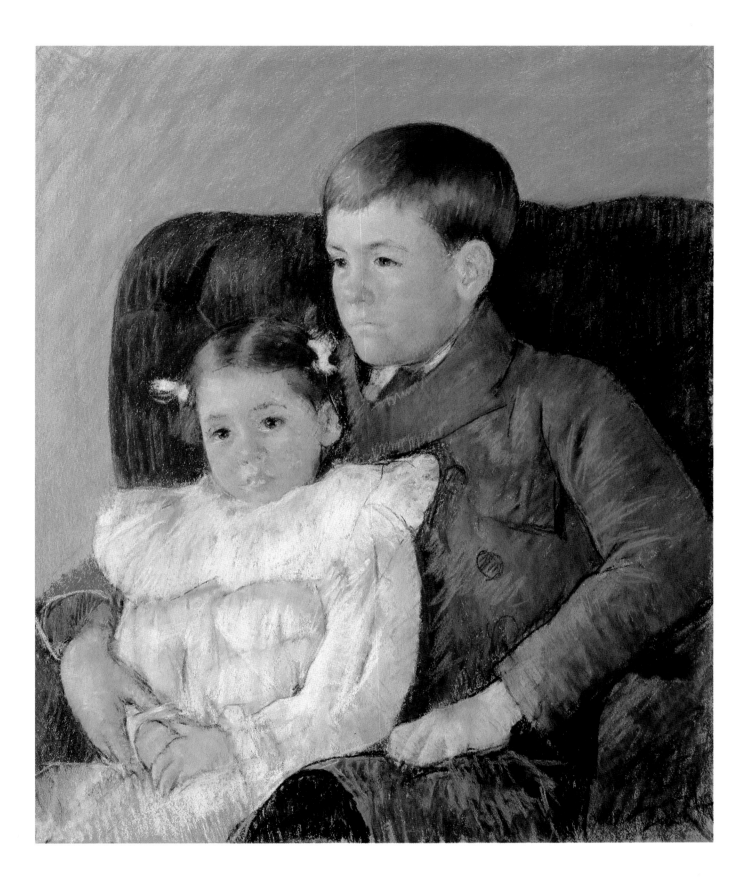

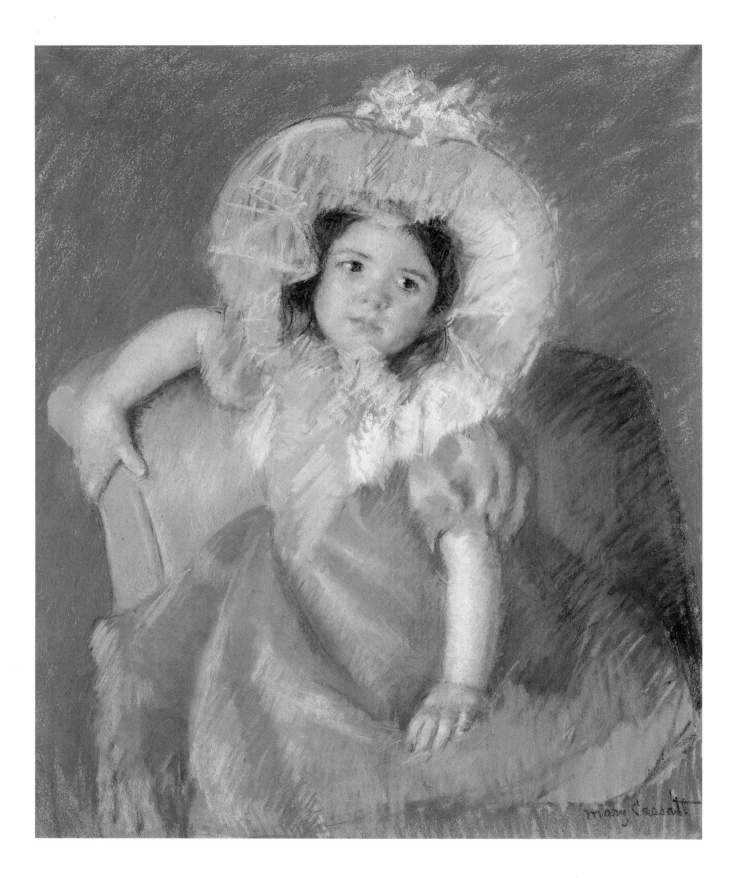

MARY CASSATT
Margot in Orange Dress, 1902

Pastel on wove paper (now discolored), mounted on linen, originally on a strainer, 28⅝ × 23⅝ in.
Signed at lower right: Mary Cassatt
From the Collection of James Stillman,
Gift of Dr. Ernest G. Stillman, 1922 (22.16.25)

At the turn of the century, Mary Cassatt began to depict older children. "It is not worthwhile to waste one's time over little children under three who are spoiled and absolutely refuse to allow themselves to be amused and are very cross, like most spoiled children," she wrote to her friend Louisine Havemeyer.[1]

From 1901 to 1906, Cassatt did many pastels of young girls like Margot Lux. Such works proved so popular that in order to meet the demand Cassatt allowed her dealer, Ambroise Vollard, to make counterproofs of some of them. These were made by running the pastel through a lithographic press together with a damp sheet of paper. The pastel would be partially transferred onto the wet paper, forming a mirror image of the original. Cassatt herself later reworked both originals and counterproofs and even signed her name to the latter. The pastel was thickly applied on the original so that the colors would remain on the paper even after the counterproof was made. No counterproof was made of *Margot in Orange Dress*, but like other pastels of this period, the pastel is densely applied and the focus is on color and vibrancy.

Cassatt's emphasis on line and form, still evident in her pastels of the 1890s, has been supplanted here by vigorous and sketchy drawing, characterized by strong, even frenzied, diagonal strokes. Dark greens and browns have given way to bright whites and orange. Margot's facial expression is disquieting and wistful, in sharp contrast to the bright, cheerful clothing that literally envelops her. Her complicated, twisted pose seems self-conscious, almost artificial, for her tender age.

Cassatt's pencil study for this pastel, entitled *Drawing for "Study of Margot in a Fluffy Hat"* (Wadsworth Atheneum, Hartford, Conn.), reflects the care and effort that she took to find the exact expression and pose she wanted.[2] The fact that Cassatt did such studies indicates that pastel was a principal medium of expression for her.

M.V.

NOTES:

1. Quoted in Breeskin 1970, p. 17.
2. Griselda Pollock, *Mary Cassatt* (London, 1980), p. 117, ill. no. 51.

REFERENCES: Breeskin 1970, p. 171, ill. no. 433 // G. Pollock, *Mary Cassatt* (1980), p. 118, ill. no. 52.
EXHIBITED: Galeries Durand-Ruel, Paris, 1908, *Tableaux et pastels par Mary Cassatt*, no. 27, as Fillette assise dans un fauteuil.
EX COLLS.: James Stillman, Paris and New York; his son, Dr. Ernest G. Stillman

MARY CASSATT
Mother and Child, 1914

Pastel on wove paper (now discolored), mounted on
canvas, originally on a strainer, 32 × 25⅝ in.
Signed at lower right: Mary Cassatt
Bequest of Mrs. H. O. Havemeyer, 1929, H. O. Havemeyer
Collection (29.100.49)

This pastel was made in the city of Grasse in the
south of France, where Mary Cassatt spent her
winters following the death of her brother Gardner
in 1911. Like Edgar Degas, she increasingly worked
with pastels during the last years of her life. Her
failing eyesight made pastels more expedient than
oils, for she felt they did not strain the eye as
severely. In her late pastel work, colors became more
vibrant and the application more vigorous, which
some critics have attributed to near blindness. Cer-
tainly her interest in detail and perhaps even her
ability to draw and model precisely had diminished
markedly in just one decade. Yet Cassatt considered
these late pastels among her best work and so did
many collectors, including Louisine Havemeyer, who
purchased this pastel from the artist.

Mother and Child was executed especially for an
exhibition, *Masterpieces by Old and Modern Masters,*
held in 1915 at M. Knoedler & Co., in New York City.
The chubby child, standing in an elongated *S* pose,
is reminiscent of the works of sixteenth-century
Italian Mannerists such as Correggio and Parmi-
gianino. In 1872 Cassatt had traveled in Italy and
had studied under Carlo Raimondi at the academy
in Parma. There she became familiar with the
Mannerist artists, whose bright colors, attenuated
figures, and complex compositions must have ap-
pealed to her. This influence can also be seen in such
oils as *Mother and Child (The Oval Mirror),* 1901
(MMA).

The pastel *Mother and Child* is one of many
examples from Cassatt's oeuvre that have been
compared to paintings depicting the Madonna and
Child. Although the similarity in composition and
subject matter would indeed invite such a com-
parison, it is unlikely that Cassatt herself would have
accepted the connection. Her compositions were
undoubtedly inspired by religious paintings, but the
settings are completely secular, with no hint of
religious symbolism or overtones. Cassatt simply
wished to explore the elementary relationship be-
tween a mother and a child—indeed, she often
entitled these works *Maternity.*

M.V.

REFERENCES: *Arts and Decoration* 33 (May 1930), ill. p. 55 //
Breeskin 1970, p. 214, ill. no. 600.
EXHIBITED: M. Knoedler & Co., New York, 1915, *Masterpieces by
Old and Modern Masters,* no. 58 // MMA, 1930, *H. O. Havemeyer
Collection Exhibition,* no. 139.
EX COLL.: Mrs. H. O. Havemeyer, New York, by 1926

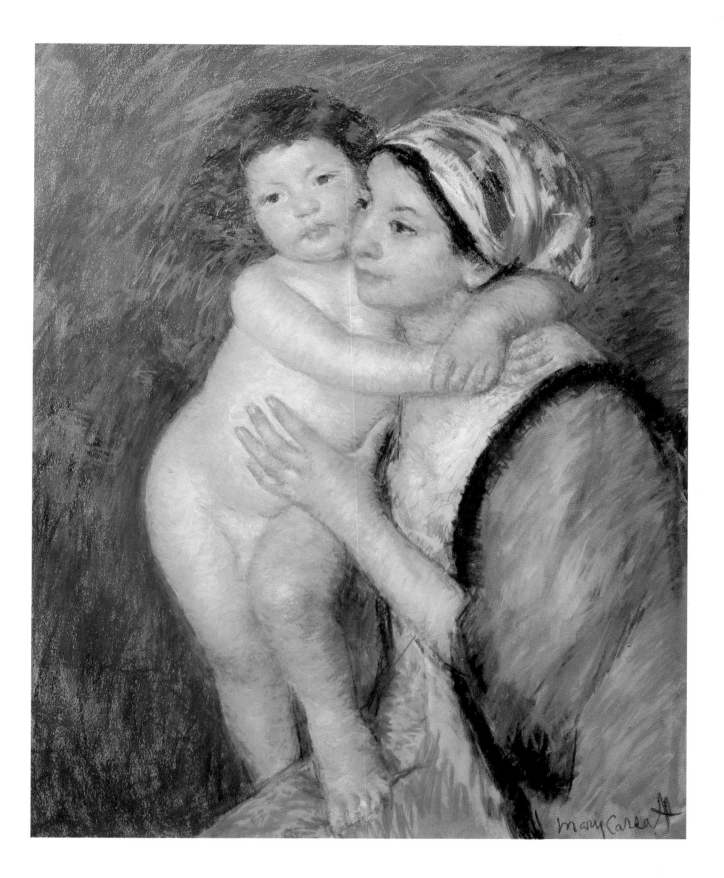

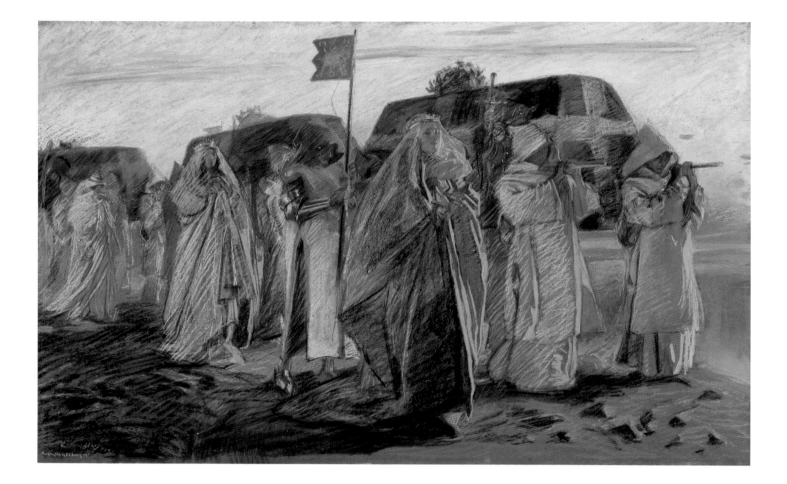

EDWIN AUSTIN ABBEY
1851–1911
The Dirge of the Three Queens,
probably 1895

Pastel on brown wove paper, mounted on canvas,
29 × 45¼ in.
Signed, dated, and inscribed at lower left: E A Abbey
1895 / Copyrighted by E A Abbey 1895
Gift of Mrs. Edwin A. Abbey, 1918 (18.142)

This pastel illustrates a scene from *Two Noble Kinsmen,* a play written by John Fletcher with the probable collaboration of William Shakespeare. The plot of the play, which was originally published in 1634, is taken from Chaucer's "Knight's Tale" and Boccaccio's *Teseide* and tells the story of Palamon and Arcite, two knights, imprisoned comrades, who fall in love with the same woman. In act I, scene V, the queens retrieve the bodies of their husbands, slain in a struggle against King Creon of Thebes. Leaving the field of battle in a procession, they raise a solemn dirge:

> Urns and odours bring away!
> Vapours, sighs, darken the day!
> Our dole more deadly looks than dying;
> Balms, and gums, and heavy cheers,
> Sacred vials fill'd with tears,
> And clamours through the wild air flying!
> Come, all sad and solemn shows,
> That are quick-eyed pleasure's foes!
> We convent nought else but woes.
> We convent nought else but woes.[1]

Edwin Austin Abbey's interest in this subject perhaps stemmed from an entire career spent illustrating Shakespeare's plays as well as from plans he made in 1894 and 1895 for two series of paintings depicting scenes from Chaucer and Boccaccio. Before taking up the pastel medium in 1894, Abbey worked primarily in black and white as an illustrator for *Harper's Weekly.*[2] Having received a commission to paint murals for the Delivery Room of the Boston Public Library, a project in which he joined John Singer Sargent and Pierre Puvis de Chavannes, Abbey began to experiment with informal color mediums. In pastel he could explore the possibilities of color, while at the same time free his style of the linear precision characteristic of his pen-and-ink illustrations. He soon adopted the practice of executing numerous preparatory sketches in different mediums for both major and minor works, often using pastel and watercolor in studies for his oils, and even making oil studies for his watercolors.

In *The Dirge of the Three Queens* Abbey depicts a dramatically somber moment through the manipulation of color and mass. He contrasts the dark, heavy palls with the brilliant colors of a vivid sunset, which strike the forms from the side in a gaudy play of light. As in his Boston Public Library murals, which depict the Quest for the Holy Grail, Abbey has created a friezelike composition. His pastels, however, are distinguished from his work in oil by their broad, loose style and, ironically, by a quality of painterliness that is lacking in all but his late oils. Abbey's eventual mastery of the painterly demands of mass and color, evidenced in such late oils as *The Play Scene in "Hamlet,"* 1897, and *Goneril and Regan from "King Lear,"* 1902 (both Yale University Art Gallery, New Haven, Conn.), grew out of his use and command of the pastel medium in the 1890s.

In the spring of 1895 Abbey exhibited his first group of pastels in New York, along with some of his canvases for the Boston Public Library commission. So successful was this venture, both critically and financially, that he exhibited another group of pastels in the autumn of the same year in London. *The Dirge of the Three Queens* was probably executed in the summer of 1895 to be included in the London show; it was displayed again in a second New York exhibition of pastels, held in the spring of 1896.

Abbey continued to use pastel and chalk throughout his career, notably in his studies for the final paintings in the Grail series and in sketches for the decoration of the Pennsylvania State Capitol at Harrisburg. He is credited with stirring up interest in the medium of pastel in England, where he became a member of the Pastel Society, founded in 1898.

M.L.S.

NOTES:

1. John Fletcher and William Shakespeare, *Two Noble Kinsmen,* ed. William J. Rolfe (New York, 1890), p. 65.

2. Lucas 1921, II, p. 273.

REFERENCES: C. Monkhouse, *Academy* 48 (Nov. 1895), p. 370 // A. L. Baldry, *Magazine of Art* 19 (1896), ill. p. 227 // C. Scribner, letters to B. Burroughs, Jan. 17 and 22, 1919, MMA Archives.

EXHIBITED: Fine Art Society, London, 1895, no. 33, as The Two Noble Kinsmen // Avery Galleries, New York, 1896, *Watercolors by the Artist Edwin A. Abbey, A.R.A.,* no. 24, as Scene from "The Two Noble Kinsmen."

EX COLL.: wife of the artist, Mary Mead Abbey, London

THOMAS W. DEWING
1851–1938
The Evening Dress, before 1926

Pastel on brown wove paper, mounted on cardboard,
14½ × 11 in.
Signed and numbered at lower right: TW Dewing / 117
George A. Hearn Fund, 1966 (66.157)

Idealized representations of the American woman
were common during the late nineteenth century.
Thomas W. Dewing's favorite subjects—elegant,
slender women with small heads and delicate fea-
tures—were nevertheless unique. His work has in-
spired a variety of interpretations, many of them
highly lyrical, from numerous critics and art
historians.

Born in Boston, Dewing first worked as a
lithographer and portraitist, and from 1876 to 1879
he studied under Jules Lefebvre at the Académie
Julian in Paris. On his return to America, he stayed
briefly in Newton, Massachusetts, and then settled in
New York, where he remained for the rest of his
career.

While Dewing's early work has been compared
to that of many artists and attributed to several
influences, among them the aestheticism of Albert
Moore, he soon developed a style and technical
idiom of his own.[1] He commanded a variety of
mediums: in his early work he used oil and water-
color; he also decorated walls and screens, and
executed fine silverpoint portraits. He did not use
pastel until 1892,[2] but it soon became his favorite
medium, and he eventually abandoned oil painting,
devoting himself almost entirely to pastel after 1919.
A group of his pastels, all of exquisite women
standing or sitting, playing instruments or simply
doing nothing, was exhibited at the Corcoran Gallery
of Art in 1923.[3]

The Evening Dress is representative of Dewing's
pastels. It is remarkable for the gracefulness of its
design, the restraint of its color scheme, and the
austerity of its composition. This work makes it clear
that Dewing did not adopt the medium because of
the possibilities it offered for rapid execution. Every
part of the pastel is carefully studied and every detail
is meticulously rendered. A balance is achieved not
by symmetry but by the deliberate placement of the
figure and by its relationship to the empty back-
ground. The arrangement of the sitter's face, shoul-
ders, and waist produces an effect of momentary
repose rather than of immobility. Each part comple-
ments the others, great attention is given to propor-

tions, and nothing is accidental. Dewing once said:
"The whole figure must be considered in everything
you draw. If you think the nose is too short you may
find that it is the elbow which is too long."[4]

He took the same care in his application of
color. With a limited range of hard pastels all related
in color to his sheet of brown paper, Dewing created
a harmony of modulated colors. There is never a
loud note; "a flush of rose to him means as much as
crimson to another."[5] He makes use of the blank
areas of colored paper to represent the hair, fore-
head, and nose; with careful modulation of white,
gray, blue, and yellow, he controls how much light
and shade each part receives. The rest of the face is
meticulously executed in white and yellow dots,
which suggest a light-filled shadow. Short strokes of
gray, yellow, and white give radiance to the arms and
shoulders. The dress, filled with color that has been
spread with a stump for a softer, freer, blended
effect, is highlighted in white. The whole image is an
arrangement of forms that fade into the background
and reappear as the light changes.

The Evening Dress is not dated, though we know
that it was delivered to Dewing's dealer, William
Macbeth, with several other pastels on June 8, 1926.
Dewing assigned his pastels numbers rather than
date them, and the Museum's example is inscribed
117. Unfortunately, it is not clear whether these
numbers indicate a chronology, and since the artist's
drawing style changed little between 1890 and
1930, the exact date of *The Evening Dress* remains
unknown.

J.H.

NOTES:

1. The most complete account of Dewing's training and the
influences on his art is found in Susan Hobbs, "Thomas Wilmer
Dewing: The Early Years, 1851–1885," *American Art Journal* 13
(Spring 1981), pp. 5–35.

2. This information was provided by Susan Hobbs, a visiting
scholar at the National Museum of American Art (formerly the
National Collection of Fine Arts), Smithsonian Institution, Wash-
ington, D.C. Dr. Hobbs is currently preparing a catalogue
raisonné of the work of Dewing. His first known pastel, *Sappho,* is
at the Freer Gallery of Art.

3. Corcoran Gallery of Art, *Special Exhibition in Pastel and Silver
Point by Thomas W. Dewing* (Washington, D.C., 1923). An article
entitled "Pastel Show by Dewing," *New York Tribune,* Apr. 18, 1923
(Kaup Papers, Arch. Am. Art, roll D22, frame 199), states that for
the last five years the artist had worked only in pastel.

4. Quoted in Ezra Tharp, "T. W. Dewing," *Art and Progress* 5
(Mar. 1914), p. 159.

5. Kenyon Cox, "Thomas W. Dewing," typescript, Kaup Papers,
Arch. Am. Art, roll D22, frame 186.

REFERENCES: A. T. Gardner and S. Feld, *MMAB* 26 (Oct. 1967),
p. 48 // P. Magriel, letter [Dec. 1983], Dept. Archives.
EX COLLS.: M. Knoedler & Co., New York; Paul Magriel,
New York; Kennedy Galleries, New York

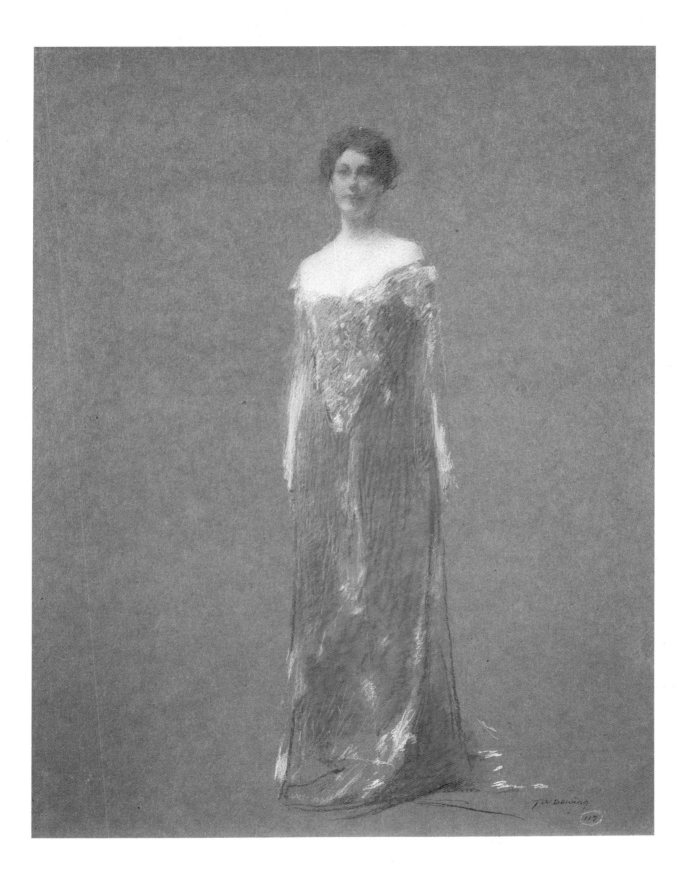

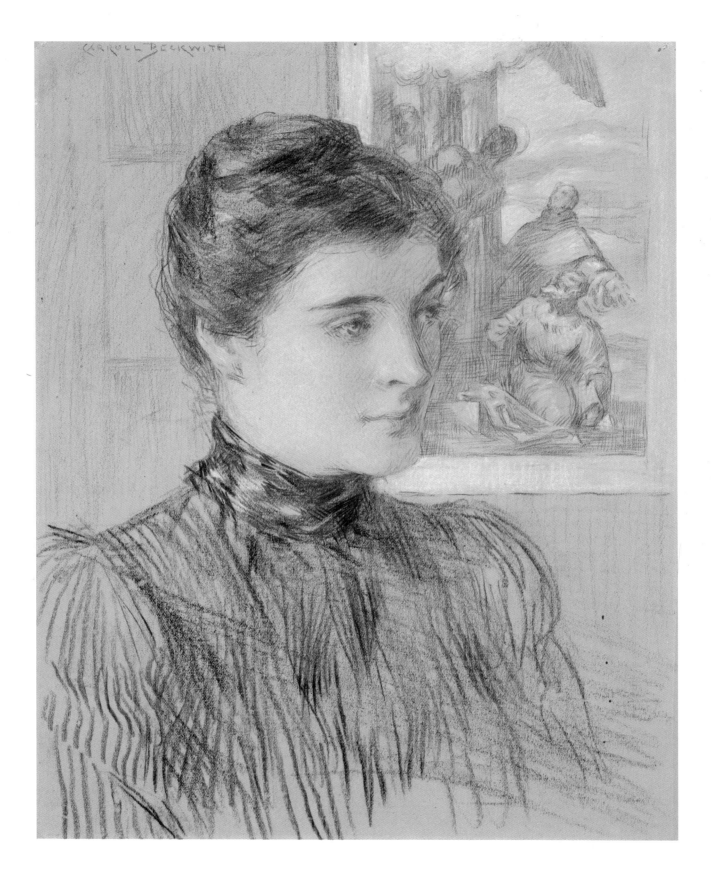

J. CARROLL BECKWITH
1852–1917
The Veronese Print, about 1890

Black chalk and pastel on wove paper (originally blue),
10¾ × 8½ in.
Signed at upper left: CARROLL BECKWITH
Gift of Janos Scholz, 1949 (49.167)

J. Carroll Beckwith was a product of America's
academic tradition. He was not, however, a slave to a
strictly academic approach, for he always tempered
his careful draftsmanship with an easy handling of
the medium, as in *The Veronese Print.* While delicate
cross-hatching is used to describe the sitter's facial
features, her hair and dress are rendered in bold,
quickly worked strokes. This stylistic variety, along
with the combination of mediums—chalk and pas-
tel—gives the work a richness characteristic of both
Beckwith's drawings and his oils. His use of tradi-
tional mediums in this typically self-confident bra-
vura manner allowed Beckwith to transcend his
academic training. This tendency was undoubtedly
encouraged by his education in the atelier of Emile-
Auguste Carolus-Duran, who espoused the practice
of direct painting on the canvas without the custom-
ary numerous preparatory sketches, as well as by his
friendship there with fellow pupil John Singer
Sargent.

While a student during the 1870s, Beckwith
toured Europe, spending much of his time in Italy,
where he studied and copied the old masters. He
was especially taken with the work of the Venetian
painters Jacopo Tintoretto, Giovanni Battista
Tiepolo, and Paolo Veronese. He made numerous
studies and sketches of his favorites, as well as full-
scale copies in oil. The title of this pastel, *The Veronese
Print,* may derive from one of Beckwith's copies after
the Venetian master. Hanging in the background to
the right of the woman's head is a fragment of a
rendition of Veronese's *Madonna in Glory with St.
Sebastian and Other Saints,* which is in the Church of
San Sebastiano in Venice.[1]

Like many of his contemporaries, Beckwith
seemed to ignore the ties that had bound artists for
so long to the "most noble" medium, oil. He
experimented freely with etching and lithography, as
well as with pastel and watercolor; he painted murals
for the World's Columbian Exposition in 1893 and
occasionally contributed illustrations to popular
magazines. He was a tireless organizer, joining with
William Merritt Chase to mount the Bartholdi
Pedestal Fund Art Loan Exhibition in 1883 and helping
to found the Society of Painters in Pastel in 1882. He
contributed works in pastel to each of the society's
four exhibitions.

M.L.S.

NOTE:
1. Illustrated and discussed in Terisio Pignatti, *Veronese,* 2 vols.
(Venice, 1976), I, no. 132, fig. 377; II, pp. 126–27.

REFERENCE: Stebbins 1976, p. 266, ill. p. 268.
EXHIBITED: MMA, 1980, *American Drawings, Watercolors, and
Prints* (not in cat.).
EX COLLS.: J. Carroll Beckwith, until 1917; J. Carroll Beckwith
estate, 1917–18; sale, American Art Galleries, New York, Mar. 20,
1918, no. 21; Ehrich Galleries, New York, 1918; Janos Scholz,
New York

J. Alden Weir
1852–1919

Boats, about 1890

Pastel and graphite pencil on wove paper (originally blue),
8¾ × 14 in.
Signed at lower right: J. Alden Weir
Gift of Mr. and Mrs. Raymond J. Horowitz, 1980
(1980.512.1)

Julian Alden Weir, one of the leading American
Impressionists, was a relatively late convert to that
style. The son and early pupil of Robert W. Weir,
drawing instructor at the United States Military
Academy at West Point, J. Alden Weir attended the
National Academy of Design in New York from 1870
to 1872 and continued his artistic education under
Jean-Léon Gérôme at the Ecole des Beaux-Arts in
Paris from 1873 to 1877. With such a background,
it is little wonder that Weir's first reaction to the
Impressionists was that these artists "do not observe
drawing nor form but give you an impression of
what they call nature."[1] For many years after his
return to America, his work, consisting mainly
of solidly constructed portraits and still lifes
executed in a dark key, remained quite conserva-
tive. It was only after the exhibition of his most
recent paintings in 1891 that an art critic noted
Weir had "gone over to the apostles of plein air
impressionism."[2]

The change in Weir's style might have appeared
sudden and abrupt, but in fact influences were
absorbed gradually and remained unperceived in his
work for a long time.[3] It now appears that Weir
turned toward Impressionism in the late 1880s and
that his experiments in pastel played an important
role in the transformation of his style and subject
matter. He first exhibited his pastels with the Society
of Painters in Pastel in 1888, but it is not clear when
he first began to use the medium, since he had been
mentioned as a member of the society five years
earlier.[4] During the late 1880s, Weir's friend John H.
Twachtman joined him at his Branchville, Connecti-
cut, farm, and they worked together painting and
drawing the countryside.[5] When the works they
produced, including some pastels, were shown to-
gether at Fifth Avenue Art Galleries in 1889, critics
noted that Weir was exhibiting a large number of
landscapes that had "little of the 'grand style.' "[6]
Weir's landscapes seemed closer to "the elder land-
scape school of France" and Twachtman's to those of
the Impressionists.[7] Weir's handling of pastel was
noted to be inferior to Twachtman's and lacking "the
light . . . so necessary in this delicate yet crisp
medium."[8]

Weir's pastel style owes much to Twachtman.
The two artists loved the American countryside and
its less spectacular sites presented in a quiet mood.
From Twachtman, Weir learned the use of blue-
gray paper, a delicate tonal palette, and a preference

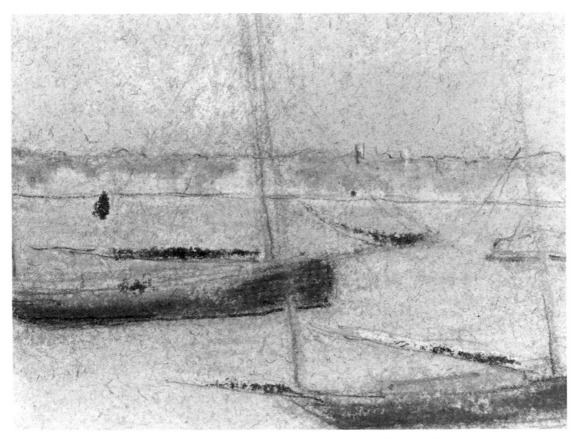

Fig. 31. This detail of *Boats* by J. Alden Weir reveals the delicate graphite-pencil underdrawing that provides a framework for the artist's broader strokes of pastel. The support, which was originally blue, has faded due to the inherently fugitive dyes that were used to color the paper and from overexposure to light.

for applying pastel sparingly rather than imitating the more finished effect of oil. Even Weir's compositions—with empty foregrounds, high horizon lines, and the forms massed in the middle distance—resemble Twachtman's. However, the differences between their pastels are quite significant. Twachtman imbued his pastels with mystery, while more realistic light and color are invariable factors in Weir's treatment of the landscape. Moreover, Twachtman used pastel to render his feeling for nature; his pastels have an evanescent quality and a sense of excitement, with rapidly drawn lines and dissolved forms. Weir, on the other hand, seems to have been fascinated by the momentary effect of a long-familiar scene rather than moved by emotion. In *Boats* the stretches of water in the harbor are rendered in long, continuous strokes of color. Weir's palette consists of a narrow range of values: sea and sky are a large expanse of blue, interrupted by only

the narrow band of the distant shore and the two rocks, all of which reflect the pinkish color of sunrise.

Boats is undated and, like most of Weir's pastels, cannot be dated, as there is no record of its exhibition during his lifetime. The artist often used the medium of pastel experimentally, and because he addressed a different problem in each picture, his work shows a variation in technique rather than a steady stylistic evolution. Seascapes are relatively uncommon in Weir's oeuvre, however, and it seems likely that this pastel belongs to the same period as his etchings of harbor and dock scenes done in Bridgeport, Connecticut, and on the Isle of Man, between 1887 and 1890.[9]

J.H.

NOTES:

1. J. Alden Weir, letter to his parents, Apr. 15, 1877, quoted in Dorothy Weir Young, *The Life and Letters of J. Alden Weir* (New Haven, 1960), p. 123.

2. Review quoted in Brooklyn Museum, *Leaders of American Impressionism*, exhib. cat. by John I. H. Baur (Brooklyn, 1937), p. 12. The exhibition of Weir's work was held at Blakeslee & Co., New York, from Jan. 21 to Feb. 7, 1891 (see Blakeslee & Co., *Catalogue of Recent Paintings by J. Alden Weir*). For magazine reviews of this exhibition see Burke 1983, pp. 285–86, 291.

3. During the 1880s, Weir responded to the influence of a succession of French artists, most important among them Jules Bastien-Lepage and Edouard Manet (see Burke 1983, chap. 3).

4. Pilgrim 1978, p. 59. According to Hale 1957, p. 69, Weir first exhibited with the society in 1889. Weir's earlier membership in the society is documented by only a newspaper article ("Fine Arts," *New York Herald*, Oct. 8, 1883, p. 8).

5. Hale 1957, p. 64; and Frederick Keppel & Co., *Etchings by J. Alden Weir*, exhib. cat. by Caroline Weir Ely (New York, 1927).

6. "Pictures by Messrs. Weir and Tnachtman [*sic*]," *New York Daily Tribune*, Feb. 7, 1889, p. 7. Each artist contributed thirty-two entries to the exhibition: Weir displayed twenty-two oils, eight pastels, and two watercolors; and Twachtman, twenty-two oils and ten pastels (Fifth Avenue Art Galleries, Ortgies & Co., *Paintings in Oil and Pastel by J. Alden Weir, N.A., . . . and John H. Twachtman* [sale, New York, Feb. 9, 1889]). For a comment on Weir's new interest in landscape painting see "Current Art Exhibitions," New York *Sun*, Feb. 4, 1889, p. 4.

7. "Current Art Exhibitions," p. 4.

8. "The Weir-Twachtman Paintings," *New York Times*, Feb. 3, 1889, p. 13.

9. For illustrations of these etchings see Frederick Keppel & Co., *Etchings by J. Alden Weir*; and Margery A. Ryerson, "J. Alden Weir's Etchings," *Art in America* 8 (Aug. 1920), pp. 243–48.

REFERENCE: R. J. Horowitz, letter, Jan. 5, 1984, Dept. Archives.
EX COLLS.: Graham Gallery, New York, early 1960s; Mr. and Mrs. Raymond J. Horowitz, New York, early 1960s

JOHN H. TWACHTMAN
1853–1902
Landscape, about 1890

Pastel on pumice paper (originally blue), mounted on cardboard, 14¾ × 18 in.
Signed at lower right: JHT. Stamped on reverse:
EXPOSITION UNIVERSELLE DE 1855 / MENTION HONORABLE / PAPIER, CARTON. CHASSIS, TOILES / ANTI-PONCE pour le Pastel / P. L. Breveté PARIS / MARQUE DÉPOSÉE
Rogers Fund, 1925 (25.107.2)

John H. Twachtman received his first formal training in Munich, where during the 1870s he studied at the Royal Academy and privately with the American Realist Frank Duveneck. In 1883, dissatisfied with his work, Twachtman returned to Europe for two years, this time drawing at the Académie Julian in Paris. It has been said of Twachtman, a landscape artist from the start, that his subject was "the world in which he lived . . . his impression of it his expression."[1] He devoted his life to a search for the best way to express his deep love of nature and his reaction to its beauty. His sentiments were never better conveyed than in his pastels.

Twachtman probably began to work in pastel as early as 1885, but it was not until 1888, at the second exhibition of the Society of Painters in Pastel, that he showed examples to the public.[2] Thereafter, pastels were featured regularly in exhibitions of his work and continued to receive critical recognition.[3] They played an important role in the evolution of his painting style. The matte surface of his oils, the delicacy with which his paint was applied, and the use of large empty spaces in his compositions may well have originated with such works as *Landscape*.

In his pastels, as in his oil paintings, Twachtman varied his technique to suit the character of his subject and the mood he was trying to achieve. He seems to have been attracted to the ease and spontaneity of the medium, which he employed to capture delicate effects, using line and color sparingly to evoke rather than inform. Twachtman was deeply involved in the struggle to represent the fleeting appearance of the landscape around him. "Ten thousand pictures come and go everyday," Twachtman wrote of nature, as early as 1880, "and those are the only complete pictures painted, pictures that shall never be polluted by paint and canvas."[4] In 1889, at a joint exhibition that included pastels by Twachtman and by his friend J. Alden Weir, the Impressionist character of their work was readily recognized. "These artists are of the modern school—the search for subjects, the taste for historical themes, the care for finish of detail, even the science of academic drawing, are not for them," wrote one critic. "The things they strive for are quality, atmosphere, values."[5]

In *Landscape* color and form are reduced to the essentials, and the simple scene is made significant by the way it is seen and rendered. The undulating hills slowly lead the eye to a clump of trees and, after a pause, into the water, which is barely visible in the distance. The generalized light and the suggestion of a moist atmosphere create soft, almost blurred contours. Working in a limited palette and using the color of the paper, Twachtman suggests the shapes of trees and hills with rapid lines and delicate strokes of pastel.

J.H.

NOTES:
1. Eliot Clark, *John Twachtman* (New York, 1924), p. 16.
2. Hale 1957, p. 259, no. 2.
3. The shows featuring pastels included the following joint exhibitions: with J. Alden Weir at Fifth Avenue Art Galleries, Ortgies & Co., New York, in 1889; with Weir and others at the American Art Association, New York, in 1893; and with his son J. Alden Twachtman at the Cincinnati Art Museum in 1900. Pastels were also included in his one-man show at H. Wunderlich & Co., New York, in 1891.
4. Quoted in Hale 1957, p. 589.
5. "Art Notes," *Art Interchange* 22 (Feb. 1889), p. 49.

REFERENCE: Hale 1957, cat. A, no. 979.
EX COLL.: Frederick Keppel & Co., New York, 1925

ROBERT BLUM
1857–1903
The Cherry Trees, 1891

Pastel on coarsely textured paper (originally blue-gray),
10 × 12½ in.
Stamped at lower right: BLUM [within a square]
Bequest of Susan Vanderpoel Clark, 1967 (67.155.6)

Pastel was the favorite medium of Robert Frederick Blum, an artist who explored many different techniques. Blum began his artistic career as an illustrator, working mainly in pen and ink. His interest in pastel may have emerged during his first trip to Europe, in 1880, when he met James McNeill Whistler. Blum immediately recognized the advantages of the pastel medium: its vivid colors, portability, and painterly quality. When he went to Holland in 1884, Blum, along with his traveling companion William Merritt Chase, used pastels frequently for sketching out-of-doors in the Dutch countryside. The year 1884 also marked the first exhibition of the Society of Painters in Pastel, and Blum joined his fellow society members—Chase, Beckwith, Edwin H. Blashfield, and H. Bolton Jones, among others—by contributing twelve pastels to the inaugural display. Blum showed his work at the two subsequent society exhibitions, in 1888 and 1889, but he was not represented in the group's final show, in 1890. That year Blum traveled to Japan to fulfill a commission from *Scribner's Magazine* to illustrate "Japonica," four articles by Sir Edwin Arnold describing the people and customs of Japan.[1]

Many of Blum's illustrations for "Japonica" and for his own series of articles for *Scribner's* entitled "An Artist in Japan" were reproduced from his pastel originals and demonstrate the extent to which he had mastered the medium. They are quick, broad, and sure-handed. In Japan the artist often made pastel studies out-of-doors, and he described to a friend how passersby would gather to watch the eccentric American at work. It was on such an outing, during the first week of April 1891, that Blum executed *The Cherry Trees*. He chose a sketching site along the Mukojima, a road famous for its yearly display of cherry blossoms, and he settled himself in a spot that afforded a view of flower-laden trees.[2] By overlaying broad diagonal strokes of pastel with random touches of pink, Blum was able to suggest masses of fragile, powdery blossoms and the play of warm April light on the roadway and river. His selection of a blue-gray paper on which to work indicates his intention of allowing the color of the paper to function with the colors of the pastel. The coarsely textured paper has faded somewhat over time, but it still gives a visual impression of the moist spring air along the Mukojima. The stamp with which Blum signed *The Cherry Trees* mimics a Japanese seal, or *jitsuin*, and is seen on many of the artist's works completed during and after his Japanese trip.

Although Blum's works in oil were often criticized, his pastels met with unanimous acclaim. A critic for the *Evening Post* wrote: "Pastel was the medium peculiarly suited to Blum's special gift for seizing elusive, evanescent effects in light and color."[3] Blum's pastels found another admirer in his friend the inimitable Oscar Wilde. Always a master of having the last word on any subject, Wilde is reported to have remarked to his friend, "Blum, your exquisite pastels give me the sensation of eating yellow satin."[4]

M.L.S.

NOTES:

1. Sir Edwin Arnold, "Japonica," *Scribner's Magazine* 8 (Dec. 1890), pp. 663–82; 9 (Jan. 1891), pp. 17–30; (Feb. 1891), pp. 165–76; (Mar. 1891), pp. 321–40. These articles were reprinted in book form as *Japonica* (New York/London, 1891).

2. Bruce Weber, letter to the author, Dec. 7, 1983. I am grateful to Dr. Weber for his assistance in researching *The Cherry Trees*.

3. "Art Notes: Memorial Loan Exhibition of the Work of Robert Blum," New York *Evening Post*, Feb. 15, 1913, p. 7.

4. Quoted in Berlin Photographic Co., *Catalogue of a Memorial Loan Exhibition of the Works of Robert Frederick Blum*, exhib. cat. by Martin Birnbaum (New York, 1913), p. 9.

REFERENCES: B. Weber, letters, Dec. 7 and 27, 1983, Dept. Archives.

EXHIBITED: Berlin Photographic Co., New York, 1913, *Memorial Loan Exhibition of the Works of Robert Frederick Blum*, exhib. cat. by M. Birnbaum, no. 26 // Dept. of Fine Arts, Carnegie Institute, Pittsburgh, 1923, *An Exhibition of Works by Robert Blum*, no. 6.

EX COLLS.: Stephen C. Clark, New York, by 1913 (d. 1960); his wife, Susan Vanderpoel Clark, New York

ARTHUR B. DAVIES
1862–1928
Spring Landscape

Pastel on thin gray laid paper, 7¼ × 10¾ in.
Gift of A. W. Bahr, 1958 (58.21.40)

Arthur B. Davies was a master of many mediums—oil, etching, lithography, watercolor, and pastel—and an advocate for progressive artists who, like him, rebelled against narrow academic strictures. It is not known when Davies took up pastel—the earliest dated works in the Museum's collection are from 1895—nor what prompted his interest in it. Dwight Williams, an upstate New York artist who taught the young Davies, was an accomplished pastelist, and in all likelihood it was through him that Davies was first exposed to the medium. When Davies traveled to Europe in 1893, sponsored by Benjamin Altman, he spent considerable time in Holland. His letters reflect a keen interest in the work of the Maris brothers, Jacob, Matthijs, and Willem, painters of the Hague School who practiced a misty notational drawing style that must have attracted Davies.[1] In his correspondence the artist also mentions viewing eighteenth-century pastels in the Rijksmuseum.[2]

For Davies pastel remained a vehicle for recording immediate observations and for experimentation. As a result, his pastels were rarely exhibited, and as early as 1898 one critic lamented the fact that "they now rest in neglected piles on the floor against the walls of his town studio."[3] There Abel W. Bahr, the donor of fifty-one pastels now in the Museum's

collection, found them years later, having first met Davies in 1911. As Bahr described his visit to Davies's studio: "I saw a pile of tempting looking artist impromptu drawings and sketches which I went through thoroughly and selected what I liked. When he . . . saw what I had discovered he remarked that he had not seen them for many years. I asked if I could acquire the group I selected; whereupon, he offered them to me as a gift."[4]

Although undated, *Spring Landscape* was probably executed in the final years of the nineteenth century. It is reminiscent of the pastels and watercolors of the Maris brothers in its vignettelike arrangement on the paper and in the ephemeral, ambiguous quality of the pastel itself. John H. Twachtman (p. 71) was also influenced by the pastels of these Dutch artists. *Spring Landscape* resembles Twachtman's work in its delicacy; the pastel seems to float on the surface. The laid lines of the fine paper cradle the particles of azure, green, and lavender pastel, giving this work vibrancy and depth. *Spring Landscape* is an example of a "touch on paper as delicate as melting light," as one critic characterized Davies's pastels of this period.[5]

E.W.

NOTES:

1. Brooks Wright, *The Artist and the Unicorn: The Lives of Arthur B. Davies (1862–1928)* (New City, N.Y., 1978), pp. 28–29.
2. Ibid., p. 29.
3. "Arthur B. Davies," *Art Collector* 9 (Dec. 1898), p. 54.
4. Abel W. Bahr, letter, Aug. 23, 1957, MMA Archives.
5. "Arthur B. Davies," p. 54.

EX COLL.: Abel W. Bahr, Ridgefield, Conn., after 1911

ARTHUR B. DAVIES
High Point

Pastel on dark gray wove paper, mounted on cardboard,
7⅜ × 13 in.
Gift of A. W. Bahr, 1958 (58.21.63)

Called a mystic, a poet, a Symbolist, a primitive, a
Realist, and a modern Piero di Cosimo, Arthur B.
Davies defied categorization even during his lifetime.
In *High Point* Davies hearkens back to some of the
mystery of Albert Pinkham Ryder, whom Davies
admired very much and actually met in 1901. The
casual but forceful use of pastel in this work testifies
to Davies's mastery of the medium and his desire to
push beyond the mere recording of facts into a more
romantic realm. This move away from empirical
reality was commented upon by Sadakichi
Hartmann, who wrote that Davies, "like Alden Weir,
suffers from experimentation fever" and criticized
the "applause bestowed on trifles to-day." He went on
to prophesy that

if art continues in this weird fashion . . . it will
soon be reduced to slips of differently coloured
paper, with a few disconnected, partly visible
figures, sometimes with only certain parts of the
body, like a knee or nose, appearing on the
edge, or even merely with a few lines and dots
and some cross-hatching, that have some hidden
symbolical meaning which one has to guess at
from the shape and tone of the paper, the
colour and the suggestiveness of the drawing.[1]

Fanciful in conception and executed with skillful
ease, *High Point* possesses just enough tangible reality
to inject the work with mystery. The manner in
which the artist has created spatial depth with a
distant, faintly delineated horizon demonstrates
Davies's technical prowess.

E.W.

NOTE:
1. Sadakichi Hartmann, *A History of American Art*, 2 vols. (Boston,
1901), II, pp. 267–68, 278–80.

EX COLL.: Abel W. Bahr, Ridgefield, Conn., after 1911

ARTHUR B. DAVIES
Through the Poplars

Pastel on blue Japanese paper, 7½ × 11 in.
Gift of A. W. Bahr, 1958 (58.21.44)

The stylistic range of the Museum's collection of pastels by Arthur B. Davies is evidence of the artist's eclectic nature and of his accomplishment as a technician. In *Through the Poplars* the blue paper reserve has been used ingeniously to create a strangely still waterway, which the artist has contrasted with solid painterly effects, seen in the heavily colored sky and in the outcropping on the left. The delicate sketchiness here recalls the imaginative pastels of Odilon Redon, a prolific French pastelist who was represented by more than seventy paintings, drawings, and prints in the Armory Show of 1913, which Davies organized. Redon exerted considerable influence on the Symbolists of the 1890s, and until his death in 1916, he was admired by the younger avant-garde. Contemporary critics linked Davies to Redon, Pierre Puvis de Chavannes, and other Symbolists. The American modernist Marsden Hartley wrote: "In the work of Davies, and of Redon, there is the splendid silence of a world created by themselves, a world for the reflection of self."[1]

E.W.

NOTE:
1. Marsden Hartley, "The Poetry of Arthur B. Davies' Art," *Touchstone* 6 (Feb. 1920), p. 283.

EX COLL.: Abel W. Bahr, Ridgefield, Conn., after 1911

ARTHUR B. DAVIES
Mysterious Barges II

Pastel on buff wove paper, 5½ × 8¾ in.
Gift of A. W. Bahr, 1958 (58.21.52)

Substantially different from the light touch seen in many of Arthur B. Davies's other pastels is the painterly use of the medium in *Mysterious Barges II*. Here pastel covers the paper more completely than is his usual practice. The artist has used minute flecks of green and blue pastel beneath the surface to enliven the overall golden glow, and he has conveyed the shadowy effects of night by blending the pastel at the edges of the forms to blur them. One cannot overlook the influence of James McNeill Whistler's nocturnes. The eclectic Davies must have seen Whistler's work, not only in exhibitions but also in publications. Although Davies may have taken a cue from Whistler in his conception of *Mysterious Barges II*, the final result is entirely characteristic of Davies's work. In commenting on a similar nocturne, the critic James Huneker wrote: "It is not a set landscape, but an interpretation of a mood, the fusing of Davies's nocturnal vision and the actual forms and facts of the vicinity."[1] *Mysterious Barges II*, which is difficult to date, is a testament to the versatile and wide-ranging talent of the artist.

E.W.

NOTE:
1. James Huneker, *The Pathos of Distance* (New York, 1913), p. 118.

EX COLL.: Abel W. Bahr, Ridgefield, Conn., after 1911

ARTHUR B. DAVIES
Meadow Weeds, 1908

Pastel on light blue Japanese paper, 6⅛ × 11¼ in.
Dated at lower right: Nov. 1ˢᵗ 1908
Gift of A. W. Bahr, 1958 (58.21.47)

In this dated pastel of 1908, Arthur B. Davies used the same vigorous strokes in the plant forms that he used in paintings of the same period. It is possible that *Meadow Weeds* was executed as a kind of preliminary to a final work; pastel was used as a study medium for experimenting with color and quick application. Almost Oriental in feeling, *Meadow Weeds* has a simplicity and a vibrancy that characterize the best of Davies's pastels. Abel W. Bahr, who acquired this and many other pastels directly from the artist, wrote: "I felt the genius of the man which I considered the greatest romantic artist of American [*sic*] as well as the inexplicable touch of the Chinese vein in some of his examples of landscaping; and that had been long before he had seen any of the Chinese style of landscaping."[1]

Even during Davies's lifetime his art was judged to be esoteric and overly introspective, but critics did acknowledge his sound draftsmanship. Although he rarely exhibited his landscape pastels, a few of his contemporaries were aware of their existence and recognized their beauty. "The painter's landscape studies in pastel are less well known," commented the writer Edward W. Root. "They deserve, neverthe-less . . . the same consideration that has been given his other work. Their spontaneity, their brevity, the spring-like lyrical intensity of their color, their independence of formula—all combine to render them as engaging as one of Shakespeare's songs. And where else, unless in some of the ancient paintings of Japan, will one find such delicate notations of the rhythmical peculiarities of trees?"[2]

E.W.

NOTES:
1. Abel W. Bahr, letter, Aug. 23, 1957, MMA Archives.
2. Edward W. Root, "An Appreciation," in *Davies Essays* 1924, p. 64.

EX COLL.: Abel W. Bahr, Ridgefield, Conn., after 1911

ARTHUR B. DAVIES
Nude Studies, before 1909

Pastel and black chalk on dark tan Japan paper, toned with
a persimmon-juice wash, 16½ × 12 in.
Signed at lower left: ABD
Anonymous Gift, 1909 (09.90.1)

The female nude was central to Arthur B. Davies's
visionary imagery in every medium. Drawn before
1909, *Nude Studies* is an example of Davies's fascina-
tion with the human form and its expressiveness.
Unlike his landscape pastels, which were executed in
an experimental vein and were rarely exhibited,
nude studies of this kind were slightly more deliber-
ate and formal in presentation. They were exhibited
periodically at New York Water Color Club annuals
and were included in shows of Davies's work at
Macbeth Gallery. In this pastel we see Davies as a
consummate draftsman. The modeling of the fig-
ures, shaped softly and knowingly, contrasts sharply
with bold, black contours to create a surface tension
in which the placement of the figures interacts with
the resulting negative space. The artist's sure hand in
drawing was described by the critic Royal Cortissoz:

> There are some strong steadying influences at
> work in his cosmos . . . his knowledge of form
> and respect for its truths, his sound habit as a
> draftsman—in a word, his instinctive feeling for
> the fundamental laws of nature and art. Above
> all, the thing that saved him from drifting about
> in a sea of theory was his interest in life, his
> ardor for humanity, the very world from which
> he departs on sublime adventures.[1]

Davies toned this sheet with persimmon juice, a
technique used by Japanese screen makers. Prior to
its acquisition, the drawing was matted, and the color
of the area that has been exposed to light has
changed.

<div align="right">E.W.</div>

NOTE:
 1. Royal Cortissoz, *American Artists* (New York, 1913), pp. 104–5.

EX COLL.: private collection

A LA TRÈS CHÈRE — A LA TRÈS BELLE — QUI REMPLIT MON CŒUR DE CLARTÉ . . A JUVINS ETC

KENNETH FRAZIER
1867–1949

Woman Asleep on a Pillow

Pastel and charcoal on brown-gray wove paper (reverse: *Woman in Red*, pastel), 9½ × 14½ in.
Inscribed at bottom: A LA TRES CHERE—A LA TRÈS BELLE—QUI REMPLIT MON COEUR de clarté · · A JUVINS ETC.
Stamped on reverse: THE ESTATE OF KENNETH FRAZIER
Gift of Mrs. Leonard Spencer Karp, in memory of her husband, 1981 (1981.200)

Kenneth Frazier's training and early career were typical for an American artist of the late nineteenth century. He studied art in Europe, at the Herkomer Art School in England from 1887 to 1889 and then at the Académie Julian in Paris from 1889 to 1893. Frazier, who was to become a prominent portrait painter, then settled in New York, where he made illustrations for books and magazines and worked in a variety of mediums—oil, pastel, watercolor, and charcoal. His 1897 and 1899 pastel exhibitions established him as a leader in the medium, but oil portraits were still considered his best work.[1]

Frazier used pastel during his student days in Paris, where he produced several studies of friends and fellow artists. The flexibility in his approach to various subjects and his handling of the medium indicate that in these early works he was experimenting with pastel and searching for a personal style. "The impressionists," he wrote, "had seized the imagination of the art students and as a consequence, we tried to see color in everything."[2]

In style and subject matter *Woman Asleep on a Pillow* is characteristic of this phase of Frazier's career. Like the majority of his pastels, it is executed on brown-gray paper in a size favored by the artist, and, typically, it is also unsigned and undated.[3] Here the pastel decorates the whole surface in a variety of ways. Black pastel was applied heavily to give texture to the fine paper, and then green, purple, and black were either stumped or rubbed to create the desired effect. White pastel rather than the color of the paper below was used to achieve highlights, as on the face. Frazier's choice of a dark-toned paper and his limited palette of muted colors suggest that he was influenced by James McNeill Whistler, a friend who visited him often in his Paris studio and encouraged him in his work.

Woman Asleep on a Pillow depicts a model who appears in several of the artist's early works and who has been tentatively identified as his mistress. She figures prominently in *Memories of the 90's* (location unknown), a painting in which Frazier grouped the most important friends he had made in Paris.[4]

J. H.

NOTES:

1. "Frazier, K.: Pastel Sketches Exhibited," *New York Times*, Dec. 18, 1897, p. 12; and "Frazier Portraits Exhibited at Wunderlich Gallery," *New York Times*, Apr. 22, 1899, p. 272.

2. Quoted in Westmoreland 1979, p. xi.

3. Paul Chew (ibid., p. 6) states that the date *96* appears at the end of the inscription. It does not appear, however, on close examination.

4. Oscar Wilde, Paul Verlaine, Charles Conder, William Rothenstein, Toulouse-Lautrec, and Whistler are all represented in this oil painting (ibid., pl. 33).

REFERENCE: B. Karp, letter, May 17, 1984, Dept. Archives.

EXHIBITED: Westmoreland County Museum of Art, Greensburg, Pa.; Far Gallery, New York; Southern Alleghenies Museum of Art, Loretto, Pa., 1979–80, *Kenneth Frazier, A.N.A., 1867–1949*, exhib. cat. by P. A. Chew, no. 95, pl. 7.

EX COLLS.: Kenneth Frazier estate; Mr. and Mrs. Leonard Spencer Karp, Garrison, N.Y.

HELEN MOSER
GORDON

NOVEMBER
MDCCCXCVI

Bryson Burroughs

BRYSON BURROUGHS
1869–1934

Mrs. Helen Moser Gordon, 1896

Pastel, and gold and lead-white paint on off-white wove paper, 19⅞ × 15½ in.
Signed at lower right: Bryson Burroughs. Inscribed at center left: HELEN MOSER / GORDON; at center right: NOVEMBER / MDCCCXCVI
Gift of Atherton Curtis, 1936 (36.38.1)

Bryson Burroughs trained under Kenyon Cox and H. Siddons Mowbray at the Art Students League in New York and with Luc-Olivier Merson and William-Adolphe Bouguereau at the Académie Julian in Paris. His early work, of which this portrait is a rare example, is characterized by precise draftsmanship. Burroughs's five years in Europe, made possible by a scholarship from the League, enabled him to travel in Italy, where he fell under the spell of fifteenth-century Florentine painting.

The portrait of Helen Moser Gordon was made the year after he returned from Europe. The influence of such masters as Domenico Ghirlandaio and Piero della Francesca is clearly evident in the pose of the figure, who sits in profile before a landscape, in the manner of Italian Renaissance portrait subjects. The motif of the portrait in profile, originally derived from antique medals, enjoyed a vogue in America near the turn of the century, when it was taken up by artists such as John White Alexander, Frank Benson, Dennis Miller Bunker, and, of course, the expatriate James McNeill Whistler.

Burroughs taught at the Art Students League after returning to New York in 1895, and in 1906 he joined the curatorial staff of The Metropolitan Museum of Art. Soon thereafter he abandoned his early drawing and painting style, which owes something to the Pre-Raphaelites as well as to the Italians, in favor of a style that has affinities with that of Pierre Puvis de Chavannes. He destroyed most of his early work, but his continuing love of the Italian Renaissance is reflected in the classical themes that dominate his late work as well as in his interest in the neglected practice of fresco painting.

In the portrait of Mrs. Gordon, as in all of Burroughs's work, there exists an odd combination of archaism and contemporary reality. An early Renaissance primitivism is suggested by the fragmentary view of the Italianate landscape, the horizontal bands of decorative molding, the carved inscription, and the carefully drawn contour of the sitter's profile, all of which serve to flatten the composition into a shallow space similar to that of bas-relief. Although these features, together with the model's Renaissance Revival gown and her transfixed gaze, were inspired by cinquecento portraits, the sitter is unmistakably modern, down to the gold-painted hairpins that secure the rose to her coiffure.

Burroughs's use of the pastel medium, like that of J. Carroll Beckwith, is very subtle. Only close examination reveals the multitude of colors, highlighted here and there by gold paint, that achieve the muted effect. Because so much of his early work was destroyed, we do not know whether pastel was an important medium in the formation of Burroughs's style or not, but it is clear that he used it to great advantage in the portrait of Helen Moser Gordon.

M.L.S.

REFERENCES: A. Curtis, letter, 1936, MMA Archives // J.L.A., *MMAB* 31 (July 1936), p. 149.
EX COLL.: Atherton Curtis, Paris

WILLIAM GLACKENS
1870–1938
Shop Girls, before 1901

Pastel and watercolor on illustration board, 13⅞ × 15⅛ in.
Signed at lower left: W. Glackens. Inscribed on reverse:
W. Glackens 13 W 30th St New York. / The. Shop Girls. a
sketch. / Price. $30. Stamped on reverse: WINSOR &
NEWTON'S / ILLUSTRATION BOARD. / LONDON & NEW YORK.
Gift of A. E. Gallatin, 1923 (23.230.1)

In 1896, after spending fifteen months in Europe,
most of them in Paris, William Glackens returned to
his native Philadelphia. Inspired but unemployed,
Glackens soon moved to New York and continued
his previous career as a newspaper artist, joining the
staffs of the *New York World* and the *New York Herald*.
Since his days with the *Philadelphia Press*, Glackens
had been recognized for his reportorial skills and his
nearly faultless memory. His forte was the depiction
of crowd scenes, and he was especially adept at
suggesting movement. Glackens's style in his illustra-
tions was informed by the work of his French
contemporaries, whose illustrations he had seen in
the United States and in Paris. Glackens's friend
John Sloan noted of the artist's formative years: "We
began to find the work of contemporary men in
imported books illustrated by Steinlen, Forain,
Toulouse-Lautrec and collections of original prints
by Goya and Daumier. . . . Steinlen was very impor-
tant to Glackens' development as a draughtsman."[1]

In New York, Glackens's talent was quickly
recognized, and by August 1897 he was illustrating
for such major publications as *McClure's*, *Putnam's*,
and *Scribner's*. In addition to providing Glackens with
a larger format than a newspaper, the illustrated
magazines also allowed him more freedom in the
execution of the work. The Ives process, a relatively
new photographic technique for reproducing half-
tones, had only recently been adapted for use by the
magazines. This process afforded greater tonal
range in reproductions and allowed artists to use a
wider variety of mediums. Everett Shinn described
his good friend Glackens's technique:

> For his tonal work he used wash and tempera,
> charcoal and carbon pencil, and, sometimes,
> mixed methods in which all of these appear in
> one drawing. Red chalk, which he discovered in
> Paris, was another favorite medium. . . . Straight
> graphite pencil was not a sympathetic medium
> for him, as he much preferred the rich blacks of
> the carbon pencil or the elastic range of good
> charcoal. Watercolor and pastel were used to
> accent his drawings, to give sparkle to some of
> his illustrations marked for black and white
> reproduction. The color instinct of the painter
> was constantly asserting itself.[2]

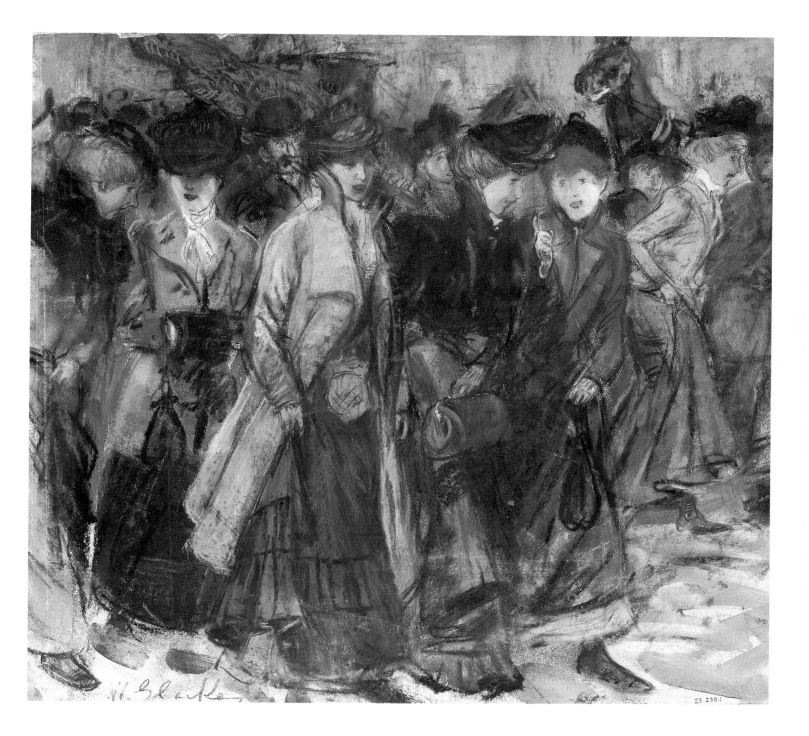

Figs. 32 and 33. The vigor of the artist's
working method is suggested in these de-
tails of *Shop Girls* by William Glackens. He
has defined broad masses of color with
outlines of black pastel and created a sense
of movement with rapid watercolor brush-
work and light scratches into the surface.

Whether actually intended for reproduction or not, *Shop Girls* is a perfect example of Glackens's technique as described by Shinn. Glackens has effectively combined pastel with watercolor, using a palette of perhaps eight colors. The suggestion of movement expressed by the thick, energetic black line is the primary force behind *Shop Girls*. Color, usually pastel's most alluring property, is used only minimally to add "sparkle." Glackens had a talent for skillfully integrating individualized figures. The man with the Christmas tree and the rushing woman holding her skirts at the right are meshed with the central figures into a rhythmic, surging mass, suggesting dense urban bustle.

Shop Girls has been dated between 1906 and 1908 because of an assumed connection with *Shoppers* (Chrysler Museum, Norfolk, Va.), an oil painting of 1909.[3] However, the pastel is not related stylistically or thematically to the oil: *Shoppers* shows the interior of a dress shop peopled with fashionable bourgeois women, while *Shop Girls* pictures working-class women. Moreover, since the pastel *Shop Girls* was exhibited in 1901, it actually predates the Chrysler painting by several years.

The animated women of *Shop Girls* correspond more closely to the figures in Théophile-Alexandre Steinlen's *Les Midinettes*,[4] and Glackens was clearly inspired by Steinlen's treatment of the same subject. *Shop Girls* belongs to a group of similar drawings executed while Glackens was under the spell of Steinlen in the first few years of this century.[5] Around 1905, the year he painted *Chez Mouquin* (Art Institute of Chicago), color became increasingly important to Glackens, and pastels played a new role in his work. Having backed away from illustration, Glackens was now free to paint what he liked, and he often used pastel in making color studies.

E.W.

NOTES:

1. Quoted in Richard Wattenmaker, "The Art of William Glackens" (Ph.D. diss., Institute of Fine Arts, New York University, 1970), p. 31.

2. Everett Shinn, "William Glackens as an Illustrator," *American Artist* 9 (Nov. 1945), pp. 36–37.

3. Wattenmaker, "Glackens," p. 142.

4. See, for example, Palais des Beaux-Arts, *Rétrospective Théophile-Alexandre Steinlen*, exhib. cat. by Robert Rousseau and Michel Thévoz (Charleroi, 1970), nos. 1, *Les Midinettes*, and 110, *Trois Midinettes*; see also Francis Jourdain, *Un Grand Imagier: Alexandre Steinlen* (Paris, 1950), no. 42, *Midi*.

5. See, for example, *Seated Woman*, c. 1902 (fig. 17).

REFERENCES: *Boston Advertiser*, Mar. 8, 1901, p. 4 // A. E. Gallatin, *Certain Contemporaries: A Set of Notes in Art Criticism* (1916), ill. p. 10 // R. Wattenmaker, "The Art of William Glackens" (Ph.D. diss., Institute of Fine Arts, New York University, 1970), ill. no. 120.

EXHIBITED: Boston Art Club, 1901, *Water Color Club: Fourteenth Annual Exhibition*, no. 19 // Bourgeois Galleries, New York, 1918, *Collection of A. E. Gallatin: Modern Paintings and Drawings, for the Benefit of the War Relief*, no. 22.

EX COLL.: A. E. Gallatin, New York, by 1918

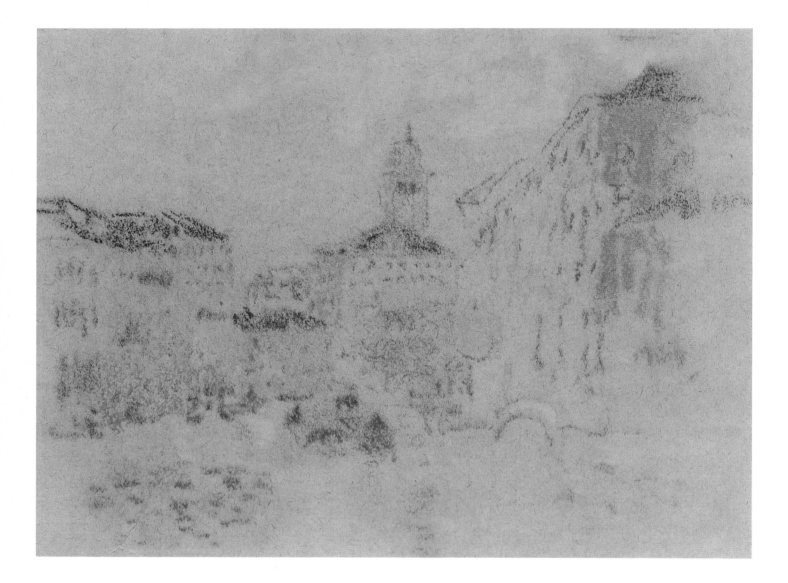

JOHN MARIN
1870–1953
Venice, 1907

Pastel on wove paper (originally blue-gray), 10 × 12 in.
Bequest of Alexandrine Sinsheimer, 1958 (59.23.86)

John Marin's stint as a pastelist, from about 1905 to 1909, represents a brief interlude in his career. During this period, which immediately preceded his increased activity as a watercolor painter and his recognition as an artist, Marin regarded himself primarily as a commercial etcher.[1] Not unexpectedly, there are close relationships between his etchings and his pastels. In Venice, in 1907, Marin executed twenty etchings and a number of pastels of similar subjects. The composition of *Venice* resembles that of his etched canal scene *Santa Maria della Salute*, 1907 (fig. 34),[2] and, in a general sense, the two works share a graphic emphasis on tone, a nervous, roving line, and the extensive use of the reserve of the paper. The etchings, most likely designed as souvenirs for a flourishing American market, are generally topographical, while the pastels, like *Venice*, were probably produced for Marin's own pleasure and as a means of experimentation.[3]

Marin may have been introduced to pastel through his studies with Thomas P. Anshutz at the Pennsylvania Academy of the Fine Arts from 1899 to 1901. At the Academy, Marin also came into contact with the work and ideas of William Merritt Chase, an accomplished pastelist who taught there. Even during these early years Marin was an admirer of James McNeill Whistler, whose influence is evident in the group of pastels Marin made in Venice.[4] Marin was clearly impressed by Whistler's quaint streets and canals imbued with light, atmosphere, and movement. Like Whistler, Marin used sketchy color notations on tinted paper to capture an immediate, vibrant impression of the scene rather than concentrate on detail or form. In 1909 Marin made the following Whistler-like observation, which could be applied to his Venetian pastels as well as his etchings: "One might call an etching a written impression of tone, more or less in the spirit of a veil to soften, as does nature's veil soften, her harshness of line."[5]

Indeed, the pastels of 1907 were listed as *Venice-Impressions* in the brochure for Marin's first one-man show, held at "291" in 1910, which received positive reviews. Elizabeth Luther Cary, art critic for the *New York Times*, wrote that Marin had "achieved a conspicuous success," which she ascribed to "the underlying tone of the . . . paper holding together the scattered notes of color as white paper never does."[6] The support of the Museum's pastel was originally blue-gray, but photo-oxidation has turned it brown.[7]

By 1909 Marin's production of watercolors in-

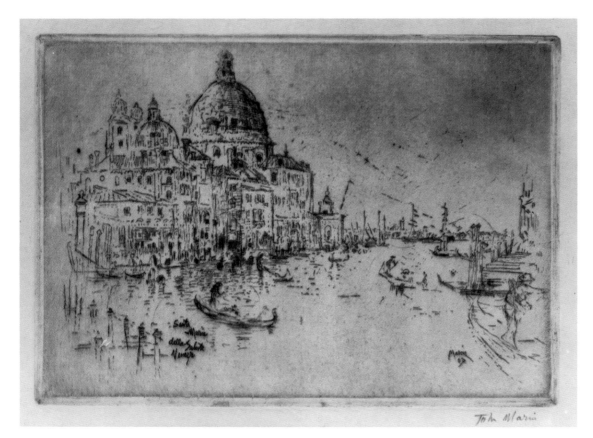

Fig. 34. John Marin, *Santa Maria della Salute*, 1907, etching, 5¹⁄₁₆ × 7¹⁄₁₆ in. (plate), The Metropolitan Museum of Art, New York, Alfred Stieglitz Collection, 1949

creased, and he began to regard himself as a painter rather than a commercial etcher. However, his use of pastel declined around this time, and his works in the medium were seldom included in exhibitions after 1910.[8] In a letter of April 4, 1935, Alfred Stieglitz asserted that "Marin hates the pastel medium although he did a few pastels in 1908 and '09."[9]

Marin continued to use pastel as a drawing medium, but his style changed radically. For example, *Taos Mountain*, of 1929 (Mr. and Mrs. Harry Pearlman), is an abstracted, lyrical, and dynamic interpretation of nature, which reflects the influences of Futurism, Cubism, and Orphism.[10] In Marin's increasingly abstract pastels and watercolors, he strove to express emotions rather than simply capture impressions.

G.S.

NOTES:

1. Homer 1977, p. 91.

2. Philadelphia Museum of Art, *The Complete Etchings of John Marin*, exhib. cat. by Carl Zigrosser (Philadelphia, 1969), no. 53.

3. Utah 1969, p. 11; and Homer 1977, p. 91.

4. Reich 1970, I, pp. 17–22.

5. Quoted in Philadelphia 1969, p. 1. For information concerning Whistler's influence see catalogue entry by Linda Ferber in Wildenstein & Co. (organized by the Department of Art History and Archaeology, Columbia University) and Philadelphia Museum of Art, *From Realism to Symbolism: Whistler and His World*, exhib. cat. by Theodore Reff and Allen Staley (New York/Philadelphia, 1971), pp. 99–100; and Allen Memorial Art Museum, *The Stamp of Whistler*, exhib. cat. by Robert H. Getscher and Allen Staley (Oberlin, Ohio, 1977), pp. 254–58.

6. [Elizabeth Luther Cary], "News and Notes of the Art World," *New York Times*, Feb. 13, 1910, p. 14.

7. The Museum's pastel was examined by Marjorie Shelley, Paper Conservation, MMA, Dec. 2, 1983. Another Venetian pastel of 1907 (New York art market, 1983), which was also executed on blue-gray paper, has not been damaged by light and thus suggests

the appearance of the Museum's pastel when it was first executed (see Philadelphia 1969, no. 4).

8. Marin did not show any pastels when he exhibited in the Salons d'Automne of 1907, 1908, and 1909. A comprehensive show at Weyhe Gallery, New York, in 1921 entitled *Etchings by John Marin* did include a few unidentified pastels of 1909 (nos. 32–37); see New York Public Library Prints Division Papers, Arch. Am. Art, microfilm N100A, frames 120–22. Pastels were conspicuously absent from his important MOMA retrospective in 1936.

9. Alfred Stieglitz, letter to Edith Halpert, Downtown Gallery, New York, Downtown Gallery Papers, Arch. Am. Art, microfilm 1342, frame 75.

10. This pastel is reproduced in Utah 1969, no. 47, p. 67. Reich mentions that many of Marin's late drawings are in color and that "one of the most striking features of his pictures in the forties and early fifties is the quality of synthesis minimizing distinctions between media" (ibid., pp. 17–18). It is therefore possible that some of the drawings illustrated in Marin's portfolio *John Marin Drawings and Watercolors* (New York, 1950) are in fact pastels (mediums are not specified).

REFERENCE: Reich 1970, I, ill. p. 17.

EXHIBITED: Little Galleries ("291") of the Photo-Secession, New York, 1910, *Exhibition of Water-Colors, Pastels and Etchings by John Marin,* one of twenty pastels identified only as nos. 44 to 64, Venice-Impressions.

EX COLL.: Alexandrine Sinsheimer, New York

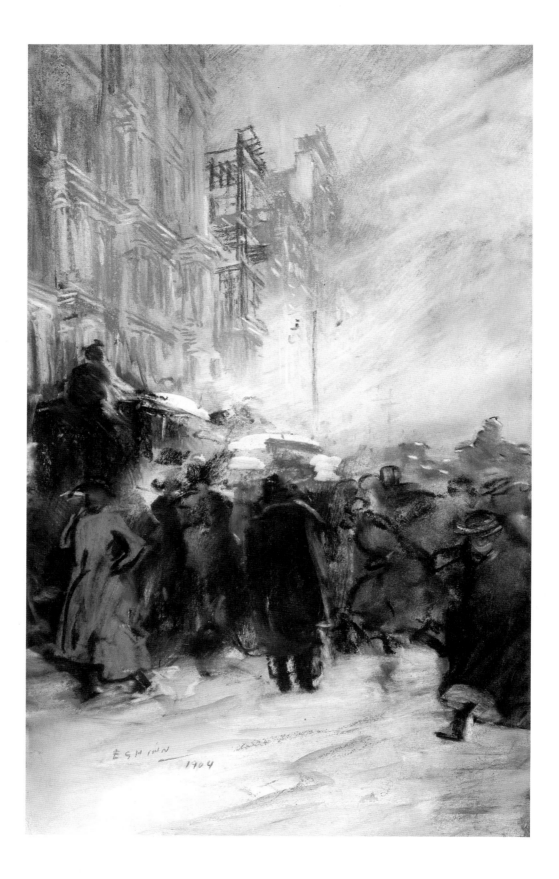

EVERETT SHINN
1876–1953

Matinee Crowd, Broadway, New York, 1904

Pastel and gouache on illustration board, 18⅛ × 11½ in.
Signed and dated at lower left: E Shinn / 1904
Gift of A. E. Gallatin, 1923 (23.230.5)

Born in Woodstown, New Jersey, Everett Shinn worked as a newspaper artist while attending the Pennsylvania Academy of the Fine Arts, where one of his teachers was Thomas P. Anshutz. In 1897 he moved to New York and continued his work for newspapers, making quick, on-the-spot sketches of newsworthy events. Fascinated by New York, Shinn took the life of the city and the theater as subjects for both his newspaper work and the illustrations he had begun to do for such magazines as *Truth* and *Ainslee's*. In 1899, the year Shinn became art editor for *Ainslee's Magazine*, he held a one-man exhibition at the Pennsylvania Academy that consisted entirely of pastels—forty-eight landscape and city scenes as well as five portraits of theatrical celebrities. Later that year Shinn's pastels were rejected by the Society of American Artists and the National Academy of Design, but he did have another successful one-man show of his works in the medium, this time at Boussod-Valadon in New York. Shinn was compared to Edgar Degas, Jean-Louis Forain, and Jean-François Raffaëlli, and one critic said the show "sparkles like a ruby on the floor."[1]

During the first decade of the twentieth century Shinn became widely known as a pastelist. His pastel style in such works as *Herald Square* (p. 217) is very much like his black-and-white illustration work. In fact, he had begun to sell his pastels to illustrated magazines such as *Harper's*, *Scribner's*, and *Century*. These were mostly New York street scenes in which linear effects play a primary role, with pastel colors laid in as highlights.

Although he had an illustrator's sense of composition and drama, Shinn seems to have allowed the unique qualities of the pastel medium—fresh color and versatility in handling—to guide him.[2] In *Matinee Crowd* he demonstrated his familiarity with the malleable nature of pastel and its easy compatibility with other mediums. Strong in mass and contrast, the work possesses an atmospheric effect that captures the excitement of urban life. "What movement there is in this drawing!" observed the writer Albert E. Gallatin, who presented this pastel to the Museum. "How the people are scurrying along in the face of the snow and wintry blast! How snow sweeps and swirls up the avenue!"[3]

E.W.

NOTES:
1. *Town Topics*, Mar. 1, 1900.
2. See, for example, *Matinee, Outdoor Stage*, and *The Laundress*, illustrated in Edith De Shazo, *Everett Shinn: A Figure in His Time* (New York, 1974), pp. 138–39.
3. A[lbert] E. G[allatin], *Whistler Notes and Footnotes and Other Memoranda* (New York/London, 1907), p. 81.

REFERENCES: A. E. Gallatin, *Studio* 39 (1907), pp. 84–87, ill. p. 85 // A[lbert] E. G[allatin], *Whistler Notes and Footnotes and Other Memoranda* (1907), p. 81, ill. p. 78.

EXHIBITED: Durand-Ruel Galleries, New York, 1904, *Exhibition of Pastels by Everett Shinn*, no. 36 // Bourgeois Galleries, New York, 1918, *Collection of A. E. Gallatin: Modern Paintings and Drawings, for the Benefit of the War Relief*, no. 33.

EX COLL.: A. E. Gallatin, New York, by 1918

EVERETT SHINN
Circus, 1906

Pastel over monotype on off-white wove paper, 3¾ × 5 in.
Signed at lower right: E Shinn. Dated at lower left: 1906
George A. Hearn Fund, 1952 (52.161)

Eclectic by nature, Everett Shinn actively experimented with a variety of mediums, working in oil, watercolor, gouache, pen and ink, sanguine, and pastels. Here he applied pastel over a black monotype print, an adventuresome combination of mediums undoubtedly inspired by his admiration for similar works by Edgar Degas. *Circus,* a small gem that the artist created in 1906 but retained until 1952, the year before he died, is a lovely example of the potential of the medium. Tightly composed, the work glows with vibrancy and depth and has none of the artifice and formula that would characterize Shinn's later production in pastel. As an associate of Robert Henri's, Shinn must have been aware of Henri's dictum: "[Invent] the necessary technique of the thing you have to express today, the technique that must be beautiful, that must be perfect because it is the only thing, the fittest, the shortest, the plainest, *the* way of painting the idea in hand."[1]

E.W.

NOTE:
1. Robert Henri, "Progress in Our National Art," *Craftsman* 15 (Jan. 1909), p. 400.

REFERENCES: E. Shinn, letter [1952], MMA Archives // MMA, *American Painting in the Twentieth Century,* exhib. cat. by H. Geldzahler (New York, 1965), ill. p. 31.

EX COLL.: Everett Shinn, New York, until 1952

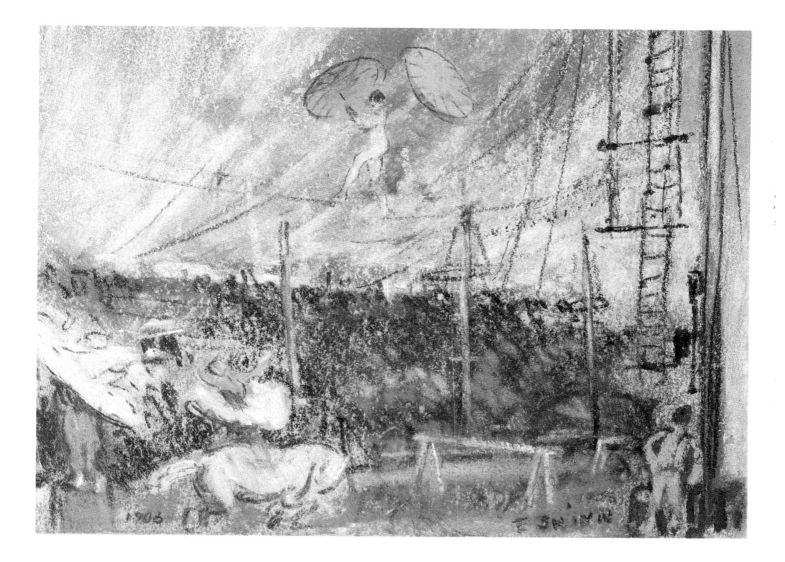

EVERETT SHINN
Julie Bonbon
(The Stage from the Orchestra), 1907

Pastel on off-white wove paper, mounted on cardboard,
21⅝ × 16 in.
Signed and dated at lower right: E Shinn / 1907. Inscribed
on reverse: "The Stage From The Orchestra" E Shinn /
112 Waverly Pl.; B88
Gift of Mrs. Maurice Stern, 1970 (1970.306)

Everett Shinn possessed a decorative flair and was
drawn to the work of Jean-Honoré Fragonard and
François Boucher. In 1899 he decorated the apart-
ments of various theatrical celebrities in the florid,
abundant style of the eighteenth-century French
masters. A minor actor and playwright himself,
Shinn constructed a small theater in his Waverly
Place house, where he staged modest productions,
using friends and fellow artists as cast and crew.
Undoubtedly inspired by Edgar Degas's treatment
of similar subjects, Shinn produced dozens of stage
and café-concert scenes in pastel following his trip
to Paris in 1900. *Julie Bonbon (The Stage from the
Orchestra)* is characteristic of his early pastels, before
his style became somewhat repetitious and formulaic.
The *repoussoir* device of the bass and the yellow strip
of footlights, for example, became virtual trade-
marks. Coinciding in date with Shinn's Rococo
decorations for the Belasco Theatre, *Julie Bonbon*
owes its spatial construction and lighting scheme to
the example of Degas. Although the decorative
quality and the composition of this work are deriva-
tive, the handling of the pastel is pure Shinn. The
decisive yet delicate application of strokes, par-
ticularly in the underlit face of the woman, testifies
to the extraordinary ease with which Shinn utilized
the medium.

E.W.

REFERENCE: Utah Museum of Fine Arts, Salt Lake City, *Graphic
Styles of the American Eight*, exhib. cat. (1976), ill. p. 15.
EXHIBITED: Art Club of Philadelphia, 1907, no. 34.
EX COLL.: Mr. and Mrs. Maurice Stern

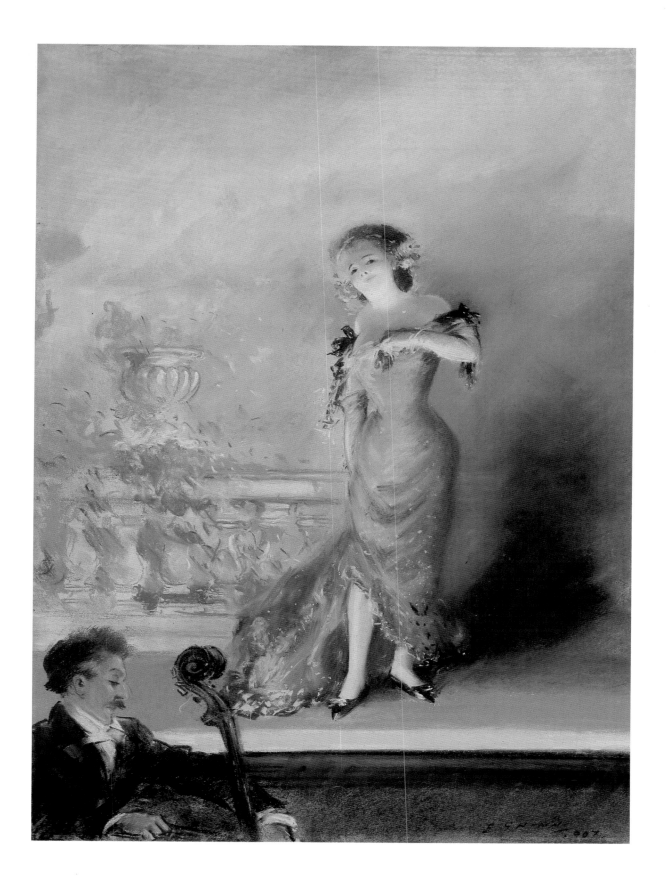

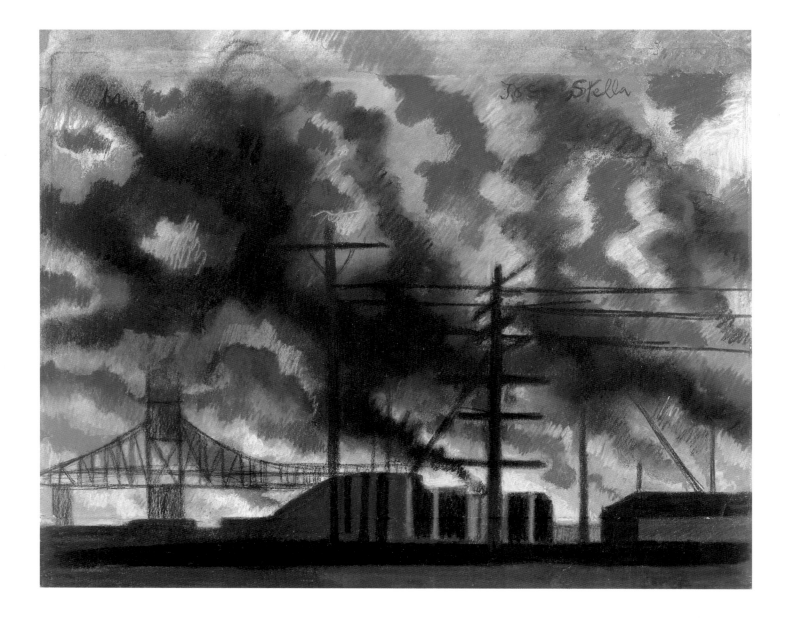

Joseph Stella
1877–1946
Pittsburgh, about 1920

Pastel on heavyweight tan wove paper (reverse: a chromolithograph), 14 × 16⅞ in.
Signed at upper right: Jos. Stella
Arthur Hoppock Hearn Fund, 1950 (50.31.5)

The modernist Joseph Stella worked in pastel, among other mediums, for most of his long career, from about 1902 until 1945.[1] Stella was most likely encouraged to use pastels when he studied with William Merritt Chase at the New York School of Art between 1900 and 1902.[2] Early pastels, such as *Old Man and Woman,* 1902 (Mr. and Mrs. Samuel Denburg), and *Head of Man,* 1908 (Sergio Stella), already indicate Stella's proficient draftsmanship and his preference for sketching from life.[3] He extended this interest into the creation of illustrations for *Survey,* a magazine dedicated to social welfare and reform, and for *Outlook.* The *Survey* commission, in 1908, resulted in more than one hundred different drawings of the Pittsburgh industrial scene, executed in a variety of mediums, including pastel, charcoal, and pencil.[4] In 1911 and 1912 Stella expanded his artistic horizons in Paris, where, in his words, "Fauvism, Cubism, and Futurism were in full swing."[5] Excited by the challenge of modern art, Stella quickly advanced from the traditional mode of his early drawings to an abstract style based on Futurism. After his return to America, he evidently used pastel to experiment with abstraction. In about 1914 he worked with a variety of geometric and curvilinear designs in a group of pastels entitled *Abstraction.*[6] These pastels are somewhat less repre-

sentational than comparable oils of the period, which have titles clearly identifying the subject.

The Museum's pastel is probably associated with a later commission that Stella received from *Survey,* in 1918, as are his depictions of the Brooklyn Bridge and the factories, smokestacks, and gas tanks of metropolitan New York, New Jersey, and Pittsburgh.[7] These works demonstrate Stella's shift of interest from the more academic figurative drawings of his 1908 *Survey* commission to formal concerns, with a greater degree of abstraction and simplification in the treatment of subject. Although not published in *Survey,* the Museum's pastel bears a resemblance to other drawings in the series. Like *Factories: Byproduct Plant,* 1918–20 (fig. 35), which appeared in the March 1, 1924, issue of the magazine, it depicts industrial elements starkly silhouetted against the sky.[8]

The forms in the Museum's pastel are so generalized that they are virtually unrecognizable.[9] The identification of the locale as Pittsburgh has been disputed by art historians Irma Jaffe and August Mosca, who believe that it might be a site in New Jersey or lower Manhattan.[10] However, Dr. Bernard Rabin, who has studied Stella's work closely, continues to assert that the Museum's pastel is stylistically related to Pittsburgh drawings for the *Survey* commission.[11]

Some of Stella's *Survey* drawings and pastels served as preparatory sketches for such major paintings as *The Bridge,* 1922 (Newark Museum), from the series *New York Interpreted.*[12] The possibility that the Museum's pastel may also be a study is supported by the seeming casualness with which it was made on the back of a chromolithograph, and by the band in a different color scheme along the edge of the sky. Nevertheless, *Pittsburgh* does not

appear to be related to any known oil paintings and it seems complete within itself, by virtue of its well-covered surface and fully articulated forms.[13]

As a synthesis of realism and abstraction, the industrial paintings and pastels of the late teens have established Stella as a forerunner of American Precisionism.[14] Stella's celebratory conception of industry is, however, more romantic and symbolic than that of the Precisionists. The visionary quality of his interpretation is evident in the swirling patterned clouds and smoke that occupy much of this composition.

G.S.

NOTES:

1. Jaffe 1970, pp. 205–13, includes a check list of all of Stella's pastels and drawings exhibited during his lifetime and therefore excludes the Museum's works, which do not meet this criterion.

2. Ibid., p. 12; and Mosca Interview 1983.

3. See also *Head of Woman*, 1908 (Baur 1971, no. 15).

4. Most of these works are carefully modeled figure studies of steelworkers and miners. There are also a small number of cityscapes and mill scenes that are more broadly handled to produce semiabstract shapes partially obscured by smoke and fog, suggesting a tendency toward abstraction that Stella would develop more fully in subsequent years (see Helen Cooper, "Stella's *Miners*," *Yale University Art Gallery Bulletin* 35 [Fall 1975], pp. 8–13).

5. Stella 1960, p. 64.

6. For reproductions of these pastels see Jaffe 1970, no. 34; and

Fig. 35. Joseph Stella, *Factories: Byproduct Plant*, 1918–20, pastel, charcoal, and metallic paint on paper, mounted on paperboard, 22⅞ × 29 in., Hirshhorn Museum and Sculpture Garden, Smithsonian Institution, Washington, D.C.

Baur 1971, nos. 34, 38. For a comparable oil see *Der Rosenkavalier*, 1913 (WMAA), Jaffe 1970, no. 33.

7. Some of these works were not published by *Survey* until 1924. Jaffe 1970, pp. 60–61, discusses dating problems for these drawings and pastels, which were published in *Survey* 51 (Mar. 1, 1924), pp. 563–68.

8. See Hirshhorn 1983, p. 32, for an illustration and discussion of *Factories: Byproduct Plant*.

9. A perusal of the photographic archives of the Pennsylvania Reading Room, Carnegie Library of Pittsburgh; of the New York Public Library; and of Joseph White and M. W. von Bernewitz, *The Bridges of Pittsburgh* (Pittsburgh, 1928), failed to establish the identity of the structures depicted.

10. Irma Jaffe, conversation with the author, Dec. 15, 1983; and Mosca Interview 1983.

11. Dr. Bernard Rabin, letter to the author, Dec. 29, 1983. Dr. Rabin has access to Stella's archives.

12. Jaffe 1970, no. 70.

13. Mosca Interview 1983.

14. San Francisco Museum of Modern Art, *Images of America: Precisionist Painting and Modern Photography*, exhib. cat. by Karen Tsujimoto (Seattle, 1982), p. 207.

EX COLL.: Downtown Gallery, New York, until 1950

JOSEPH STELLA
Landscape, 1920s

Pastel and charcoal on light blue blotting paper,
21⅝ × 16⅞ in.
Bequest of Katherine S. Dreier, 1952 (53.45.4)

Throughout the 1920s and 1930s Joseph Stella often traveled abroad, periodically returning to New York. The Museum's pastel *Landscape* may have been created during one of these trips to Europe in the 1920s, or it may represent his recollection of the village basilica in Muro Lucano, Italy, where he spent his childhood.[1] Although a now-lost cardboard backing reportedly bore Stella's signature and the date 1911, the pastel seems too stylistically advanced to have been executed in that year.[2] Rendered in high-keyed colors—lemon yellow, blues, greens, and oranges—*Landscape* exemplifies Stella's enchantment with Henri Matisse's vivid palette.[3] Following the example of the French master, Stella worked with brilliant colors as if they were "high notes soaring upon the most luscious deep tonalities."[4] The lively, prismatic colors and stacked composition, and the geometrically simplified, dynamic rendition of the church, sky, and trees also reveal Stella's debt to Analytical Cubism, Futurism, and Orphism. The stylization associated with these movements has been fully absorbed into Stella's artistic vocabulary and is particularly evident in the central axial motifs of the tree and church spire flanked by the curvilinear forms of the forest.[5] Working on a soft, heavy paper, Stella completely covered the surface of *Landscape*, freely hatching lines and rubbing pastels over areas of preparatory charcoal drawing.

Stella's pastels are often very painterly; the surfaces are almost totally obscured by rich, thick pastel, and a number of them approach the ambitious scale of paintings. Throughout his career he frequently exhibited them along with his work in other mediums—watercolors, oil paintings, drawings, and silverpoints. In his 1920 retrospective at Bourgeois Galleries, many of his pastels were exhibited as paintings. Stella, in his autobiographical notes, called painting his "chief concern," but also observed that he "employed the watercolor and the pastel, besides the oil, and for drawing . . . the unbending . . . silverpoint," thereby implying that he also conceived of the other mediums as painterly.[6]

G.S.

NOTES:

1. In a letter of Feb. 10, 1984, to the author, Judith Zilczer noted that the building appears to represent an Italian church or basilica "which recurs in many of Stella's landscapes." See Hirshhorn 1983, pp. 22–23, for an illustration and discussion of the painting *Italian Church*, 1909–11; and Jaffe 1970, pp. 6–8, for an account of Stella's boyhood in Muro Lucano and his depiction of San Gerardo da Maiello's deeds.

2. Mosca, Jaffe, and Rabin concur in dating this pastel to the 1920s, possibly during a trip to Italy. A notation concerning the cardboard backing is in the card catalogue of the Museum. The alleged signature and date may have been written by someone other than Stella.

3. Stella 1960, p. 64; and Jane Glaubinger, "Drawings by Joseph Stella," *Bulletin of the Cleveland Museum of Art* 70 (Dec. 1983), p. 386.

4. Stella 1960, p. 64.

5. A similar hieratic symmetrical arrangement has been utilized in the pastel *The Palm (Herons)*, 1926 (Hirshhorn Museum and Sculpture Garden); see Hirshhorn 1983, pp. 44–45.

6. Stella Papers, Arch. Am. Art, microfilm 346, frames 262, 274.

EXHIBITED: MMA, 1965, *American Painting in the Twentieth Century*, exhib. cat. by H. Geldzahler, p. 69.

EX COLL.: Katherine S. Dreier

ARTHUR G. DOVE
1880–1946
Cow, about 1911

Pastel on linen, 18 × 20⅝ in.
Alfred Stieglitz Collection, 1949 (49.70.72)

In 1903, after studying for three years at Cornell University with Charles Furlong, a painter and magazine illustrator, Arthur Garfield Dove went to Manhattan, where he initially took up illustration as a profession. Until 1907, when Dove left to spend eighteen months in Europe, he also painted and drew, chiefly with pastels, which he ground himself.[1] No pastels from this period survive, but many examples of his illustrations are known. For these Dove employed a wide range of mediums—Conté crayon, ink, oil, and watercolor—and it is possible that he also used pastel, as did his close friend William Glackens.[2] In 1910, after returning from Europe, Dove moved to a farm in Westport, Connecticut, where pastel became his chief medium and cows an important subject.[3]

Dove's earliest surviving work in pastel is a series dating from 1911 and 1912. Ten of these pastels formed the core of his first one-man show, held in February and March 1912 at Alfred Stieglitz's gallery "291." Dove chose to make his debut in pastel, which attests to the strong appeal the medium held for him and to his confidence with it.

Variously dated 1911 and 1914, *Cow* may have been among the pastels he exhibited in 1912. Since no titles were used and none of the known reviews refer definitively to *Cow,* its inclusion cannot be positively confirmed, though recent scholarship tends to favor both its 1911 date and its presence in the show.[4] *Cow* and a comparable pastel, *Calf*

(fig. 36), are duller in color and more curvilinear than any other pastels that have been more securely placed in the show, and Dove himself considered *Cow* more advanced than all of the others in its freedom of line.[5] Nevertheless, Dove's style in *Cow* is strongly rooted in that of his early illustrations of 1904, which have been described as "Poster Style" because of their winding outlines of large forms and their contrasting areas of light and dark.[6]

Cow illustrates the nature of Dove's attraction to pastel at this time. The matte finish interacts with the weave of the "butcher" linen, which Dove may have selected for its association with meat, to actualize the feel of cowhide.[7] Critic Paul Rosenfeld, for instance, reveled in the

> great udders and hairy flanks of nature; animals at their business of feeding . . . the fawns and tans and soft, warm whites call to mind the smell of hay, the breath of kine, the taste of warm-squirted milk. One hears perforce the grunting of piglets, the lowing of oxen, the swishing of great slow tails. Butter and cheese and all dairy products have a sort of apotheosis here. Dove's Cows . . . with their synthetization of natural forms are very poems of earthfastness.[8]

This was precisely the sort of primal sensory experience Dove aspired to arouse in viewers, and the inviting, light-absorptive quality of pastel—in contrast to the distracting glare of oils and glazes—can be seen to have stimulated this involvement.[9]

Dove's palette was championed more enthusiastically than any other aspect of the works shown in 1912. One critic wrote: "In color they are beautiful and strange, and the eye returns to them again and again as if with delight in finding something which it is not required to understand at all but which is

Fig. 36. Arthur G. Dove, *Calf*, c. 1912, pastel on linen (or very fine canvas),
17¾ × 21½ in., William C. Janss, Courtesy of Richard York Gallery, New York

intrinsically agreeable."[10] At the root of Dove's en-
chanting color schemes, as the artist later explained,
"was a long period of searching for something in
color which I then called 'a condition of light.' It
applied to all objects in nature, flowers, trees,
people, apples, cows. These all have their certain
condition of light, which establishes them to the eye,
to each other, and to the understanding."[11] In other
words, Dove sought to extract the local color from a
given form with the utmost possible precision. Citing
one of his early pastels, he explained that to realize
this "condition of light" technically, "colors were
weighted out and graded with black and white into
an instrument to be used in making that certain
painting."[12] When later compiling archival file cards
on his works, the only information Dove generally
included besides title and date were the names of the
pigments he had used.[13]

To the perceptive and forward-looking critic
George Cram Cook, the pastels Dove exhibited in
1912 represented "the real creative impulse of our
century . . . presentative painting, not represen-

tative . . . painting trying to use its own elements—
lines, masses, colors—with the same freedom from
representativeness which exists in musical notes—
and rhythms."[14] Max Weber, who visited Dove's farm
in 1911, claimed to have prompted Dove's symbolical
approach to form, but in view of Weber's wide-
ranging eclecticism at this time and his penchant for
self-aggrandizement, his influence on Dove seems
suspect.[15]

Dove continued to work largely in pastel
through 1917 and sporadically until as late as 1922;
thereafter, he did not make any pastels for several
years.[16] Living aboard a yawl, he took up collage,
incorporating a host of nontraditional materials,
among them animal furs.[17] In 1926 Stieglitz orga-
nized the second one-man exhibition of Dove's
career, at Intimate Gallery. *Cow*, evidently included
along with the Museum's *Sentimental Music* (p. 115),
was now viewed with nostalgic affection in the light
of the new collages. Calling Dove the "one time
painter of beautiful forms," Murdock Pemberton
commented: "The introspective cow, the derrick

wheel, the storms, the sentimental music are all there. The new things he has turned out this year are of the MISS WOOLWORTH family; bits of driftwood, pine cones, sticks and stones, sea shells, cork insulation, blue steel covered with chiffon."[18]

<div align="right">M.W.F.</div>

NOTES:

1. Frederick S. Wight, "Dove, Arthur Garfield," *DAB*, supp. 4 (1974), p. 280; and Phillips 1981, p. 55.

2. Gallati 1981, pp. 14–15.

3. There is no mention of Dove's use of pastel abroad. His extant works from that period are all oils, as are a group of six small abstractions thought to date from 1910, after his return to the United States.

4. See William Innes Homer, "Identifying Arthur Dove's 'The Ten Commandments,'" *American Art Journal* 12 (Summer 1980), pp. 43–62.

5. In 1930 Dove, whose file cards often assign premature dates to his early works, commented: "'The Cow' 1911 is an example of the line motive freed still further. The line at first followed the edges of planes, or was drawn over the surface, and was used to express actual size, as that gave a sense of dimension; later it was used in and through objects and ideas as force lines, growth lines, with its accompanying color condition" (quoted in Kootz 1930, p. 38).

6. Gallati 1981, p. 14.

7. Smith 1944, p. 37. As the four pastels in the Museum's collection illustrate, Dove delighted in experimenting with novel support materials: *Cow* (linen), *Pagan Philosophy* (cardboard), *Sentimental Music* (gray paper, mounted on plywood), *Tree Forms and Water* (plywood).

8. Paul Rosenfeld, "American Painting," *Dial* 71 (Dec. 1921), p. 665.

9. H. Effa Webster quotes Dove characterizing one of the pastels of 1911–12, *Wind on a Hillside* (now called *Nature Symbolized No. 2*, Art Institute of Chicago): "Yes, I could paint a cyclone. Not in the usual mode of sweeps of gray wind over the earth, trees bending and a furious sky. I would show repetitions and convolutions of the rage of the tempest. I would paint the wind, not a landscape chastised by the cyclone" ("Artist Dove Paints Rhythms of Color," *Chicago Examiner*, Mar. 15, 1912, Downtown Gallery Papers, Arch. Am. Art, microfilm ND32, frame 040).

10. Joseph Edgar Chamberlin, "Pattern Paintings by A. G. Dove," New York *Evening Mail*, Mar. 2, 1912, p. 8. At the 1916 Forum Exhibition Dove again showed pastels, among them possibly the Museum's *Pagan Philosophy*, on the reverse of which is penciled *Forum Exhibition*. Again his colors were accorded particular praise. Charles Caffin wrote of the pastels that "their chief beauty is color, with its variety of expressional suggestion. And the latter is personal; so personal in fact to the artist, that the impression produced in the spectator is in the first instance one of pleasurable sensation" ("New and Important Things in Art; Last Week: Forum Exhibit of Modern American Painters," *New York American*, Mar. 20, 1916, p. 7).

11. Quoted in Kootz 1930, p. 37.

12. Ibid.

13. According to Dove's file cards, the pigments used in his pastels of 1911 and 1912 include, among others, ultramarine blue, chrome green, yellow ocher, viridian orange, Indian red, and Mars violet (Dove 1932–37, frames 719–49).

14. George Cram Cook, "Causerie Post-Impressionism after Seeing Mr. Dove's Pictures at Thurber's," *Chicago Evening Post Literary Review*, Mar. 29, 1912, p. 1.

15. Homer 1977, p. 114.

16. According to Theodore Turner, *Mowing Machine*, 1921 (Vassar College Art Gallery, Poughkeepsie, N.Y.), "must have been one of the last pastels of the period" ("Arthur G. Dove" [M.A. thesis, Institute of Fine Arts, New York University, 1950], p. 28). This is in fact the last recorded pastel in Dove's oeuvre before the late 1920s.

17. O'Keeffe suggested that Dove, in increasingly tight financial straits, turned to collage partly because it was cheaper than painting (University of Maryland Art Gallery, *Arthur Dove: The Years of Collage*, exhib. cat. by Dorothy Rylander Johnson [College Park, 1967], p. 13). The fact that he lived aboard a yawl with limited work space throughout this period may have made hand-ground pastel an impractical medium.

18. Pemberton 1926, pp. 25–26.

REFERENCES: P. Rosenfeld, *Dial* 71 (Dec. 1921), p. 665, ill. p. 692 // O. Herford, *Ladies Home Journal* 40 (Jan. 1923), p. 8, Downtown Gallery Papers, Arch. Am. Art, microfilm ND32, frame 029, clipping annotated by Arthur Dove // W. Frank, *New Republic* 45 (Jan. 27, 1926), p. 269 // Pemberton 1926, pp. 25–26 // Kootz 1930, p. 38 // Dove 1932–37, microfilm 2803, frame 723 // E. McCausland, *Springfield Sunday Union and Republican*, Apr. 22, 1934 // *Parnassus* 9 (1937), p. 5 // Smith 1944, p. 37 n. 4 // S. M. Smith, archival file card, "Catalogue: Arthur G. Dove," 1944, rev. 1976, Suzanne Mullet Smith Papers, Arch. Am. Art., microfilm 1043, frames 485–86 // S. M. Smith, comp., Am. Art Res. Coun. Papers, c. 1944, rev. c. 1976, Suzanne Mullet Smith Papers, Arch. Am. Art, microfilm 2425, frame 142 // Stieglitz Catalogue [1949], VI, p. 23 // R. Coates, *New Yorker* 27 (June 2, 1951), p. 76 // F. S. Wight in Art Galleries of UCLA, *Arthur G. Dove* (1958), p. 35 // Morgan 1973, p. 232 // A. Frankenstein, *Art in America* 63 (Mar. 1975), p. 61 // S. Schwartz, *Artforum* 14 (Feb. 1976), ill. p. 30 // W. I. Homer, *American Art Journal* 12 (Summer 1980), ill. p. 29 // Phillips 1981, p. 29 // Morgan 1984, pp. 46, 48, 69 n. 23, 112–13 // A. L. Morgan, ed., *Dear Stieglitz, Dear Dove* (1988), p. 62, ill. p. 63.

EXHIBITED: Little Galleries ("291") of the Photo-Secession, New York, 1912, *Arthur G. Dove: First Exhibition Anywhere* (possibly this pastel) // W. Scott Thurber Galleries, Chicago, 1912, *The Paintings of Arthur G. Dove* (possibly this pastel) // Intimate Gallery, New York, 1926, *Exhibition II: Arthur G. Dove* (no cat. available) // An American Place, New York, 1934, *Arthur G. Dove: New Things and Old*, no. 2 // An American Place, New York, 1937, *Beginnings and Landmarks, "291," 1905–1917*, no. 54 // Phillips Memorial Gallery, Washington, D.C., 1937, *Retrospective Exhibition of Works in Various Media by Arthur G. Dove*, no. 24 // Philadelphia Museum of Art, 1944, *History of an American—Alfred Stieglitz: "291" and After*, no. 252 // MOMA, 1947, *Alfred Stieglitz: His Collection*, no. 23 // MMA, 1950, *Twentieth Century Painters: A Special Exhibition of Oils, Water Colors, and Drawings Selected from the Collections of American Art in The Metropolitan Museum* (alphabetical check list), p. 5 // MMA, 1965, *American Painting in the Twentieth Century*, exhib. cat. by H. Geldzahler, ill. p. 53 // MMA, 1965, *Three Centuries of American Painting* // San Francisco Museum of Art, 1975, *Arthur Dove*, ill. p. 25.

EX COLL.: Alfred Stieglitz, New York (d. 1946)

ARTHUR G. DOVE
Sentimental Music, 1917

Pastel on gray paper, mounted on plywood, 21¼ × 17⅞ in.
Alfred Stieglitz Collection, 1949 (49.70.77)

From 1913 on, Arthur G. Dove did many works with musical themes, including the pastel *Sentimental Music*.[1] Wassily Kandinsky, whose book *On the Spiritual in Art* (1912) Dove owned, likely sparked the artist's interest in synaesthesia and thereby fueled his increasingly penetrative and nonmimetic explorations using the pastel medium.[2] Here the thick, brushy pastel, with its constantly shifting color-value gradations, meshes with the rough-textured paper to form a richly active surface. The freedom of line in *Sentimental Music* evolves from Dove's concerns in *Cow* (p. 110). As Henry Geldzahler noted, the upward thrust of arabesque lines in *Sentimental Music* also relates closely to a subsequent pastel by Dove, *A Walk: Poplars*, 1920 (Terra Museum of American Art, Chicago, Ill.).[3] Dove's 1927 pastel *Rhythm Rag* (location unknown) is his only other recorded use of the medium for a synaesthetic subject.[4]

M.W.F.

NOTES:

1. An oil, *Music*, 1913 (William C. Dove), is the earliest documented synaesthetic work by Dove; *Sentimental Music* is the next.

2. Homer 1977, p. 209. Dove shared this interest in music with other members of the Stieglitz circle, particularly Weber, Walkowitz, and O'Keeffe.

3. Henry Geldzahler in MMA, *American Painting of the Twentieth Century*, exhib. cat. (New York, 1965), p. 54.

4. Dove 1932–37, frame 735.

REFERENCES: Pemberton 1926, pp. 25–26 // Dove 1932–37, frame 736 // S. M. Smith, archival file card, "Catalogue: Arthur G. Dove," 1944, rev. 1976, Suzanne Mullet Smith Papers, Arch. Am. Art, microfilm 1043, frame 499 // S. M. Smith, comp., Am. Art Res. Coun. Papers, c. 1944, rev. c. 1976, Suzanne Mullet Smith Papers, Arch. Am. Art, microfilm 2425, frame 157 // B. Rose, *American Art since 1900* (1967), p. 59, ill. p. 60 // Morgan 1973, pp. 60, 238 // B. Haskell in San Francisco Museum of Art, *Arthur Dove*, exhib. cat. (1974), p. 29 // Homer 1977, p. 212 // Phillips 1981, p. 43 // Morgan 1984, pp. 47, 67 n. 23, 114–15 // J. Zilczer, *Art Journal* 44 (Winter 1984), p. 362, ill. p. 363.

EXHIBITED: Intimate Gallery, New York, 1926, *Exhibition II: Arthur G. Dove* (no cat. available) // WMAA, 1935, *Abstract Painting in America*, no. 39 // MMA, 1965, *American Painting in the Twentieth Century*, exhib. cat. by H. Geldzahler, p. 54, ill. p. 52 // MMA, 1965, *Three Centuries of American Painting*.

EX COLL.: Alfred Stieglitz, New York (d. 1946)

ARTHUR G. DOVE
Tree Forms and Water, about 1928

Pastel on plywood, 29¾ × 25⅞ in.
Alfred Stieglitz Collection, 1949 (49.92.3)

Tree Forms and Water conveys Arthur G. Dove's aesthetic and technical concerns during his brief resumption of the pastel medium in the late 1920s. In the catalogue that accompanied his 1927 show at Intimate Gallery, Dove explained that the colors of one work from this period "were chosen looking down into a stream. . . . The line is a moving point reducing the moving volume to one dimension. From then on it is expressed in terms of color. . . ." [1] Here the "wet" colors and the more cohesive integration of color, line, and volume signal an advance over earlier pastels in which these elements were used more discretely. [2] Indeed, the pastel does look fluid, a sensation that results both from Dove's pigments, which are difficult to define in conventional terms, and from the interaction of the medium with the rippling grain of the plywood, a support he used during these years, expressly because of its inherent linear movement. [3] In places, the pastel seems to have been brushed on like paint. Dove, who had long experimented with oils, here achieved a painterly quality with pastel. [4]

Edward Alden Jewell found Dove's exhibition at Intimate Gallery in 1929 "more arresting than usual . . . more robust" and cited his "tendency toward broader treatment." [5] *Tree Forms and Water,* though apparently not exhibited, illustrates this new tendency. Two years later Jewell noticed a " 'bigger-and-better' movement on at An American Place," with Georgia O'Keeffe, like Dove, showing "a decided leaning toward larger, bolder expression." Jewell continued: "Mr. Stieglitz quaintly relates the expansiveness of Dove's present mood to a shift in working quarters. For a long while, years and years, Dove did all his abstract painting aboard a small boat, the top of whose tiny cabin was so low that he couldn't stand erect. Now he has, if one gets it aright, moved ashore into a studio with plenty of headroom." [6]

According to the artist's son, William, *Tree Forms and Water* can be dated between 1926 and 1929. [7]

Although not recorded in Dove's archival file cards on his works, the pastel would seem to date between 1928 and 1930, judging from information on cards for other pastels that the artist assigned to these years. [8]

M.W.F.

NOTES:

1. Arthur G. Dove, "An Idea," in Intimate Gallery, *Arthur G. Dove Paintings, 1927,* exhib. cat. (New York, 1927), unpaginated.

2. Arthur Jerome Eddy included a color reproduction of *Based on Leaf Forms and Spaces,* 1911–12 (location unknown), one of the pastels exhibited at "291" in 1912 (*Cubists and Post-Impressionism* [Chicago, 1914], opp. p. 48). Eddy added Dove's description of the pastel as a choice of "three colors . . . and three forms selected from trees and the spaces between them that to me were expressive of the movement of the thing which I felt" (ibid., p. 49).

3. In the catalogue accompanying his 1929 annual Dove wrote, "Perhaps one might take 2 or 3 motifs. . .the line motive to be the line in the grain of wood" ("Notes by Arthur G. Dove," in Intimate Gallery, *Dove Exhibition,* exhib. cat. [New York, 1929]).

4. In his collages of the early and mid-1920s he experimented with metallic paints and with mixtures of sand or moss and oil. Ann Lee Morgan's observation that Dove experimented "so much so, that probably most of his 'oils' are not done with oil paint alone" reveals the extent of his elasticity with mediums (Morgan 1973, p. 173).

5. Edward Alden Jewell, "Two Cryptic Artists: New Paintings by Arthur Dove and Striking Sculptural Forms by Noguchi Now on View," *New York Times,* Apr. 14, 1929, sec. 10, p. 13.

6. Edward Alden Jewell, "Dove Again: A Movement toward Larger Design," *New York Times,* Mar. 15, 1931, sec. 9, p. 12. O'Keeffe, after Duncan Phillips and Stieglitz the third largest collector of Dove's work, owned *Tree Forms and Water.*

7. William Dove, letter(?) to MMA, n.d., cited on catalogue card.

8. The following pastels resemble the Museum's example in either their titles or their wood supports: *Composition,* pastel on wood, 1928; *Image,* pastel and oil on wood, 1930; and *Running Tree,* pastel on canvas, 1928 (Dove 1932–37, frames 724, 728, and 735, respectively). Another contemporary pastel, *The Tree* (1929), is cited in Suzanne Mullett Smith, comp., Am. Art Res. Coun. Papers, c. 1944, rev. c. 1976, Suzanne Mullett Smith Papers, Arch. Am. Art, microfilm 2425, frame 361. According to Smith, this pastel was included in Dove's 1929 show at Intimate Gallery. However, no entry by that title appears in the exhibition catalogue.

REFERENCES: Stieglitz Catalogue [1949], VI, p. 23 // T. Turner, "Arthur G. Dove" (M.A. thesis, Institute of Fine Arts, New York University, 1950), p. 42 // Morgan 1973, p. 264 // Morgan 1984, pp. 53, 165–66.
EXHIBITED: Philadelphia Museum of Art, 1944, *History of an American—Alfred Stieglitz: "291" and After,* no. 256 // MMA, 1950, *Twentieth Century Painters: A Special Exhibition of Oils, Water Colors, and Drawings Selected from the Collections of American Art in The Metropolitan Museum* (alphabetical check list), p. 5.
EX COLL.: Alfred Stieglitz (d. 1946)

ABRAHAM WALKOWITZ
1880–1965

Creation, probably 1913–14

Wax crayon and pastel on eight sheets of off-white wove paper, mounted together, 35¹⁵⁄₁₆ × 45¹³⁄₁₆ in. overall
Signed and dated at lower right: A. WALKOWITZ [between horizontal bars] 14
Alfred Stieglitz Collection, 1949 (49.70.168)

Abraham Walkowitz, one of the artists associated with Alfred Stieglitz, was among the earliest exponents of European modernist abstraction in America. He traveled to Europe in 1906, 1907, and 1914. Walkowitz shared his apartment in New York for a few months in 1909 with Max Weber, whom he had met in Europe. It is possible that Weber encouraged Walkowitz's use of pastel.[1] Around this time, Walkowitz began to do frontal heads in pastel, which he continued producing into the 1920s.[2] These pastels are characterized by a thick, rubbed application of the medium, with almost no reserve of the paper in evidence. In some, Walkowitz may have applied steam to achieve gouachelike passages.

Walkowitz's second one-man show of drawings, watercolors, and pastels at "291," from November 19, 1913, to January 4, 1914, was described as signaling a new direction in his work.[3] Indeed, from 1913 to 1917 Walkowitz explored non-objectivity, primarily in the more direct mediums of drawing and watercolor, and produced numerous small studies, which seldom culminated in larger oil paintings.[4] His new interest in non-objectivity can be seen in *Creation,* a composite of eight separate drawings probably done between 1913 and 1914 and later mounted and framed as a group. It is not known when these pastels were first brought together, but Walkowitz may have assembled them as one piece for display in the Forum Exhibition of 1916, an important group show organized by American modernists. (In this exhibition, however, they could have been framed separately and simply displayed as a group.)[5] Late in his career, Walkowitz made a practice of assembling groups of drawings from earlier periods for his books, including *A Demonstration of Objective, Abstract, and Non-Objective Art* (1945), *Improvisations of New York: A Symphony in Lines* (1948), and *Art from Life to Life* (1951). *Creation* may also be the result of Walkowitz's grouping of earlier works into a new arrangement. The issue is further complicated by Walkowitz's tendency to date his works retrospectively, often earlier than the actual date of their execution, to establish his role as a pioneer of modernism.[6]

Walkowitz's new tendency toward abstraction was probably inspired by European modernist works that he had seen at the Armory Show in 1913, particularly Kandinsky's *Improvisation No. 27: The Garden of Love,* 1912 (fig. 37). He was fascinated with the ideas Kandinsky expounded in his book *On the Spiritual in Art* (1912), a copy of which Walkowitz owned and annotated, frequently underlining pertinent passages concerning the expressive potential of abstract form.[7] Walkowitz was one of the first American artists to develop a personal abstract style based on Kandinsky's principles.[8] The use of primary colors and their variants, the free-floating curvilinear forms, and the combination of jagged lines with patches of color in *Creation* are certainly related to Kandinsky's energetic paintings.

The application of pastel in *Creation* is fairly thick, though areas of reserve are prominent in several panels—for example, the second panel from the left on the top. This panel resembles Walkowitz's early abstract drawings, such as *From Life to Life No. 1*, 1912 (fig. 38),[9] which were inspired by Pablo Picasso's Analytical Cubist drawings. Walkowitz began to fragment the human body into an allover composition of curvilinear forms, a transformation based on his belief that "art is creation and not imitation. Art has its own life. One receives impressions from contacts or objects and then new forms are born in equivalents of line or color improvisations . . . the artist creates a new form of life."[10] *Creation* is thus a celebration of the artistic process of generation. The fact that Walkowitz frequently employed the term *creation* or variants of it in his writings to refer to his work and to art in general supports this interpretation of the subject.[11]

Walkowitz returned to the theme of Creation in the 1920s or 1930s with a twenty-four-panel watercolor that continues to reflect the impact of Kandinsky, but of his later work.[12] The free-floating, soft-edged forms of Walkowitz's earlier Kandinsky-inspired work have given way to a harder-edged, geometric style that reflects the art of Kandinsky's Bauhaus years, from 1922 to 1933.

In May 1950 Walkowitz renamed the Museum's pastel *Symphony in Creation in Eight Movements*, a title in keeping with those of other works such as the watercolor *Color Symphony #1–4*, 1913 (WMAA).[13] Although Walkowitz ascribed to Kandinsky's synaesthetic principles of equivalences between art and music, he did not strictly follow his predecessor's system of assigning meanings to certain colors and forms. Instead, in such works as *Creation*, color and form were generated intuitively as a lyrical response to the world.[14]

G.S.

NOTES:

1. Sawin 1967, p. 13, discusses Weber's contact with Walkowitz (Weber being the more advanced of the two).

2. Pastel heads and other works in this medium are at Zabriskie Gallery, New York, which handles the artist's estate. For published pastel heads see Utah 1975, nos. 107, 108.

3. Paul B. Haviland, "Photo-Secession Notes," *Camera Work* 44 (Oct. 1913; published Mar. 1914), p. 39. Sawin 1967, p. 26, states that no lists of Walkowitz's four one-man exhibitions at "291" survive.

4. Sawin 1967, p. 64. Virginia Zabriskie, conversation with the author, Jan. 6, 1984, observed that the size of these works could have been related to the small scale of "291." *Abstraction No. 1*, 1914 (Brooklyn Museum), is a watercolor generally related to *Creation* (see Utah 1975, p. 33). Walkowitz used mixed mediums—pencil,

watercolor, and pastel—in *Color Abstraction*, 1913 (Utah 1975, no. 71, p. 48). Walkowitz's book *One Hundred Drawings by A. Walkowitz* (1925) includes only a few pastels and does not usually indicate this medium. Several watercolors and oils are identified, yet only once is pastel mentioned (no. 89); nevertheless, works such as no. 21, *Head of a Young Girl* (location unknown), are probably pastels.

5. Bluemner Papers, Arch. Am. Art, microfilm N737, frame 494. Charles H. Caffin, in reviewing the exhibition, described the pastels ambiguously as "the series of pastels . . . 'Creation'" ("New and Important Things in Art; Last Week: Forum Exhibit of Modern American Painters," *New York American*, Mar. 29, 1916, p. 7). The probable inclusion of the Museum's pastel in the Forum Exhibition has been confirmed (Martica Sawin, conversation with the author, Jan. 13, 1984; and Christopher Knight, letter to the author, Jan. 14, 1984). For further information on the Forum show see Christopher Knight, "The 1916 Forum Exhibition and the Concept of an American Modernism" (M.A. thesis, State University of New York at Binghamton, 1976).

6. See Sawin 1967, p. 4, for dating problems with Walkowitz. *Creation* was in Stieglitz's collection and probably exhibited in the Forum show, which somewhat alleviates the usual dating problem.

7. Utah 1975, p. 13, also refers to the impact of Synchronism through Morgan Russell.

8. Sandra Gail Levin, "Wassily Kandinsky and the American Avant-garde, 1912–1950," 2 vols. (Ph.D. diss., Rutgers University, State University of New Jersey, 1976), p. 64, also notes that Walkowitz's choice of a title for one his books, *Improvisations of New York: A Symphony in Lines* (1948), recalls Kandinsky's use of the term *improvisation*. The abstract drawings in this book are somewhat stylistically related to *Creation*; some may be pastels (mediums are not specified).

9. Utah 1975, p. 13, ill. p. 32.

10. Abraham Walkowitz, *A Demonstration of Objective, Abstract, and Non-Objective Art* (Girard, Kans., 1945), unpaginated. In a reprint of a 1913 statement, Walkowitz referred to his need to create "a record of an experience."

11. In a letter of Aug. 24, 1933, to Alfred Stieglitz, Walkowitz referred to his nostalgic vision of the dealer's first gallery, "291": "Twenty-five years of time came [back] to me and I began to see the creations on paper, canvases, and photos . . . including my own work. I was [never] more a life [*sic*] in my creations then [*sic*] I was that day" (Stieglitz Archives, Beinecke Rare Book and Manuscript Library, Yale University, New Haven, Conn.). Walkowitz also wrote an undated prose poem entitled "Portrait of Stieglitz," which described "291" as follows: "The place created itself to proof [*sic*] the facts through demonstrations in various other Arts . . . from inner vision to imaginative fantazys [*sic*] in new forms and creations through lines, colors, and . . . other mediums, as life. . . . The perfect work of art is life in itself. . . . It was made possible for few Artist [*sic*] to create, for they were given a chance to grow and not to surpass [*sic*] their desires in creating their own vision as part of all humanity" (ibid.).

12. Sidney Janis (*Abstract and Surrealist Art in America* [New York, 1944], p. 44, no. 27) has dated this watercolor to 1918. Virginia Zabriskie has convincingly refuted this date, ascribing the work to the 1920s and to Kandinsky's influence. A drawing entitled *Abstraction* and dated 1933 (Société Anonyme, Yale University Art Gallery, New Haven, Conn.) is very similar to the so-called *Creation* of 1918 in its background of wavy lines with superimposed, hard-edged, geometric forms. See Société Anonyme 1984, p. 732, no. 838.

13. Card catalogue, MMA. This title is in accord with Kandinsky's definition of a "symphonic" composition (Levin, "Kandinsky," p. 61).

14. See Homer 1977, p. 215; and Oscar Bluemner, "Kandinsky and Walkowitz," *Camera Work* 44 (Oct. 1913; published Mar. 1914), pp. 25–26, 37–38.

REFERENCES: "Alfred Stieglitz: Collection for Metropolitan Museum," typescript, Stieglitz scrapbook, MOMA Library, II, 4/1949, sec. B, no. 12 // Stieglitz Catalogue [1949], IX, unpaginated // C. Knight, *Art in America* 71 (Oct. 1983), ill. p. 172.

EXHIBITED: Anderson Galleries, New York, 1916, *The Forum Exhibition of Modern American Painters*, no. 112// San Francisco Museum of Art, 1944, *Abstract and Surrealist Art in the United States*, exhib. cat. by S. Janis, no. 11 // WMAA, 1978–79, *Synchronism and American Color Abstraction, 1910–1925*, exhib. cat. by G. Levin, pp. 43, 144, color pl. 48 // WMAA at Philip Morris, 1983, *The Forum Exhibition: Selections and Additions*, ill. p. 32.

EX COLL.: Alfred Stieglitz, New York (d. 1946)

BELOW
Fig. 37. Wassily Kandinsky, *Improvisation No. 27: The Garden of Love*, 1912, oil on canvas, 47⅜ × 55¼ in., The Metropolitan Museum of Art, New York, Alfred Stieglitz Collection, 1949

RIGHT
Fig. 38. Abraham Walkowitz, *From Life to Life No. 1*, 1912, pencil on paper, 12⁹⁄₁₆ × 8½ in., The Metropolitan Museum of Art, New York, Alfred Stieglitz Collection, 1949

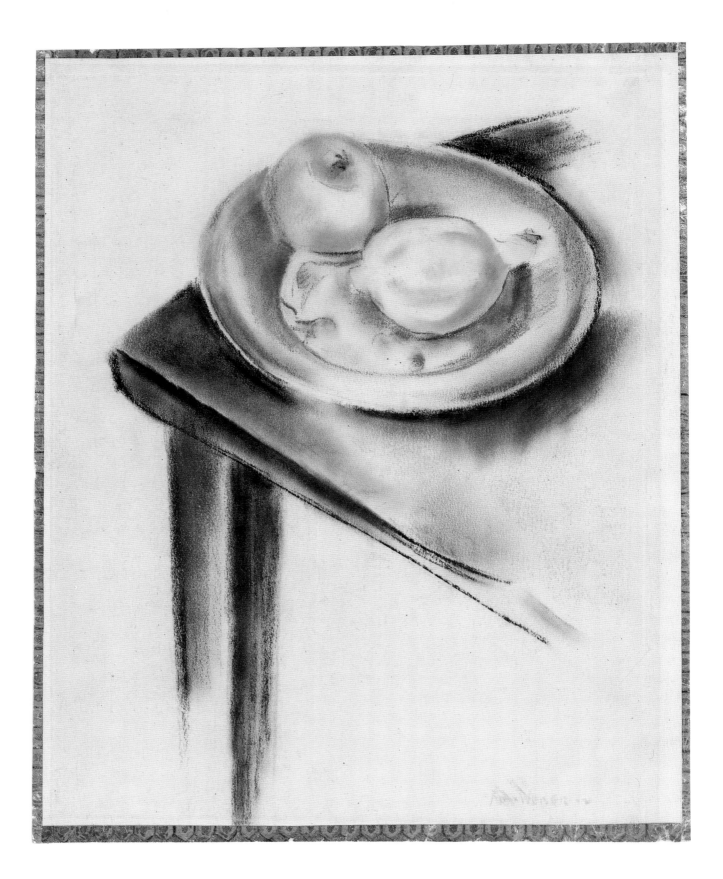

MAX WEBER
1881–1961
Still Life, 1912

Pastel on light tan wove paper with a printed metallic-paper border, 12⅝ × 9⅞ in.
Signed and dated at lower right: MAX WEBER 12
Gift of A. W. Bahr, 1958 (58.21.18)

The pioneering modernist Max Weber has been described by art historian William Innes Homer as the most advanced painter in America in 1911.[1] Weber studied art theory and the practice of design at Pratt Institute from 1898 to 1900 with the artist Arthur Wesley Dow. Weber absorbed Dow's interests in Oriental art and modernism, as well as Dow's belief in the expressive potential of art. While visiting Europe from 1905 to 1909, Weber was exposed to some of the most progressive art movements of the period. He met Pablo Picasso and Henri Rousseau, studied briefly with Henri Matisse, and encountered the work of Paul Cézanne in the Salon d'Automne exhibitions of 1906 and 1907. Returning to New York in 1909, the impoverished young artist evidently reduced his expenses for the next decade by working primarily in gouache, watercolor, and pastel, and by restricting his use of costly oils and canvas.[2] In 1911 he had a one-man exhibition at "291," his only solo show at Alfred Stieglitz's gallery. The exhibition received highly negative reviews and only one picture was sold, a pastel head of a young woman, which was acquired by Mrs. Agnes Meyer, who subsequently became a patron of Weber's.[3]

In 1912, according to Lloyd Goodrich, Weber "drew a series of pastels which were among the purest abstractions he ever did and among the earliest produced anywhere."[4] Weber's friendship with Arthur G. Dove most likely reinforced his exploration of abstraction with simplified colors, shapes, and flattened space.[5] Weber's curvilinear abstractions of leaf shapes were inspired by Dove's pastels of 1911 and 1912, among them *Nature Symbolized No. 2* (Art Institute of Chicago).[6] Pastels of 1912 such as *Untitled Abstraction* and *Music* (both Forum Gallery, New York) probably reflect Weber's awareness of Wassily Kandinsky's art and ideas.[7]

Although stylistically unlike these works of the same period, the Museum's pastel is one of several still-life subjects that reflect Weber's continuing interest in Cézanne's paintings and watercolors.[8] Like the French artist, Weber presents frontally modeled fruit seen from the top and side on a tilted tabletop. The light, washlike application of pastel, achieved by passages of stumpwork, and the use of light tan paper to suggest volume remind one of Cézanne's watercolors, which Weber may have seen at a 1911 exhibition at "291." Weber later noted the "alluring, archaic type of beauty and austerity" of Cézanne's art, an apt descriptive phrase for his own *Still Life* as well.[9]

Fig. 39. The subtle texture of the support of *Still Life* by Max Weber is complemented by the sketchy charcoal outlines and the delicate masses of unblended pastel.

Although Weber was primarily a figure painter, still life was a favorite subject, which demonstrated the artist's fascination with the objects of his immediate surroundings. In his *Essays on Art* (1916), Weber expressed his delight in the color, texture, and forms of still-life objects.[10]

The Museum's *Still Life* may have been included in a 1912 group show of pastels at Powell Gallery in New York, but this is difficult to verify because Weber often listed his works generically in early catalogues, calling them simply "Still Life."[11]

Still Life has a decorative, printed metallic-paper border of Japanese or Chinese origin attached to its perimeter, a characteristic of Weber's pastels since the early teens, when he was interested in collage.[12] This border, which is similar to devices sometimes used by folk artists, suggests Weber's interest in

primitive, ancient, and non-Western art and shows his willingness to experiment with different styles and mediums.[13]

G.S.

NOTES:

1. Homer 1977, p. 130.

2. North 1975, pp. 84, 111, 144; and Jewish Museum 1982, p. 27.

3. Homer 1977, p. 136. See also "The Exhibitions at '291,'" *Camera Work* 36 (Oct. 1911), pp. 31–34, 45–46, for excerpts from reviews. See Alfred Stieglitz, "The Story of Weber," MS., Feb. 22, 1923, Collection of American Literature, Beinecke Rare Book and Manuscript Library, Yale University, New Haven, Conn., pp. 14–15, for Stieglitz's account of Mrs. Meyer's purchase and his falling out with Weber. According to Stieglitz, the pastel was the only work in the show that Weber did not want to sell; evidently it reminded him of his grandmother.

4. WMAA, *Max Weber: Retrospective Exhibition*, exhib. cat. by Lloyd Goodrich (New York, 1949), p. 27.

5. North 1975, pp. 77–79, 89, 101–2.

6. Ibid., p. 101.

7. See WMAA 1978, p. 43, color ills. nos. 49, 50. See also the pastel *Music Concert*, 1914, in Danenberg 1971, no. 38, p. 16.

8. See Bernard Danenberg Galleries, *Max Weber: The Years 1906–1916*, exhib. cat. (New York, 1970), pp. 12, 14–15, 22, 40–41, 45; and Danenberg 1971, p. 14, for examples. A larger pastel, *Still Life with Red Bottle*, 1911 (Forum Gallery, New York), similarly depicts a Cézannesque tilted tabletop and a bowl of fruit seen from a variety of vantage points.

9. "The Matisse Class," typescript of a symposium at MOMA, Nov. 19, 1951, Arch. Am. Art, microfilm NY59–56, frame 151.

10. Max Weber, *Essays on Art* (New York, 1916), pp. 31–36 ("Things"), and pp. 67–71 ("The Equilibrium of the Inanimate"). For a synopsis of Weber's ideas in *Essays* see North 1975, p. 176.

11. North 1975, pp. ix, 111, mentions that Weber displayed a still life in this show. "Matters of Art," *New York Tribune*, Feb. 18, 1912, sec. 2, p. 7, contains a review of this exhibition of pastels by fourteen artists, which included "a still life, a figure, and an interior with figures" by Weber.

12. In a letter of Jan. 26, 1984, to the author, Percy North noted that the metallic paper is an element in a number of works, including the pastel, collage, and watercolor *Performance* (Robert L. B. Tobin), ill. in Jewish Museum 1982, p. 29.

13. North 1975, pp. xii, xiii, 4, 58, 206. Weber studied native American art in the American Museum of Natural History, New York, and selections from his *Essays on Art* show his interest in Oriental art (see Downtown Gallery, *Max Weber*, exhib. cat. by Holger Cahill [New York, 1930], pp. 27, 33).

EX COLL.: Abel W. Bahr, Ridgefield, Conn.

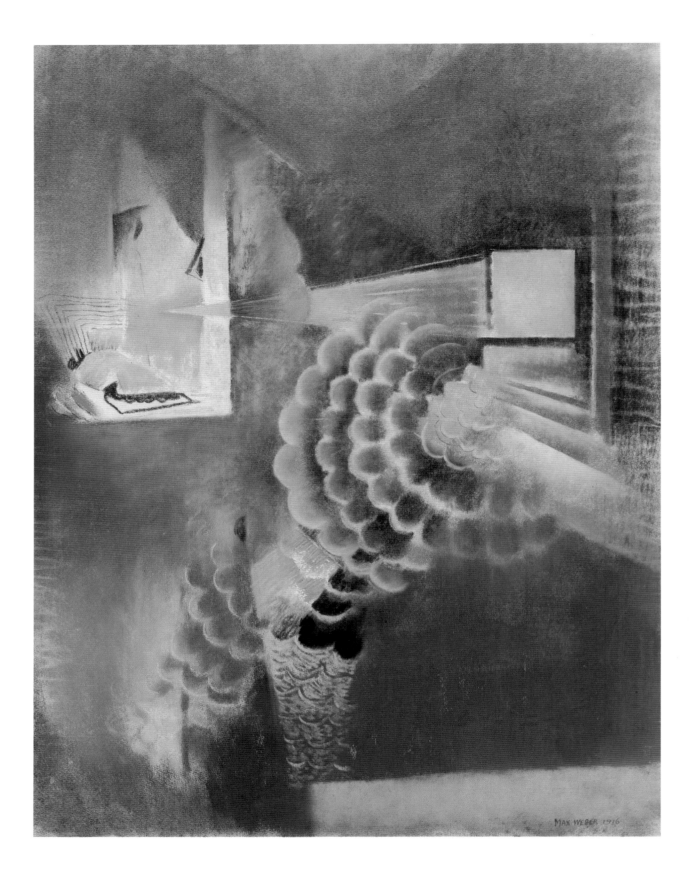

MAX WEBER
Lecture at the Metropolitan, 1916

Pastel on off-white laid paper, 24¼ × 18½ in.
Signed and dated at lower right: MAX WEBER 1916
Gift of Dr. Irving F. Burton, 1975 (1975.321)

Max Weber concentrated on the pastel medium between 1912 and 1916, creating decorative works with New York City themes that were expressive of urban dynamism and modern technology.[1] Stimulated by Cubist and Futurist works that he had seen at "291" and the 1913 Armory Show, Weber made *In an Automobile,* 1915 (location unknown), a pastel that was based on his experience of driving up Fifth Avenue in the car of his patron Mrs. Agnes Meyer.[2] In 1915 Weber also made the pastel *Foundry in Baltimore* (Forum Gallery, New York), which is stylistically similar to *Lecture at the Metropolitan.* Both works are characterized by delicate color harmonies, dynamic and decorative curves, and a variety of pastel applications, from crisp lines or staccato marks to rubbed passages.

From 1914 to 1918 Weber taught art history as well as composition and design at the Clarence H. White School for Photography in New York.[3] Created during his period of appointment at the school, *Lecture at the Metropolitan* is one of several works that seem to relate to his teaching experiences.[4] Weber described it in 1930:

A lecture on Giotto was given at the Metropolitan Museum. The late hastening visitor finds himself in an interior of plum-colored darkness on leaving the glaring daylight, speed and noise behind. The darkness of the interior becomes a background upon which one discerns the focussing spray-like yellowish-white light, the concentric, circular rows of seats, a portion of the screen, and indications of figures upon it. There was much more visible, but the memory retained only the essential expressed in this pastel study.[5]

According to Percy North, this pastel represents Weber's efforts to combine Futurist and Synthetic Cubist motifs in a decorative style expressive of the liveliness of his experiences in New York.[6] The flattened space of the dark room is pierced by two light areas indicating the projection room (fig. 40) and the screen (fig. 41). Seen as simultaneously advancing and receding, the flat planes of these areas produce a Cubist spatial ambiguity, while the diagonal lines and scalloped forms suggesting projected light produce a somewhat Futurist sense of movement. These decoratively balanced lines and forms direct one's attention to the screen, where no recognizable image of the art under discussion is visible. It seems that the process of illumination, not the projected work of art itself, is the actual subject.

Weber's conception of a dynamic, ambiguous spatial continuum in *Lecture at the Metropolitan* is related to his theories of the fourth dimension. In

1910 he defined this "plastic" dimension of infinity as "the consciousness of a great and overwhelming sense of space-magnitude in all directions at one time . . . the space that envelops a tree, a tower, a mountain, or any solid."[7]

Like several other pastels in the artist's estate, *Lecture at the Metropolitan* is the size of a small painting—about twenty-five by nineteen inches—and the heavily textured paper is almost entirely covered with pastel. Not surprisingly, the pastel has sometimes been mistaken for an oil.[8]

G.S.

NOTES:

1. North 1975, p. 145. North also notes (p. 144) that during the summer of 1914 Weber began a series of abstract pastels in Maine. See Downtown Gallery, *Max Weber*, exhib. cat. by Holger Cahill (New York, 1930), ill. no. 3, *Maine*, 1914. In a letter of Jan. 26, 1984, to the author, Percy North observed that Weber "didn't really seem to turn to a consistent use of the medium [pastel] until 1912 to 1916. The majority of his 1913–14 works are pastel or gouache or watercolor." Weber continued to create pastels even in his later more successful years when he was very able to afford oils and canvas. See Alfred Werner, *Max Weber* (New York, 1975), no. 143, *Contemplation*, 1946–47 (Hirshhorn Museum and Sculpture Garden, Washington, D.C.), and no. 157, *Hairdressing*, 1956 (Brandeis University, Waltham, Mass.).

2. *In an Automobile* is discussed in North 1975, p. 157. It was exhibited in Weber's 1915 Montross Gallery show, which included ten pastels from 1912 to 1915. Reviews of the exhibit can be found in the Weber Papers, Arch. Am. Art, microfilm N69–87, esp. frame 341, a review in the *Boston Daily Globe*, Dec. 1915: "A pastel entitled *In an Automobile* leads one to presume that Mr. Weber has been speeding, as only the most rapid movement conceivable could produce such an effect on the mind."

3. North 1975, p. 143.

4. See also *The Screen*, a pastel reproduced in Danenberg 1971, p. 13; and *Performance*, reproduced and discussed in Jewish Museum 1982, p. 29.

5. MOMA, *Max Weber Retrospective Exhibition, 1907–1930*, exhib. cat., intro. by Alfred H. Barr, Jr., cat. notes by Max Weber (New York, 1930), p. 18.

6. North 1975, p. 180. One of the few American artists to exploit the Synthetic Cubist device of collage, Weber in 1913 created *Sunday Tribune*, a simplified pastel still life, floating upside down on a newspaper page (Danenberg 1971, ill. p. 29).

7. Max Weber, "The Fourth Dimension from a Plastic Point of View," *Camera Work* 31 (July 1910), p. 25. For information on Weber's theories see Linda Dalrymple Henderson, *The Fourth Dimension and Non-Euclidean Geometry in Modern Art* (Princeton, 1983), pp. 167–82.

8. The two reviewers who mistook *Lecture at the Metropolitan* for a painting are Elizabeth Luther Cary, "Moderns on the Avenue . . . Max Weber, Paul Klee, Aristide Maillol, and Lehmbruck at Museum of Modern Art," *New York Times*, Mar. 16, 1930, sec. 10, p. 18; and Henry J. Seldis, "Max Weber Show in Channel City," *Los Angeles Times Calendar*, Feb. 18, 1963, p. 46.

REFERENCES: E. L. Cary, *New York Times*, Mar. 16, 1930, sec. 10, ill. p. 18 // M. Weber, *Max Weber* (1945), unpaginated. // H. J. Seldis, *Los Angeles Times Calendar*, Feb. 18, 1963, p. 46 // North 1975, pp. 178, 180 // A. Werner, *Max Weber* (1975), p. 51, color ill. no. 20.

EXHIBITED: MOMA, 1930, *Max Weber Retrospective Exhibition, 1907–1930*, ill. no. 42 // WMAA, 1935, *Abstract Painting in America*, no. 125 // WMAA and Walker Art Center, Minneapolis, 1949, *Max Weber Retrospective Exhibition*, exhib. cat. by L. Goodrich, no. 91 // Tweed Gallery, Duluth Branch, University of Minnesota, 1951, *A Retrospective Exhibition of the Works of Max Weber*, no. 5 // Newark Museum, 1959, *Max Weber*, no. 80 // American Academy of Arts and Letters, New York, and Boston University Art Gallery, 1962, *Max Weber, 1881–1961, Memorial Exhibition: Paintings, Drawings, Sculpture*, no. 3 // University Art Museum, Santa Barbara, 1968, *First Comprehensive Retrospective Exhibition in the West of Oils, Gouaches, Pastels, Drawings, and Graphic Works by Max Weber (1881–1961)*, exhib. cat. by Ala Story, no. 11, ill. p. 42 // Detroit Institute of Arts, 1969, *Selections from the Collection of the Friends of Modern Art*, no. 195 // Jewish Museum, New York, 1982–83, *Max Weber: American Modern*, exhib. cat. by P. North, no. 109, ill. p. 30.

EX COLLS.: Max Weber, until 1964; A. P. Rosenberg & Co., New York, 1949; Downtown Gallery, New York, c. 1959–64; Dr. and Mrs. Irving F. Burton, Huntington Woods, Mich., 1964

Figs. 40 and 41. In *Lecture at the Metropolitan* Max Weber
integrated the handling of pastel and the texture of the
support by varying the pressure with which the color
was applied. The artist created a middle tone by
applying the pastel lightly, so that it rests only on the
crests of the paper grain. He achieved a deeper tone
by applying heavier pressure, filling the furrows with
color.

GEORGIA O'KEEFFE
1887–1986

A Storm, 1922

Pastel on off-white laid paper, mounted on illustration
board, 18 × 24⅛ in.
Anonymous Gift, 1981 (1981.35)

Unlike many modernists, Georgia O'Keeffe intro-
duced mediums into her work cautiously, one at a
time, and digested each one slowly. In 1976 she
recalled:

> It was in the fall of 1915 that I first had the idea
> that what I had been taught was of little value to
> me except for the use of my materials as a
> language—charcoal, pencil, pen and ink, water-
> color, pastel and oil. I had become fluent with
> them when I was so young that they were simply
> another language that I handled easily. But what
> to say with them? . . . I began with charcoal and
> paper and decided not to use any color until it
> was impossible to do what I wanted to do in
> black and white. I believe it was June [1916]
> before I needed blue.[1]

O'Keeffe used pastel regularly from 1920 until
about 1945, but how and when she became fluent in
the medium is not clear.[2] She studied with William
Merritt Chase at the Art Students League from 1907
to 1908. "I loved using the rich pigment he admired
so much," she recalled, "but I began to wonder
whether this method would ever work for me."[3]
Immediately thereafter she stopped working for
four years and destroyed her student work.[4]

Two pastels of 1914 are O'Keeffe's earliest
surviving works in any medium.[5] They show swirling
abstract linear motifs and may have been executed
while she was studying with Arthur Wesley Dow at
Columbia University from 1914 to 1915. Dow had
"one dominating idea: to fill a space in a beautiful
way—and that interested me," she stated.[6] Elsewhere
she noted that he "gave us exercises in the arrange-
ment of color and shape, light and dark, smooth and
rough."[7] There may also be a connection between

these two early works and O'Keeffe's enthusiasm at
encountering Arthur G. Dove's pastel *Based on Leaf
Forms and Spaces,* 1911–12 (location unknown). She
recounted: "I discovered Dove and picked him out
before I was picked out and discovered. Where did I
see him? A reproduction in a book. The Eddy book,
I guess, a picture of Fall leaves. Then I trekked the
streets looking for others. In the Forum exhibition
there were 2 or 3—then later there were more."[8] In
addition, *A Storm* is reminiscent of Dove's charcoal
Thunderstorm, 1917–20 (The University of Iowa Mu-
seum of Art, Iowa City), and of his 1921 oil version
(Columbus Museum of Art, Ohio) in the stylized
treatment of the subject using contrasting curved
and sawtooth lines.

O'Keeffe's approach to pastel seems to have
evolved from her earlier experience with other
mediums. *A Storm,* with its sharp contours and
gradual transitions from light to dark, reflects her
earlier handling of charcoal, just as the broad,
washlike expanse and organic fusion of pigments
seem heir to her treatment of watercolor. The rich
pigmentation of *A Storm* and the application of the
pastel in a dense blanket, virtually impartial to the
laid-paper support, derive from her work in oil.

As *A Storm* suggests, the intensity of color that
pastel affords seems a likely rationale for her
adoption of the medium. In fact, her pastels and oils
were often named for the pigments employed. The
malleability of pastel probably also appealed to her.
In 1976 O'Keeffe was still impressed by her 1922
pastel *Single Alligator Pear* (Georgia O'Keeffe estate)
because "I have always considered it was one of the
times when I did what I really intended to do."[9] Her
pastels reveal her sensitivity to the exquisitely subtle
distinctions in application that this medium allows,
but her resolutely smooth pastel surfaces also act
passively as a foil for arresting color schemes and
motifs, as in *A Storm.*

O'Keeffe's pastels generally correspond in sub-
ject matter with contemporary oils. *A Storm* belongs
to a group of land- and seascape pastels of 1921 and
1922, most of which have titles that refer to either
Lake George or Maine, where O'Keeffe summered
from 1918 to 1928. *A Storm,* with its flat, bare

Fig. 42. Georgia O'Keeffe, *Lightning at Sea*, 1922, pastel on paper, 19 × 25½ in., The Lane Collection, Courtesy of the Museum of Fine Arts, Boston, Mass.

horizon, isolated lightning bolt, and broad funnel of rain shifting to rainbow, also has a pronounced western character reminiscent of watercolors O'Keeffe made in Amarillo in 1917.

Specific parallels can be drawn between the Museum's pastel and works acknowledged to have Texan thematic origins. A motif of rainbow-colored rings around a circle, conceivably abbreviated in the lower left of the pastel, was used for a series of ten watercolors, *Evening Star I-X*, 1917, inspired by the Texas dusk. O'Keeffe recalled: "We often walked away from the town in the late afternoon sunset. There were no paved roads and no fences, no trees—it was like the ocean, but it was wide, wide land. The evening star would be high in the sunset sky when it was still broad daylight. That evening star fascinated me."[10] The sweeping curves, flat horizon, and fusion of red, yellow, and black in *A Storm* find a precedent in *Red and Orange Streak*, 1919 (Georgia O'Keeffe estate), an oil that O'Keeffe mentioned having painted in New York "months after I left that wide world" and that she said was prompted by the sound of cattle lowing for their calves.[11]

A Storm was included in O'Keeffe's second one-man exhibition, in January and February 1923, organized by Stieglitz at Anderson Galleries.[12] As Daniel Catton Rich later remarked, "Many of the works shown were small in format and in many her color had not developed its full daring and control,"

whereas in her work of 1924 he detected an "enlargement of earlier organic rhythms" and a new "intense and unpredictable color."[13]

Critics have tended to look back on these images of 1921 and 1922 as the most direct and elemental responses to nature in her oeuvre.[14] In scanning an O'Keeffe retrospective at An American Place in 1934, Edward Alden Jewell singled out two maritime storm pictures of 1921 and 1922 for comment; one was most likely *Lightning at Sea*, 1922 (fig. 42). "As Benjamin Franklin baited lightning with a kited key, so O'Keeffe, in these impressions, has given it an everlasting investiture of brilliant abstract design. Perhaps her thrilling imprisonment of the sky's wild splendor may even outline—who can say?—our dynamos."[15]

M.W.F.

NOTES:

1. O'Keeffe 1976, unpaginated.

2. From 1920 until about 1945 pastel was the second most important medium in O'Keeffe's oeuvre. Between one and four pastels were interspersed among twenty-five to forty oils in most of her annual shows organized by Stieglitz during these years. For O'Keeffe exhibition check lists see Am. Art Res. Coun. Papers, Arch. Am. Art, microfilm N679, frames 084–211. For installation photographs of these exhibitions see microfilm NY59–15, frame 161f.

3. Quoted in Kuh 1962, p. 189.

4. Art Institute of Chicago, *Georgia O'Keeffe*, exhib. cat. by Daniel Catton Rich (Chicago, 1943), p. 12.

5. The pastels are *Special No. 32* and *Special No. 33* (both location unknown); ill. in Am. Art Res. Coun. Papers, Arch. Am. Art, microfilm NY59–13. Other early works, possibly pastels, entitled *Special Nos. 2, 3, 4*, and *7*, all dated 1915 (all location unknown), are illustrated in Downtown Gallery Papers, Arch. Am. Art, microfilm ND34, frames 627–29, 631.

6. Quoted in Kuh 1962, p. 190.

7. Quoted in Tomkins 1974, p. 42.

8. Quoted in Smith 1944, p. 27. Dove's pastel is illustrated in color in Arthur Jerome Eddy, *Cubists and Post-Impressionism* (Chicago, 1914), opp. p. 48. "I looked at the Eddy very carefully," wrote O'Keeffe (O'Keeffe 1976, unpaginated). Smith does not indicate when O'Keeffe came into contact with Eddy's book. O'Keeffe credited Alon Bement with recommending that she study the illustrations in it. She studied with Bement in the summer of 1912 at the University of Virginia, where she herself taught in the summers of 1913 to 1916.

9. O'Keeffe 1976, unpaginated.

10. Ibid.

11. Ibid. O'Keeffe's further assertion that "years later I painted it twice again. The cattle in the pen lowing for their calves day and night was a sound that has always haunted me" indicates the powerful grip that the West had on her, even years after her move to New York.

12. Known from an installation photograph, Am. Art Res. Coun. Papers, Arch. Am. Art, microfilm NY59–15, frame 161.

13. Art Institute of Chicago, *Georgia O'Keeffe*, p. 23.

14. Elizabeth McCausland, reviewing an O'Keeffe retrospective at MOMA in 1946, noted the artist's "simple eye" of "a quarter of a

century ago" and affirmed that "in the early work one can see a spirit stirred to the wonder and excitement of life, pulled to the forms of Nature" ("Georgia O'Keeffe in a Retrospective Exhibition," *Springfield Sunday Union and Republican*, May 26, 1946, p. 6C). To Jerome Mellquist, it was in a pastel landscape, *Birch and Blue*, c. 1921 (location unknown), that O'Keeffe "first confirmed the existence of an independent personality. . . . It depicted a summer day at Lake George. Two trees stood upon a bank, blue air circulated behind, and a current of joy was somehow conveyed through it" (*The Emergence of an American Art* [New York, 1942], p. 342).

15. Edward Alden Jewell, "Georgia O'Keeffe in an Art Review," *New York Times*, Feb. 2, 1934, p. 15. No check list could be located to determine whether *A Storm* might have been one of the works referred to by Jewell. The almost certain candidate *Lightning at Sea* (William H. Lane Foundation) appears in an installation photograph inscribed "An American Place, probably 1934 exhibition" (Am. Art Res. Coun. Papers, Arch. Am. Art, microfilm NY59–15,

frame 188). Unlike *A Storm* in its depiction of ships' sails and its more precise title, *Lightning at Sea* is similar in size, horizontal orientation, flat horizon, and stylization, particularly in its huge funnel of rain with broad, out-turned arcs converging on or springing from the lower center.

REFERENCES: E. A. Jewell, *New York Times*, Feb. 2, 1934, p. 15 // Am. Art Res. Coun. Papers, Arch. Am. Art, microfilm NY59–15, frame 161 // L. Goodrich, ed., Am. Art Res. Coun. Papers, Arch. Am. Art, microfilm N678, frame 710.

EXHIBITED: Anderson Galleries, New York, 1923, *Alfred Stieglitz Presents One Hundred Pictures: Oils, Watercolors, Pastels, Drawings, by Georgia O'Keeffe, American* // An American Place, New York, 1934, *Georgia O'Keeffe: Forty-four Selected Paintings (1915–1927)* (no cat. available; possibly this pastel).

EX COLLS.: Downtown Gallery, New York, c. 1960; private collection, Wilmington, Del.; Robert Miller Gallery, New York, c. 1980; private collection

PRESTON DICKINSON
1891–1930
The Water Gate, 1922

Pastel, charcoal, and India ink on off-white laid paper,
23 1/16 × 18 7/8 in.
Signed and dated at lower left: P. Dickinson '22
Gift of Sam A. Lewisohn, 1950 (50.40.2)

According to his friend Moritz Jagendorf, Preston
Dickinson "always said he favored pastels to water
colors because he could play with the pastels much
more."[1] For one whose art was synthetic in style as
well as technique, the pastel medium with its capacity
for manipulation seems a natural preference.

Dickinson was undoubtedly introduced to pastel
early in his career. He studied with William Merritt
Chase and Birge Harrison at the Art Students
League in New York from 1906 to 1910; and at the
Académie Julian in Paris, from about 1911 to 1912,
he worked with two leading French pastelists, Marcel
Baschet and Henri Royer.[2] Nevertheless, Dickinson
did not work seriously in pastel until the late teens,
when his burgeoning interest in color probably drew
him toward the medium. This was a time of
experimentation for Dickinson. Thomas Hart Ben-
ton related that in 1916 he and Dickinson tried
painting in Synchronist style.[3] Dickinson's sister, with
whom he lived, recalled that "about 1917 . . . he
spent months doing no painting, but studying the

work of the old Persians," rich in color.[4] In his
earlier works on paper he had used and often mixed
primarily black and white mediums—charcoal,
chalk, India ink, and pencil—all of which he would
come to use in combination with pastel, and some of
which likely conditioned his approach to it.

Works dating from his stay in Paris and from
shortly after his return to New York, at the outbreak
of World War I, indicate the wide range of art
materials and styles he encountered abroad. Dickin-
son especially liked to combine Western and non-
Western art materials, as evidenced in works of about
1915 portraying industry along the Harlem River.[5] In
1922 he again depicted the area in his first major
series of pastels. One of the few dated pastels in this
series, *The Water Gate* shows the waterworks buildings
that once stood near the George Washington Bridge.

In their restrained handling and palette, the
Harlem River pastels differ markedly from Dickin-
son's few known earlier works in the medium, which
are characterized by vigorous, sketchy treatment.[6]
They also differ in technique from his earlier
Harlem River images. He no longer integrated
Eastern and Western materials, but rather worked
the pastel and ink to evoke Oriental qualities. One
essayist wrote: "The delicacy of line in his pastels . . .
the chalk barely skipping across the surface of the
paper, is reminiscent of oriental brushwork."[7] The
artist Louis Bouché likened Dickinson's color to the
"tones of silk dyes," an apt comment, since in *The
Water Gate* finely fused browns and blues interact

Fig. 43. In *The Water Gate* Preston Dickinson manipulated the different textural properties of charcoal, ink, and pastel. The limited but vivid pastel palette and the charcoal are lightly played over the laid paper to reveal its surface. In contrast, the pronounced outlines in smooth, lustrous black ink obscure the support. The central field of this sheet has darkened due to the oxidation of the fixative that was applied to it in the past.

with the grain of the laid paper, calling to mind Chinese silk.[8]

In contrast to his industrial landscapes of 1915, the later works, suggested Ruth Cloudman, "convey a more realistic, though still lyrical response to the landscape. . . . Dickinson draws on the qualities of pastel . . . and even of the paper itself, to suggest the surfaces of the subjects, from the stonework of . . . buildings to the soft smudge of smoke."[9] Yet in *The Water Gate* he struck a delicate balance between realism and abstraction. The strokes representing the masonry serve as a vehicle for the decorative surface play of mediums. Likewise, despite the seeming realism of the composition, vertical and

horizontal lines intersect neatly at its center and divide it abstractly. Here again the animation of the mediums contributes much to the disguise. Pastel, ink, and charcoal are so painstakingly applied that each architectural surface is uniquely detailed and invites close scrutiny. The resulting planarity, similar in feeling to Paul Cézanne's work, competes with the massiveness of the subject, recalling the bulky forms of Giotto, whose work Dickinson reportedly admired.[10]

The Water Gate may have been among the Harlem River landscapes featured in Dickinson's first one-man show, held at Daniel Gallery in April 1923. The pastels were especially well received; one critic wrote: "In many cases I personally enjoyed them even more than his paintings."[11]

<div align="right">M.W.F.</div>

NOTES:

1. Quoted in William M. Milliken, "Dickinson, Preston," *DAB*, supp. 1 (1944), p. 246.

2. Baschet and Royer, both later active in the Société des Pastellistes, were noted for their highly finished, delicately colored society portraits in the medium. Royer exhibited two pastel portraits in the 1912 Exposition Nationale des Beaux-Arts, to which Dickinson submitted two oils.

3. Thomas Hart Benton, *An American in Art: A Professional and Technical Biography* (Lawrence, Kans., 1969), p. 53. For a recent study of Synchronism see WMAA 1978.

4. Enid Dickinson Collins, "Biographical Sketch of Preston Dickinson" (Northampton, Mass., 1934), unpaginated MS.

5. *Tower of Gold*, c. 1915–17 (Stephen Lion; oil and gold leaf on canvas), and *High Bridge*, c. 1915 (Ella M. Foshay; ink and charcoal on rice paper), document his study of Islamic and Chinese painting, respectively. The fact that Dickinson was abroad during the Armory Show may actually have drawn him toward an even broader range of stylistic influences and mediums.

6. See Dickinson's earliest recorded pastel, *Composition Landscape*, c. 1916 (Robert Hull Fleming Museum, University of Vermont, Burlington), and the watercolor and pastel *The Black House*, c. 1919 (Columbus Museum of Art). In one exhibition catalogue, in fact, *The Water Gate* was mistaken for a "pastel with wash" (MMA, *One Hundred American Painters of the Twentieth Century*, alphabetical check list [New York, 1950], p. xiv).

7. Catherine Turrill, "Preston Dickinson," in Delaware Art Museum, *Avant-garde Painting and Sculpture in America, 1910–1925*, exhib. cat. (Wilmington, 1975), p. 64.

8. Louis Bouché, "Preston Dickinson," *Living American Art Bulletin*, Oct. 1939, p. 3.

9. Sheldon 1979, p. 26.

10. Ibid., p. 19.

11. Alexander Brook, "The Exhibitions," *Arts* 3 (Apr. 1923), p. 276. Other writers shared Brook's opinion. For example, in Jerome Mellquist's view, Dickinson "developed a personal style in the pastel. Indeed, he is to be noted for his production in this medium rather than for his oils. . . . Something in his dry, precise, crisp temperament suited him to it" (*The Emergence of an American Art* [New York, 1942], p. 320). Holger Cahill and Alfred H. Barr, Jr., asserted that "next to Mary Cassatt he was the greatest American virtuoso of the pastel medium" (*Art in America in Modern Times* [New York, 1934], p. 37).

EXHIBITED: Daniel Gallery, New York, 1923, *Paintings and Drawings by Preston Dickinson*, no. 4 (no cat. available; probably this pastel) // Cleveland Museum of Art, 1930, *Eighth Exhibition of Watercolors and Pastels*, no. 2453.30 (no cat. available) // MMA, 1950, *One Hundred American Painters of the Twentieth Century* (alphabetical check list), p. xiv, as The Ramparts, Quebec // Sheldon Memorial Art Gallery, University of Nebraska, Lincoln, 1979, *Preston Dickinson, 1889–1930*, exhib. cat. by R. Cloudman, no. 27, pp. 26, 106, ill. p. 107.

EX COLLS.: Daniel Gallery, New York; Sam A. Lewisohn, New York, 1927.

PRESTON DICKINSON
Still Life

Pastel on white laid paper, mounted on cardboard,
18⅞ × 25 in.
Signed at lower right: Preston Dickinson
The Lesley and Emma Sheafer Collection, Bequest of
Emma A. Sheafer, 1973 (1974.356.18)

Preston Dickinson's second one-man exhibition,
held in 1924 at Daniel Gallery, featured still lifes, a
subject that emerged in his work in about 1922 and
remained important thereafter. Still lifes were well
suited to Dickinson, who, from the outset of his
career, delighted in varying motifs, mediums, color
schemes, and compositional arrangements. The still
lifes he exhibited in 1924, hailed as "living designs
modeled and luxuriously rich in form and magnifi-
cent in color," departed significantly in style and
technique from the industrial landscapes typical of
his earlier work.[1] Staccato handling of the pastel and
bold calligraphy gave way to fine penciled outlines
filled in with smoothly modulated pastel. Blunt lines
and rectilinear forms were replaced by flowing,
curvilinear contours, like those of Henri Matisse,
whom Dickinson greatly esteemed.[2]

By bathing a rounded surface in various hues,
as in *Still Life*, Dickinson created an opalescent
chiaroscuro, which characterized his pastels of later
years. As the 1920s progressed, the objects in his still
lifes appeared increasingly plastic and the lighting
more dramatic. Like his other still lifes, this example
incorporates objects with light-reflective, light-
refractive, and light-absorptive surfaces that provided
an ideal vehicle for his sensuous and responsive
application of pastel, here ranging from the sheen of a
knife blade to the gloss of pickles to the matte
surfaces of crackers and bread sticks. Dickinson's
sinuous, elongated forms, his electric, mannered
color schemes, and his unsettling spatial distortions,
all evident in this pastel, are reminiscent of the art of
El Greco, which Dickinson is said to have revered.[3]

M.W.F.

NOTES:

1. "Art: Exhibitions of the Week," *New York Times*, May 4, 1924,
sec. 8, p. 5.

2. Sheldon 1979, p. 27.

3. Ibid., p. 33. For some critics Dickinson proved too manip-
ulative with still-life subjects. One, for example, marveled at their
"masterful . . . edges and their clever refractions of color," but
hastened to add, "they lack vitality. They are too obviously
arranged" (Duncan Phillips, *A Collection in the Making* [New York,
1926], pp. 74–75).

EX COLL.: Lesley and Emma A. Sheafer, New York

Check List of American Pastels in The Metropolitan Museum of Art

This check list includes American works in pastel—exclusively or in conjunction with other mediums—that were acquired before 1983 by the departments of American Art, Prints and Photographs, and Twentieth Century Art or by the Robert Lehman Collection. Artists are arranged alphabetically; unknown artists appear first. Pastels by each artist are ordered by accession number. The color and texture of the support are given unless the pastel layer is so thick that they cannot be determined.

Benjamin Franklin (1706–1790)
Pastel on paper, 21⅜ × 17 in.
Gift of William H. Huntington, 1883
83.2.467

Thomas Dering (1720–1785)
Pastel on paper, 22⅛ × 17¼ in.
Gift of Sylvester Dering, 1916
16.68.1

Head of a Young Woman
Pastel on paper, 16 × 11¾ in.
Bequest of Helen Hay Whitney, 1944
45.128.17

North Battery or "Red Fort"
Pastel on pumice paper, 9¹⁄₁₆ × 14½ in.
The Edward W. C. Arnold Collection of
 New York Prints, Maps, and Pictures,
 Bequest of Edward W. C. Arnold, 1954
54.90.276

Profile of a Woman
Graphite pencil and pastel on paper,
 11¾ × 9⅝ in.
Gift of Edgar William and Bernice Chrysler
 Garbisch, 1966
66.242.10

Profile of a Man
Graphite pencil and pastel on paper,
 11¾ × 9¾ in.
Gift of Edgar William and Bernice Chrysler
 Garbisch, 1966
66.242.11

Captain Abraham Vorhees
Pastel on off-white wove paper,
 26 × 22 in.
Gift of Edgar William and Bernice Chrysler
 Garbisch, 1966
66.242.15

Mrs. Abraham Vorhees
(née Leah Nevins)
Pastel on off-white wove paper, with black
 grosgrain ribbon applied on cap and
 under chin, 26³⁄₁₆ × 22 in.
Gift of Edgar William and Bernice Chrysler
 Garbisch, 1966
66.242.16

EDWIN AUSTIN ABBEY
(1852–1911)

The Dirge of the Three Queens
Pastel on brown wove paper, mounted on
 canvas, 29 × 45¼ in.
Signed, dated, and inscribed at lower left:
 E A Abbey 1895 / Copyrighted by
 E A Abbey 1895
Gift of Mrs. Edwin A. Abbey, 1918
18.142

PEGGY BACON
(1895–1987)

The Great Question
Pastel on off-white wove paper,
 19¾ × 25⅝ in.
Signed at lower right: Peggy Bacon
George A. Hearn Fund, 1939
39.99.4

Moonlight Sonata
Pastel on light tan wove paper,
 20½ × 26⅛ in.
Signed and dated at lower right: Peggy
 Bacon / Nov. [1939 or 1934]
George A. Hearn Fund, 1945
45.34.1

J. CARROLL BECKWITH
(1852–1917)

The Veronese Print
Black chalk and pastel on wove paper
 (originally blue), 10¾ × 8½ in.
Signed at upper left: CARROLL BECKWITH
Gift of Janos Scholz, 1949
49.167

Seated Female Figure with Birds
Black, white, and sanguine chalk, and pastel
 on gray wove paper, 7⅛ × 6⅞ in.
Signed at lower center: CARROLL BECKWITH
Gift of Mrs. Henry L. Moses, 1961
61.168.4

ROBERT BLUM
(1857–1903)

The Cherry Trees
Pastel on coarsely textured paper (originally
 blue-gray), 10 × 12½ in.
Stamped at lower right: BLUM [within a
 square]
Bequest of Susan Vanderpoel Clark, 1967
67.155.6

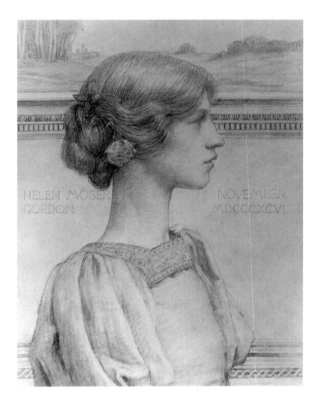

BRYSON BURROUGHS
(1869–1934)

Mrs. Helen Moser Gordon
Pastel, and gold and lead-white paint on off-
white wove paper, 19⅞ × 15½ in.
Signed at lower right: Bryson Burroughs.
Inscribed at center left: HELEN
MOSER / GORDON; at center right:
NOVEMBER / MDCCCXCVI
Gift of Atherton Curtis, 1936
36.38.1

Study of a Child
Pastel and graphite pencil on tan wove
paper, 21½ × 12 in.
Signed and dated at upper right: BRYSON
BURROUGHS. 1896.
Gift of Atherton Curtis, 1936
36.38.2

*Mars and Venus Caught
in the Web of Vulcan*
Pastel, graphite pencil, and brown ink on
off-white laid paper, 12½ × 8½ in.
Anonymous Gift, 1951
51.78.1

HOWARD RUSSELL BUTLER
(1856–1934)

Marine: Sunlight, Seas Beyond
Pastel on off-white wove paper, mounted on
cardboard, 6¾ × 9¾ in.
Signed at lower right: H.R.B.
Gift of H. Russell Butler, Jr., 1976
1976.226.2

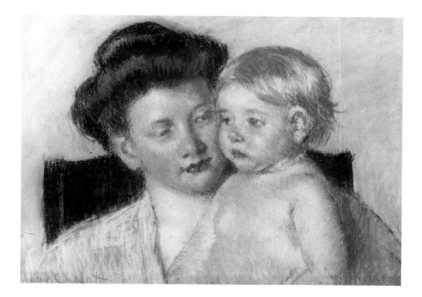

MARY CASSATT
(1844–1926)

Mother and Child
Pastel on wove paper (now discolored),
 11½ × 19¾ in.
Signed at lower left: Mary Cassatt
From the Collection of James Stillman,
 Gift of Dr. Ernest G. Stillman, 1922
22.16.21

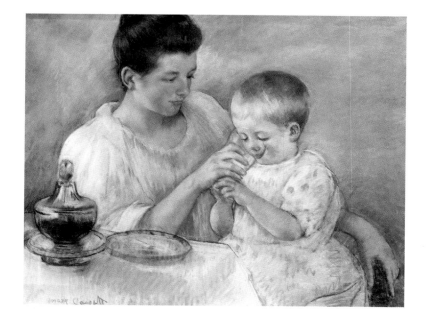

Mother Feeding Child
Pastel on wove paper (now discolored),
 mounted on canvas, 25½ × 32 in.
Signed at lower left: Mary Cassatt
From the Collection of James Stillman,
 Gift of Dr. Ernest G. Stillman, 1922
22.16.22

Mother Playing with Her Child
Pastel on wove paper (now discolored),
 25½ × 31½ in.
Signed at lower right: Mary Cassatt
From the Collection of James Stillman,
 Gift of Dr. Ernest G. Stillman, 1922
22.16.23

Child in a Green Coat
Pastel on white paper, 23½ × 19½ in.
Signed at lower right: Mary Cassatt
From the Collection of James Stillman,
 Gift of Dr. Ernest G. Stillman, 1922
22.16.24

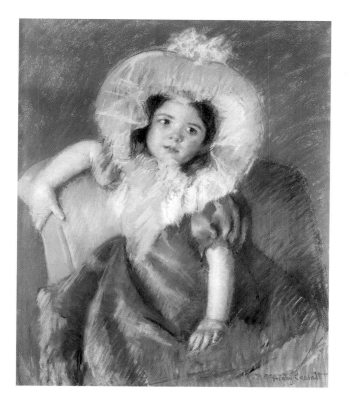

Margot in Orange Dress

Pastel on wove paper (now discolored),
 mounted on linen, originally on a
 strainer, 28⅝ × 23⅝ in.
Signed at lower right: Mary Cassatt
From the Collection of James Stillman,
 Gift of Dr. Ernest G. Stillman, 1922
22.16.25

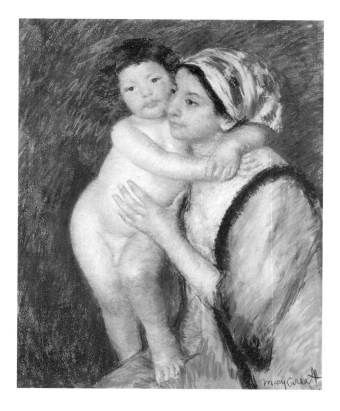

Mother and Child

Pastel on wove paper (now discolored),
 mounted on canvas, originally on a
 strainer, 32 × 25⅝ in.
Signed at lower right: Mary Cassatt
Bequest of Mrs. H. O. Havemeyer, 1929,
 H. O. Havemeyer Collection
29.100.49

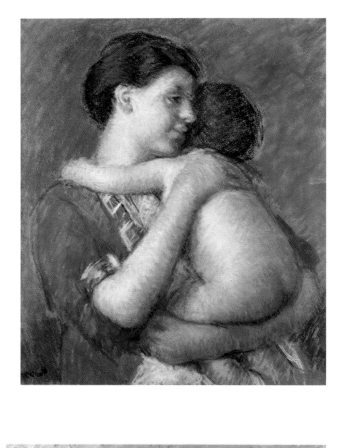

Mother and Child
Pastel on wove paper (now discolored),
 mounted on canvas, 26⅝ × 22½ in.
Signed at lower left: Mary Cassatt
Bequest of Mrs. H. O. Havemeyer, 1929,
 H. O. Havemeyer Collection
29.100.50

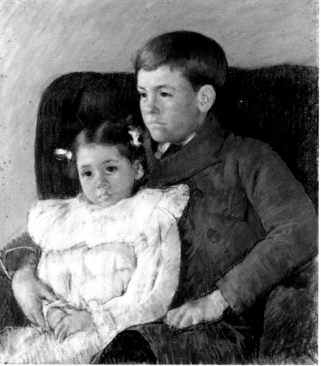

Gardner and Ellen Mary Cassatt
Pastel on wove paper (now discolored),
 originally on a strainer, 25 × 18¾ in.
Signed at lower right: Mary Cassatt
Gift of Mrs. Gardner Cassatt, 1957
57.182

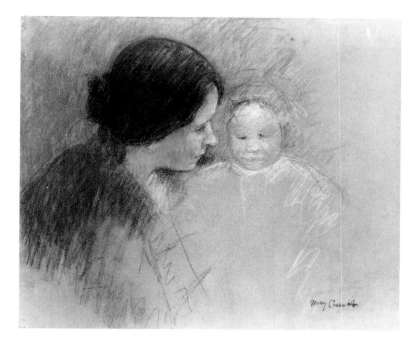

Mother and Child
Pastel on wove paper (now discolored),
 mounted on canvas, originally on a
 strainer, 21¼ × 25¾ in.
Signed at lower right: Mary Cassatt
Gift of Mrs. Gardner Cassatt, 1958
58.191.1

Woman on a Bench
Pastel on green wove paper, mounted on
 illustration board, 18⁵⁄₁₆ × 24⅛ in.
Gift of Mrs. Gardner Cassatt, 1958
58.191.2

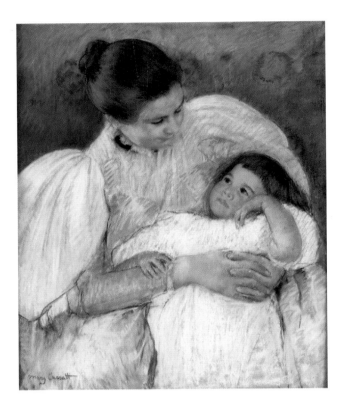

Nurse and Child
Pastel on wove paper (originally blue),
 mounted on canvas, 31½ × 26¼ in.
Signed at lower left: Mary Cassatt
Gift of Mrs. Ralph J. Hines, 1960
60.181

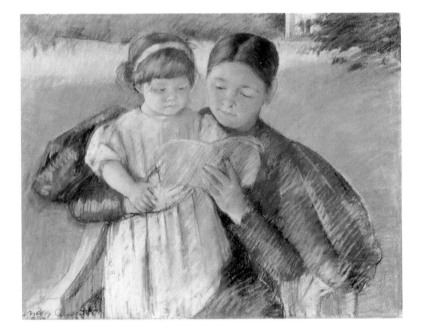

Nurse Reading to a Little Girl
Pastel on wove paper (now discolored),
 mounted on canvas, 23⅝ × 28¾ in.
Signed at lower left: Mary Cassatt / [95]
Gift of Mrs. Hope Williams Read, 1962
62.72

HOWARD CHANDLER CHRISTY
(1872–1952)

Woman in a White Dress
Pastel and gouache on cardboard,
 38¼ × 18¾ in.
Inscribed, signed, and dated at lower left:
 To Lieut Hutch Scott / from your friend /
 Howard Chandler Christy / Mar 17th
 [1906 or 1908]
George A. Hearn Fund, 1960
60.90

WILLIAM CLUTZ
(b. 1933)

Landscape
Pastel on white wove paper, 28¼ × 22¼ in.
Signed and dated at lower left: Clutz 80
Gift of Robert H. Luck, 1980
1980.576

Bus Stop
Pastel on white wove paper, 28¼ × 22¼ in.
Signed and dated at lower right: Clutz 80
Gift of Suzanne Cole, in memory of Marian
 and Wallace H. Cole, 1980
1980.578

GLENN O. COLEMAN
(1887–1932)

Posters Wanted
India ink, charcoal, Conté crayon, and pastel
 on tan bristol board, 22¾ × 18½ in.
Signed at lower right: Coleman
Purchase, Robert E. Grow Gift, 1983
1983.174

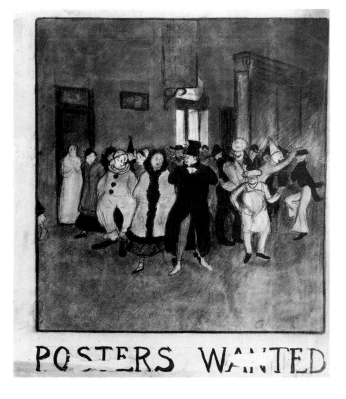

JOHN S. COPLEY
(1738–1815)

Mrs. Edward Green
Pastel on laid paper, 23 × 17½ in.
Signed and dated at left center: John S.
 Copley / fect 1765
Charles B. Curtis Fund, 1908
08.1

Mr. Ebenezer Storer
Pastel on laid paper, mounted on canvas, on
 a strainer, 24 × 18 in.
Gift of Thomas J. Watson, 1940
40.161.1

Mrs. Ebenezer Storer (née Mary Edwards, 1700–1771)
Pastel on laid paper, mounted on canvas, on a strainer, 24 × 18 in.
Gift of Thomas J. Watson, 1940
40.161.2

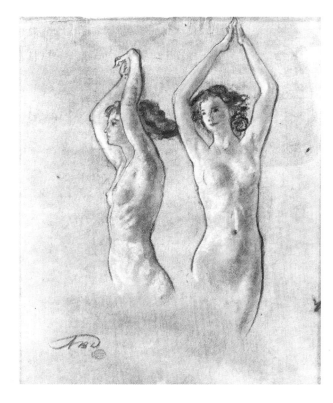

ARTHUR B. DAVIES
(1862–1928)

Nude Studies
Pastel and black chalk on dark tan Japan paper, toned with a persimmon-juice wash, 16½ × 12 in.
Signed at lower left: ABD
Anonymous Gift, 1909
09.90.1

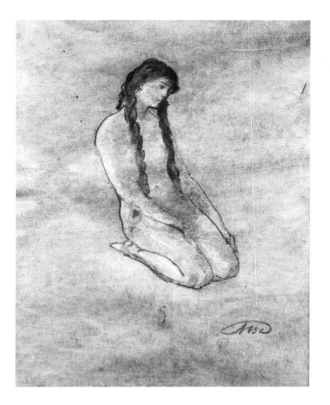

Girl Kneeling
Pastel and black chalk on tan Japan paper,
 toned with a persimmon-juice wash,
 16½ × 12 in.
Signed at lower right: ABD
Anonymous Gift, 1909
09.90.2

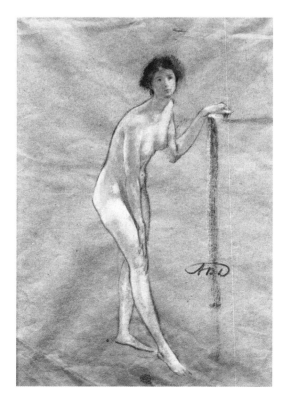

Nude Study
Pastel and black chalk on tan Japan paper,
 toned with a persimmon-juice wash,
 17¾ × 13⅛ in.
Signed at lower right: ABD
Anonymous Gift, 1909
09.90.4

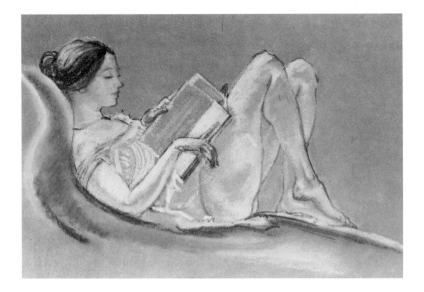

Reclining Woman
Pastel on gray paper, 8⅜ × 11½ in.
Alfred Stieglitz Collection, 1949
49.70.54

Landscape with Clouds
Pastel on gray-green wove paper, 6 × 11 in.
Gift of A. W. Bahr, 1958
58.21.1

Trees
Pastel on black wove paper, 7¾ × 10¼ in.
Gift of A. W. Bahr, 1958
58.21.2

Blue Landscape
Pastel on dark blue wove paper, 6⅜ × 11½ in.
Gift of A. W. Bahr, 1958
58.21.3

The Red Barn
Pastel and graphite pencil on buff laid paper,
6⅜ × 9¾ in.
Dated at lower left: May 4ᵗʰ 1895
Gift of A. W. Bahr, 1958
58.21.19

Spring
Pastel on gray-green wove paper,
 7¼ × 10⅜ in.
Gift of A. W. Bahr, 1958
58.21.24

Landscape: Fields
Pastel on blue Japanese paper, 7¾ × 12⅛ in.
Gift of A. W. Bahr, 1958
58.21.25

Cliffs and Waves
Pastel on dark gray wove paper,
10¼ × 12½ in.
Gift of A. W. Bahr, 1958
58.21.26

Pine Tree, Dogwood, and Sailboat
Pastel on gray laid paper, 7 × 11 in.
Gift of A. W. Bahr, 1958
58.21.27

Mysterious Barges I
Pastel on buff wove paper, 5⅝ × 8¾ in.
Gift of A. W. Bahr, 1958
58.21.28

Mountains in Moonlight
Pastel and tempera on dark blue wove
 paper, 8 × 11 9/16 in.
Gift of A. W. Bahr, 1958
58.21.30

The Bright Blue Ocean
Pastel on dark gray wove paper,
10⅜ × 12½ in.
Gift of A. W. Bahr, 1958
58.21.31

Surf on Rocks
Pastel on dark gray wove paper,
10³⁄₁₆ × 12½ in.
Gift of A. W. Bahr, 1958
58.21.32

Ocean Swells
Pastel on dark gray wove paper, 9 × 12½ in.
Gift of A. W. Bahr, 1958
58.21.33

Bear Island Light
Pastel on blue wove paper, 10⅛ × 12⅜ in.
Gift of A. W. Bahr, 1958
58.21.34

Boat in Distress
Pastel on gray wove paper, 10¼ × 12½ in.
Gift of A. W. Bahr, 1958
58.21.35

Heavy Weather
Pastel on dark gray wove paper,
 9⅜ × 12½ in.
Gift of A. W. Bahr, 1958
58.21.36

Autumn Trees
Pastel on light gray laid paper, 7⅜ × 11 in.
Gift of A. W. Bahr, 1958
58.21.37

Landscape: Two Trees
Pastel on medium gray wove paper,
 7⅜ × 11⅜ in.
Gift of A. W. Bahr, 1958
58.21.38

Red Autumn Trees
Pastel on gray-green wove paper, 7 × 10 in.
Gift of A. W. Bahr, 1958
58.21.39

Spring Landscape
Pastel on thin gray laid paper, 7¼ × 10¾ in.
Gift of A. W. Bahr, 1958
58.21.40

Hill Town
Pastel on light orange-brown wove paper,
 10¹³⁄₁₆ × 12¹¹⁄₁₆ in.
Gift of A. W. Bahr, 1958
58.21.41

Dry Landscape
Pastel on pink-orange wove paper,
 6¼ × 10 in.
Gift of A. W. Bahr, 1958
58.21.42

Pine Woods
Pastel on dark buff wove paper,
5¾ × 8¹³⁄₁₆ in.
Gift of A. W. Bahr, 1958
58.21.43

Through the Poplars
Pastel on blue Japanese paper, 7½ × 11 in.
Gift of A. W. Bahr, 1958
58.21.44

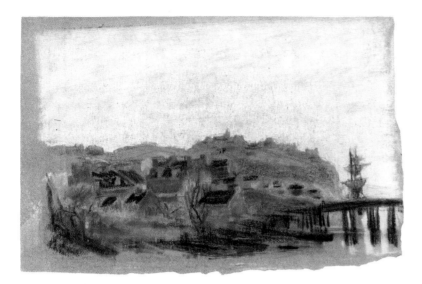

Village on the Shore
Pastel on gray wove paper, mounted on
 cardboard, 10¼ × 15 in.
Gift of A. W. Bahr, 1958
58.21.45

Landscape with Yellow Tree
Pastel on dark blue wove paper,
 6¼ × 10¼ in.
Gift of A. W. Bahr, 1958
58.21.46

Meadow Weeds
Pastel on light blue Japanese paper,
 6⅛ × 11¼ in.
Dated at lower right: Nov. 1ˢᵗ 1908
Gift of A. W. Bahr, 1958
58.21.47

Wood Scene
Pastel on green-brown wove paper,
 7⅛ × 11½ in.
Gift of A. W. Bahr, 1958
58.21.48

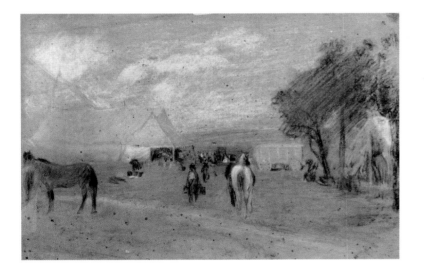

Fair Grounds
Pastel on gray-brown wove paper,
 10¼ × 15¼ in.
Gift of A. W. Bahr, 1958
58.21.49

Two Horses Grazing
Pastel on tan wove paper, 7½ × 10 in.
Gift of A. W. Bahr, 1958
58.21.50

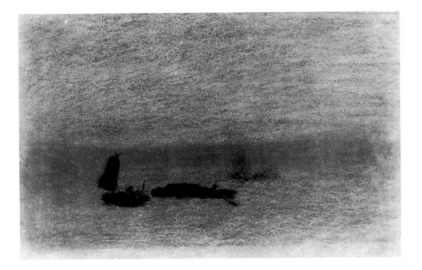

Boats at Night
Pastel on brown-gray wove paper,
 7⅜ × 11⅛ in.
Gift of A. W. Bahr, 1958
58.21.51

Mysterious Barges II
Pastel on buff wove paper, 5½ × 8¾ in.
Gift of A. W. Bahr, 1958
58.21.52

Islands of Victories
Pastel on light buff wove paper, 9¾ × 10 in.
Inscribed at lower center:
 Islands of Victories
Gift of A. W. Bahr, 1958
58.21.53

Islands of Victories

Boats at Evening
Pastel on buff wove paper, 5¾ × 8⅞ in.
Gift of A. W. Bahr, 1958
58.21.54

Spring Woods
Pastel on medium gray laid paper,
 7¼ × 10¾ in.
Gift of A. W. Bahr, 1958
58.21.55

Trees and Fields
Pastel on medium gray laid paper,
 7⅜ × 11 in.
Gift of A. W. Bahr, 1958
58.21.56

Autumn Colors
Pastel on light buff wove paper, 6⅜ × 10⅛ in.
Gift of A. W. Bahr, 1958
58.21.57

Meadow Edge
Pastel on off-white wove paper, 5¼ × 10 in.
Gift of A. W. Bahr, 1958
58.21.58

Trees in Spring
Pastel on light gray wove paper,
 19⅜ × 6⁹⁄₁₆ in.
Gift of A. W. Bahr, 1958
58.21.59

Spring Beauties
Pastel and graphite pencil on buff wove
 paper, mounted on cardboard, 11⅛ × 6 in.
Inscribed at lower center: Spring Beauties.
 Dated at lower right: May 7th 1895
Gift of A. W. Bahr, 1958
58.21.60

Across the Valley
Pastel on cerulean blue Japanese paper,
 7⅝ × 10⅝ in.
Gift of A. W. Bahr, 1958
58.21.61

Landscape with Cedars
Pastel on gray Japanese paper, 6⅞ × 10⅜ in.
Gift of A. W. Bahr, 1958
58.21.62

High Point
Pastel on dark gray wove paper, mounted on
 cardboard, 7⅜ × 13 in.
Gift of A. W. Bahr, 1958
58.21.63

181 Arthur B. Davies

The Lake
Pastel on gray-brown wove paper,
 9½ × 12½ in.
Gift of A. W. Bahr, 1958
58.21.64

Tree Study
Pastel on blue wove paper, 7⅜ × 11⁷⁄₁₆ in.
Gift of A. W. Bahr, 1958
58.21.65

Autumn Woods
Pastel on dark gray-green wove paper,
 7¼ × 11 in.
Gift of A. W. Bahr, 1958
58.21.66

Pickerel Weed
Pastel on gray laid paper, 7³⁄₁₆ × 10⅞ in.
Gift of A. W. Bahr, 1958
58.21.67

House on Hillside
Pastel on gray-green laid paper, 7⅝ × 10 in.
Gift of A. W. Bahr, 1958
58.21.69

Blue Thicket
Pastel on gray laid paper, 7⅛ × 10¾ in.
Gift of A. W. Bahr, 1958
58.21.70

Landscape with Cows

Watercolor, gouache, graphite pencil, and
 pastel on blue wove paper, 12⅝ × 9⅝ in.
Stamped at lower right: Arthur B. Davies
Bequest of Susan Dwight Bliss, 1966
67.55.137

Coast Scene with Boat

Watercolor, pastel, and wax crayon on buff
 paper with scattered blue fibers,
 9½ × 12½ in.
Stamped at lower right: Arthur B. Davies
Bequest of Susan Dwight Bliss, 1966
67.55.138

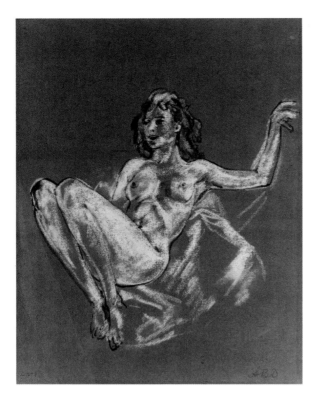

Girl
Pastel and charcoal on brown wove paper,
17¼ × 12⅜ in.
Inscribed at lower left: [illegible] 2781.
Signed at lower right: ABD
Bequest of Miss Adelaide Milton de Groot
(1876–1967), 1967
67.187.147

Thomas W. Dewing
(1851–1938)

The Evening Dress
Pastel on brown wove paper, mounted on
cardboard, 14½ × 11 in.
Signed and numbered at lower right:
Tᵂ Dewing / 117
George A. Hearn Fund, 1966
66.157

PRESTON DICKINSON
(1891–1930)

The Water Gate
Pastel, charcoal, and India ink on off-white
 laid paper, 23 1/16 × 18 7/8 in.
Signed and dated at lower left:
 P. Dickinson '22
Gift of Sam A. Lewisohn, 1950
50.40.2

Still Life
Pastel on white laid paper, mounted on
 cardboard, 18 7/8 × 25 in.
Signed at lower right: Preston Dickinson
The Lesley and Emma Sheafer Collection,
 Bequest of Emma A. Sheafer, 1973
1974.356.18

W. HUNT DIEDERICH
(1884–1953)

Horse Race
Pastel on brown wove paper, 12 × 20⅛ in.
Signed at lower right: WHD
Gift of A. W. Bahr, 1958
58.21.7

ARTHUR G. DOVE
(1880–1946)

Cow
Pastel on linen, 18 × 20⅝ in.
Alfred Stieglitz Collection, 1949
49.70.72

Pagan Philosophy
Pastel on cardboard, 21½ × 18 in.
Alfred Stieglitz Collection, 1949
49.70.74

Sentimental Music
Pastel on gray paper, mounted on plywood,
 21¼ × 17⅞ in.
Alfred Stieglitz Collection, 1949
49.70.77

Tree Forms and Water
Pastel on plywood, 29¾ × 25⅞ in.
Alfred Stieglitz Collection, 1949
49.92.3

ROBERT EBENDORF
(b. 1938)

Design for a Brooch, #6038
Pastel, graphite pencil, and ink on tracing
 paper, 8⅞ × 6⅛ in.
Gift of the artist, 1980
1980.330

HUGH FERRISS
(1889–1962)

Facade of the Main Entrance to The Metropolitan Museum of Art

Pastel and charcoal on off-white paper,
 15⅛ × 18¼ in.
Gift of Mrs. Hugh Ferriss, 1963
63.82.2

ERNEST FIENE
(1894–1965)

Granary

Pastel and charcoal on white wove paper,
 14¼ × 22⅝ in.
Signed and dated at lower right:
 Ernest Fiene 36
The Lesley and Emma Sheafer Collection,
 Bequest of Emma A. Sheafer, 1973
1974.356.4

Factory Building and Riverboat
Pastel and charcoal on white wove paper,
 15 × 22½ in.
Signed and dated at lower left:
 Ernest Fiene 1936
The Lesley and Emma Sheafer Collection,
 Bequest of Emma A. Sheafer, 1973
1974.356.5

Locomotive
Pastel and charcoal on white wove paper,
 14½ × 22¾ in.
Signed and dated at lower right:
 Ernest Fiene 36–
The Lesley and Emma Sheafer Collection,
 Bequest of Emma A. Sheafer, 1973
1974.356.6

JANET FISH
(b. 1938)

Green Grapes
Pastel and watercolor on white wove paper,
 28½ × 25¼ in.
Numbered, signed, and dated at lower right:
 87 / Janet Fish 79 ©
Purchase, Lila Acheson Wallace Gift, 1980
1980.15

THOMAS FLAVELL
(b. 1906)

Composition of a House
Pastel on tracing paper, 14½ × 19¾ in.
Gift of the Pennsylvania W.P.A., 1943
43.46.7

Atlantic & Pacific
Pastel on white wove paper, 19¼ × 24⅛ in.
Signed at lower right: Thomas Flavell
Gift of the Pennsylvania W.P.A., 1943
43.46.8

KENNETH FRAZIER
(1867–1949)

Woman Asleep on a Pillow
Pastel and charcoal on brown-gray wove
 paper (reverse: *Woman in Red*, pastel),
 9½ × 14½ in.
Inscribed at bottom: A LA TRES CHERE—A LA
 TRÈS BELLE—QUI REMPLIT MON COEUR
 de clarté · · A JUVINS ETC. Stamped
 on reverse: THE ESTATE OF
 KENNETH FRAZIER
Gift of Mrs. Leonard Spencer Karp, in
 memory of her husband, 1981
1981.200

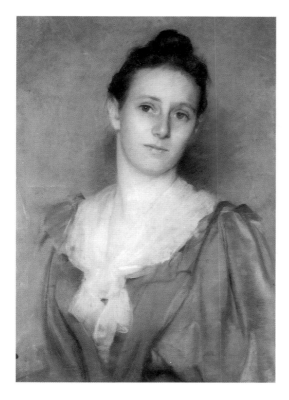

DANIEL CHESTER FRENCH
(1850–1931)

Mrs. Edward Clark Potter
(née May Dumont)
Pastel on off-white wove paper, 18 × 24 in.
Inscribed at lower left: D.C.F. / to E.C.P. /
1894. Stamped on reverse: EXPOSITION
UNIVERSELLE DE 1855 / MENTION
HONORABLE / PAPIER, CARTON. CHASSIS,
TOILES / ANTI-PONCE pour le Pastel / P. L.
Breveté PARIS / MARQUE DÉPOSÉE
Gift of Fenton L. B. Brown, 1980
1980.513

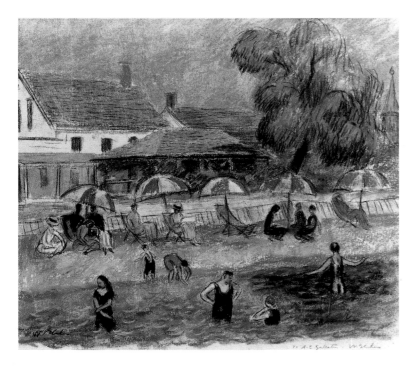

WILLIAM GLACKENS
(1870–1938)

Beach Scene
Pastel and black chalk on white wove paper,
17¼ × 22 in.
Signed at lower left: W. Glackens. Inscribed
at lower right: To A. E. Gallatin—
W. Glackens
Gift of A. E. Gallatin, 1915
15.151

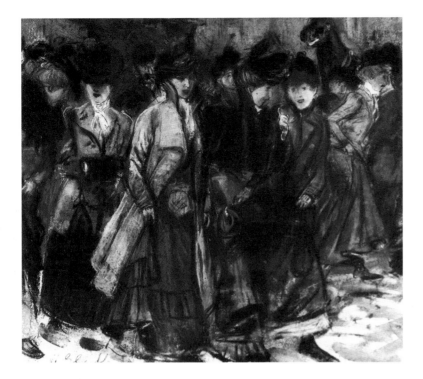

Shop Girls
Pastel and watercolor on illustration board,
 13⅞ × 15⅛ in.
Signed at lower left: W. Glackens. Inscribed
 on reverse: W. Glackens 13 W 30th St
 New York. / The. Shop Girls. a sketch. /
 Price. $30. Stamped on reverse: WINSOR
 & NEWTON'S / ILLUSTRATION BOARD. /
 LONDON & NEW YORK.
Gift of A. E. Gallatin, 1923
23.230.1

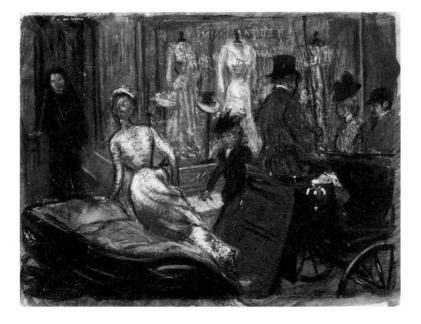

At the Milliner's
Pastel on brown wove paper, mounted on
 cardboard, 10⅛ × 13⅛ in.
Gift of Mr. and Mrs. Raymond J. Horowitz,
 1968
68.20

ARSHILE GORKY
(1904–1948)

Portrait
Pastel, charcoal, and watercolor on tan wove
 paper, 27¾ × 21¾ in.
Gift of David A. Prager, 1983
1983.109

JOHN GRILLO
(b. 1917)

Untitled
Pastel on off-white laid paper, 25 × 19 in.
Signed and dated at lower right: Grillo '48.
 Inscribed on reverse: John Grillo / Drawn
 in class of / Hans Hofmann / on 8th St /
 1948
Gift of the artist, 1978
1978.450

MARSDEN HARTLEY
(1877–1943)

Lobster Fishermen
Pastel on light brown wove paper,
 21¼ × 27 in.
Arthur Hoppock Hearn Fund, 1956
56.77

JOSEPH HIRSCH
(1910–1981)

Air Raid
Pastel on red-brown wove paper,
 20 × 16¼ in.
Signed at lower left: J Hirsch
Gift of the Pennsylvania W.P.A., 1943
43.46.9

Yvonne Jacquette
(b. 1934)

East River Drive
Pastel on gray laid paper, 18¾ × 23 in.
Signed at lower right: Jacquette
Purchase, Friends of the Department Gifts
and matching funds from the National
Endowment for the Arts, 1978
1978.199

Jet Composite: Raleigh, Virginia—
Greensboro, North Carolina
Pastel on gray wove paper, 17½ × 14 in.
Gift of Brooke and Carolyn Alexander, 1980
1980.571

Study for Little River Farm II
Pastel on tracing paper, 16¾ × 13¾ in.
Signed at lower right: Jacquette
Gift of Dr. and Mrs. Robert E. Carroll, 1982
1982.182.2

Study for Little River Farm IV
Pastel on tracing paper, 13¾ × 10⅞ in.
Gift of Dr. and Mrs. Robert E. Carroll, 1982
1982.182.3

EASTMAN JOHNSON
(1824–1906)

Woman Feeding Turkey
Pastel on wove paper, mounted on canvas,
 on a strainer, 24 × 14 in.
Anonymous Gift, in memory of William
 Brown Cogswell, 1946
46.47

HENRIETTA JOHNSON
(active 1707–1729)

*Mrs. Pierre Bacot (née Marie
 Peronneau, 1685–1778)*
Pastel on laid paper, 12½ × 10 in.
Gift of Mrs. J. Insley Blair, 1947
47.103.23

Pierre Bacot (b. 1670?)
Pastel on laid paper, 11¾ × 9½ in.
Gift of Mrs. J. Insley Blair, 1947
47.103.24

ELMER MACRAE
(1875–1955)

Schooner at Dock
Pastel on pumice paper, mounted on
 illustration board, 9⅞ × 11¾ in.
Dated and signed at lower right: [1911 or
 1914] EL MACRAE
Robert Lehman Collection, 1975
1975.1.916

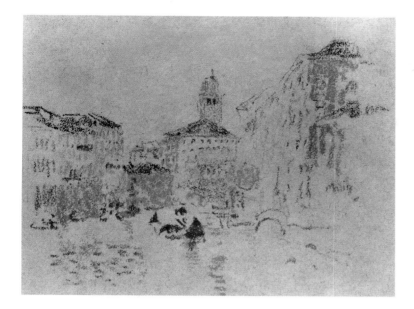

JOHN MARIN
(1870–1953)

Venice
Pastel on wove paper (originally blue-gray),
 10 × 12 in.
Bequest of Alexandrine Sinsheimer, 1958
59.23.86

VIOLET OAKLEY
(1874–1961)

Cleveland Johnson
Pastel and charcoal on gray laid paper,
 18⅝ × 11⅝ in.
Inscribed at lower left: Cleveland Johnson.
 Signed at lower right: · VIOLET · /
 · OAKLEY ·
Gift of Edith Emerson, 1978
1978.294.2

GEORGIA O'KEEFFE
(1887–1986)

A Storm
Pastel on off-white laid paper, mounted on
 illustration board, 18 × 24⅛ in.
Anonymous Gift, 1981
1981.35

GLENN STUART PEARCE
(b. 1909)

Winter Sunlight
Pastel on white wove paper, 21⅛ × 28 in.
Signed at lower left: G. Pearce
Gift of the Pennsylvania W.P.A., 1943
43.46.17

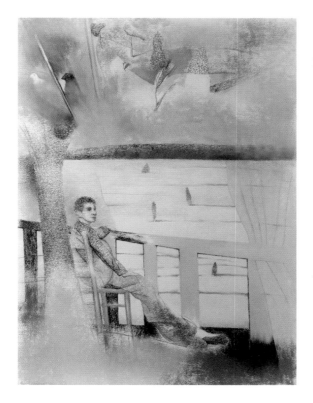

IRVING PETLIN
(b. 1934)

Self-Portrait as a Young Man
Pastel on white wove paper, 41½ × 29¾ in.
Signed and dated at lower right: Petlin 81
George A. Hearn Fund, 1982
1982.431

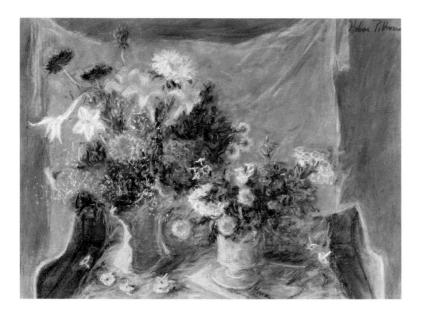

HOBSON PITTMAN
(1899–1972)

Summer Bouquet
Pastel on gray wove paper, 19 × 24⅞ in.
Signed at upper right: Hobson Pittman.
 Inscribed at lower right: Pittman /
 Manoa Pa.
George A. Hearn Fund, 1945
45.34.5

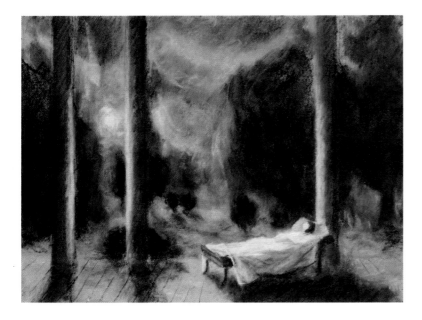

Moonlight with Figure, Columns
Pastel on gray laid paper, 19 × 24⅞ in.
Bequest of Hobson L. Pittman, 1973
1973.30.1

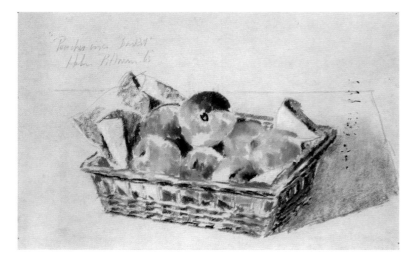

Peaches in a Basket
Pastel on white laid paper, 12¾ × 20 in.
Inscribed, signed, and dated at upper
 left: "Peaches in a Basket" / Hobson
 Pittman. '63
Bequest of Hobson L. Pittman, 1973
1973.30.2

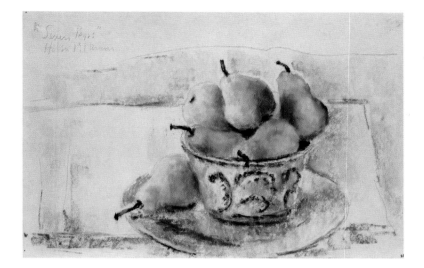

Seven Pears
Pastel on white laid paper, 12⅜ × 18⅞ in.
Inscribed and signed at upper left: "Seven
 Pears" / Hobson Pittman
Bequest of Hobson L. Pittman, 1973
1973.30.3

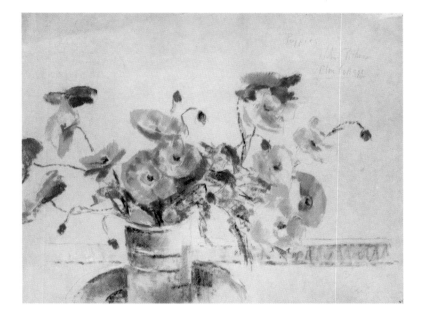

Poppies, Elm Cottage
Pastel on white laid paper, 19 × 24¾ in.
Inscribed and signed at upper right:
 "Poppies" / Hobson Pittman / <u>Elm
 Cottage</u>
Bequest of Hobson L. Pittman, 1973
1973.30.4

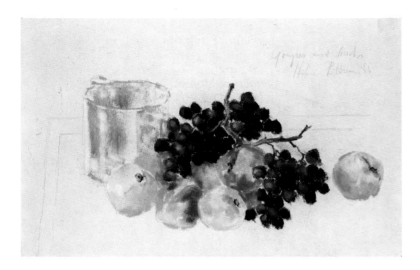

Grapes and Peaches

Pastel on white laid paper, 12⅜ × 19 in.
Inscribed, signed, and dated at upper right:
 "Grapes and Peaches" / Hobson
 Pittman. '63
Bequest of Hobson L. Pittman, 1973
1973.30.5

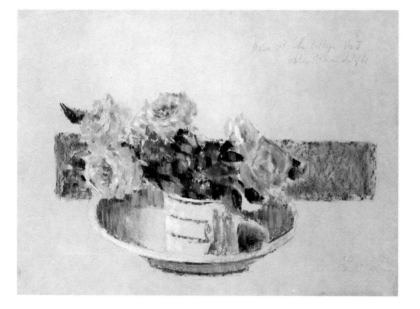

Roses at Elm Cottage II

Pastel on white laid paper, 19 × 25 in.
Inscribed, signed, and dated at upper right:
 "Roses at Elm Cottage" No. II / Hobson
 Pittman July '62
Bequest of Hobson L. Pittman, 1973
1973.30.6

Fading Flowers
Pastel on white wove paper, 19⅛ × 25 in.
Inscribed and signed at upper right:
 "Fading Flowers" / Hobson Pittman
Bequest of Hobson L. Pittman, 1973
1973.30.7

*Arrangement with Grapes and
 Flowers*
Pastel on white wove paper, 20 × 25½ in.
Signed at upper right: Hobson Pittman
Bequest of Hobson L. Pittman, 1973
1973.30.8

Ladies by Pool
Pastel on white laid paper, 11¹⁵⁄₁₆ × 18¾ in.
Bequest of Hobson L. Pittman, 1973
1973.30.9

MAURICE B. PRENDERGAST
(1859–1924)

Annisquam
Pastel and watercolor on off-white wove
 paper (reverse: graphite-pencil drawing),
 13¾ × 19¾ in.
Signed at lower right: Prendergast.
 Inscribed on reverse: Annisquam
Gift of Mr. and Mrs. Daniel H. Silberberg,
 1964
64.123.1

GARRETT PRICE
(1897–1979)

Cover for The New Yorker,
 October 21, 1950
Watercolor, pastel, and gouache on tan
 heavyweight laid paper, 13½ × 10 in.
Signed at lower right: Garrett Price
Gift of the artist, 1962
62.640

JULIUS ROLSHOVEN
(1858–1930)

Fiesta in Taos
Pastel on black wove paper, 10⅞ × 13⅞ in.
Numbered, signed, and inscribed at lower
 left:
 7 — ROLSHOVEN — / TAOS N.M.
Gift of Harriette B. Rolshoven, 1954
54.99

JAMES N. ROSENBERG
(1874–1970)

Mountains near Safed, Israel
Pastel on tan wove ("velour") paper,
 9½ × 12⅞ in.
Signed and dated twice at lower right: JR 56
Gift of the artist, 1956
56.191.2

March Blizzard
Watercolor, pastel, and gouache on white
 wove paper, 13½ × 10½ in.
Inscribed, dated, and signed at lower left:
 March Blizzard / 1956 / Pastel & / Water
 color / JNR
Gift of the artist, 1956
56.191.3

JAMES SHARPLES
(c. 1750–1811)

Albert Gallatin (1761–1849)
Pastel on laid paper (rubbed to a smooth
 surface), 9⅜ × 7⅜ in.
Gift of Miss Josephine L. Stevens, 1908
08.144

Josiah Ingersoll
Pastel on laid paper (rubbed to a smooth
 surface), 9¹³⁄₁₆ × 7⅞ in.
Gift of Mrs. Caroline E. Lawrence Ingersoll,
 1908
08.238

*Médéric-Louis-Elie Moreau
de Saint-Méry (1750–1819)*
Pastel on laid paper (rubbed to a smooth
surface), 9⅞ × 8⅛ in.
Bequest of Charles Allen Munn, 1924
24.109.89

George Washington (1732–1799)
Pastel on laid paper (rubbed to a smooth
surface), 9¾ × 7¾ in.
Bequest of Charles Allen Munn, 1924
24.109.97

*Alexander Hamilton
(1755/57–1804)*
Pastel on laid paper (rubbed to a smooth
 surface), 9½ × 7⅜ in.
Bequest of Charles Allen Munn, 1924
24.109.98

Noah Webster (1758–1843)
Pastel on laid paper (rubbed to a smooth
 surface), 8⅞ × 7¾ in.
Bequest of Charles Allen Munn, 1924
24.109.99

Dorothea Hart
Pastel on laid paper (rubbed to a smooth
 surface), 9 × 7⅞ in.
Inscribed on reverse: Dorothea Hart / aged
 60 years / March 1ˢᵗ 1809
Fletcher Fund, 1935
35.17

EVERETT SHINN
(1876–1953)

*Matinee Crowd, Broadway,
 New York*
Pastel and gouache on illustration board,
 18⅛ × 11½ in.
Signed and dated at lower left:
 E Shinn / 1904
Gift of A. E. Gallatin, 1923
23.230.5

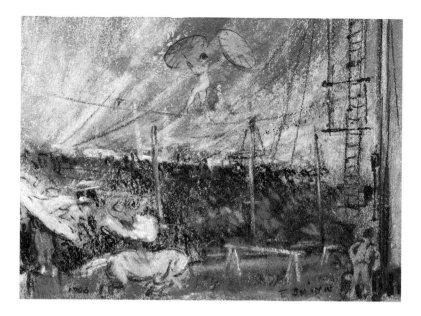

Circus
Pastel over monotype on off-white wove
 paper, 3¾ × 5 in.
Signed at lower right: E Shinn. Dated at
 lower left: 1906
George A. Hearn Fund, 1952
52.161

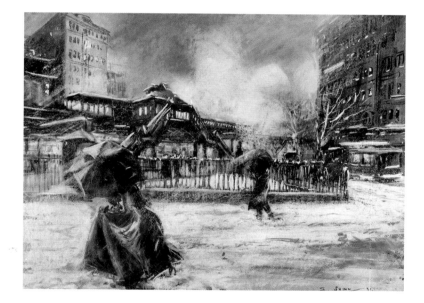

Herald Square
Pastel, black ink, and watercolor on light
 brown paper, 21¾ × 29⅜ in.
Signed at lower right: E Shinn [illegible]
Arthur Hoppock Hearn Fund, 1955
55.178.1

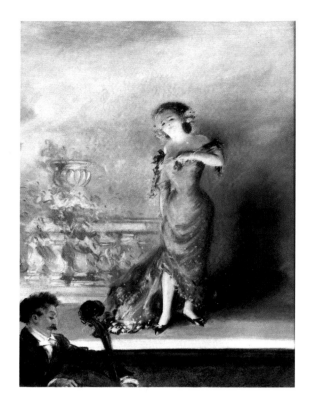

Julie Bonbon
(The Stage from the Orchestra)
Pastel on off-white wove paper, mounted on
cardboard, 21⅝ × 16 in.
Signed and dated at lower right: E Shinn /
1907. Inscribed on reverse: "The Stage
From The Orchestra" E Shinn / 112
Waverly Pl.; B88
Gift of Mrs. Maurice Stern, 1970
1970.306

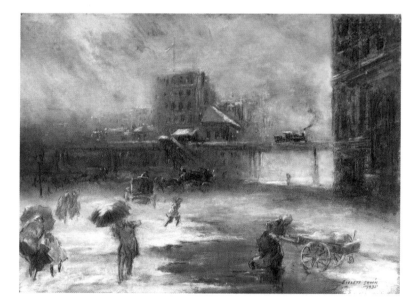

A Rainy Day at Cooper Square
Pastel on white wove paper, mounted on
cardboard, 11¾ × 15¼ in.
Signed and dated at lower right: Everett
Shinn / 1935
Gift of Rita and Daniel Fraad, Jr., 1978
1978.509.5

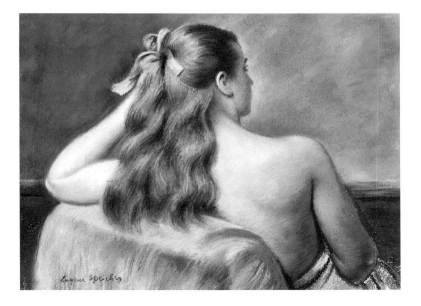

EUGENE SPEICHER
(1883–1962)

Portrait of a Young Girl
Pastel on white wove paper, 14¹¹⁄₁₆ × 19⅛ in.
Signed at lower left: Eugene Speicher
Bequest of Stephen C. Clark, 1960
61.101.31

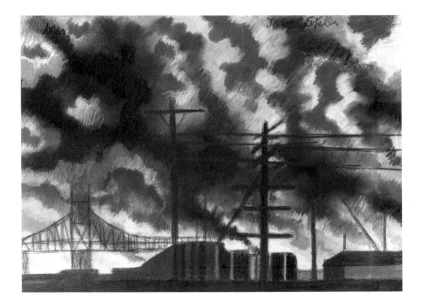

JOSEPH STELLA
(1877–1946)

Pittsburgh
Pastel on heavyweight tan wove
 paper (reverse: a chromolithograph),
 14 × 16⅞ in.
Signed at upper right: Jos. Stella
Arthur Hoppock Hearn Fund, 1950
50.31.5

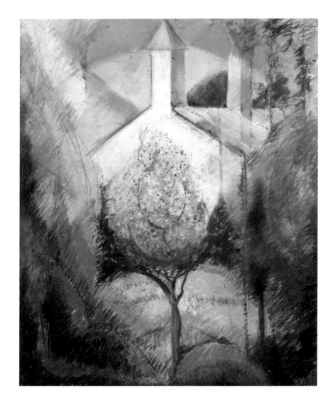

Landscape
Pastel and charcoal on light blue blotting
 paper, 21⅝ × 16⅞ in.
Bequest of Katherine S. Dreier, 1952
53.45.4

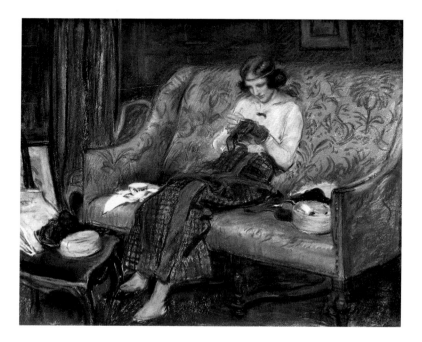

ALBERT STERNER
(1863–1946)

The Blue Stocking
Pastel on tan wove paper, 23¾ × 29½ in.
Signed and dated at lower right: Albert
 Sterner / 1915
Gift of Adolph Lewisohn, 1919
19.65

Tanker in Drydock
Pastel on wove paper (originally off-white),
 16¼ × 20¾ in.
Signed, dated, and inscribed at lower left:
 Albert Sterner / Jan 1 '37 / Newport News
 Va
Morris K. Jesup Fund, 1977
1977.337

BILLY SULLIVAN
(b. 1946)

The Continental
Pastel on white wove paper, 30½ × 42 in.
Signed and dated at lower right: Billy
 Sullivan / 82
Purchase, Mr. and Mrs. Clarence Y. Palitz
 Gift, in memory of her father, Nathan
 Dobson, and Edward and Lydie Shufro,
 Lawrence J. Mohr, and Anonymous Gifts,
 1982
1982.95

JOHN H. TWACHTMAN
(1853–1902)

Landscape
Pastel on pumice paper (originally blue),
 mounted on cardboard, 14¾ × 18 in.
Signed at lower right: JHT. Stamped on
 reverse: EXPOSITION UNIVERSELLE DE
 1855 / MENTION HONORABLE / PAPIER,
 CARTON. CHASSIS, TOILES / ANTI-PONCE
 pour le Pastel / P. L. Breveté PARIS /
 MARQUE DÉPOSÉE
Rogers Fund, 1925
25.107.2

ELIHU VEDDER
(1836–1923)

Ulysses's Wife
Gouache, watercolor, and pastel on gray
 wove paper, 11⅝ × 8⅝ in.
Inscribed and signed at lower center: To /
 Mrs. A. S. Vedder, with the very best
 regards of / 1883 [drawing of a flower]
 Elihu Vedder. Inscribed on reverse:
 Ulysses' Wife / by Elihu Vedder
The Elisha Whittelsey Collection, The Elisha
 Whittelsey Fund, 1960
60.537.2

ABRAHAM WALKOWITZ
(1880–1965)

Creation
Wax crayon and pastel on eight sheets of off-
 white wove paper, mounted together,
 35^{15}/$_{16}$ × 45^{13}/$_{16}$ in. overall
Signed and dated at lower right:
 A. WALKOWITZ [between horizontal bars] 14
Alfred Stieglitz Collection, 1949
49.70.168

Scene in the Park
Pastel on buff wove paper, 13^{5}/$_{8}$ × 35^{1}/$_{2}$ in.
Signed at lower left: A. WALKOWITZ
Bequest of Charles F. Iklé, 1963
64.27.7

MAX WEBER
(1881–1961)

Still Life
Pastel on light tan wove paper with a printed
 metallic-paper border, 12⅝ × 9⅞ in.
Signed and dated at lower right:
 MAX WEBER 12
Gift of A. W. Bahr, 1958
58.21.18

Lecture at the Metropolitan
Pastel on off-white laid paper, 24¼ × 18½ in.
Signed and dated at lower right:
 MAX WEBER 1916
Gift of Dr. Irving F. Burton, 1975
1975.321

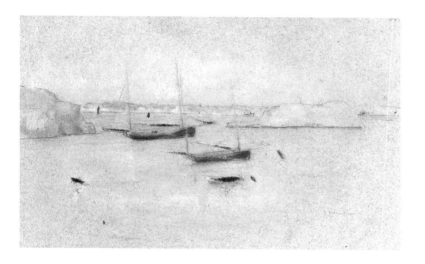

J. Alden Weir
(1852–1919)

Boats
Pastel and graphite pencil on wove paper
(originally blue), 8¾ × 14 in.
Signed at lower right: J. Alden Weir
Gift of Mr. and Mrs. Raymond J. Horowitz,
1980
1980.512.1

James McNeill Whistler
(1834–1903)

Bead Stringing, Venice
(probably *Note in Pink and Brown*)
Pastel on gray-brown wove paper,
11¾ × 7¼ in.
At right: [butterfly monogram]
Harris Brisbane Dick Fund, 1917
17.97.5

FOLLOWER OF JAMES McNEILL WHISTLER

Street Scene
Black chalk and pastel on brown paper,
12⅜ × 8¾ in.
Inscribed at bottom: Chez Mario—Bruges
[butterfly monogram]. Inscribed on
cardboard backing, in a later hand: This
is considered to be a very late Whistler /
probably 1900—02
Gift of Stephen Spector, 1970
1971.557

HENRY WILLIAMS
(1787–1830)

Mrs. Ichabod M. Cushman
(née Isabel Blymer)
Pastel on paper, 22¼ × 17¾ in.
Signed at lower left: Williams / [illegible
date]
Fletcher Fund, 1927
27.77

MAHONRI M. YOUNG
(1877–1957)

Man with a Sledgehammer
Charcoal and pastel on off-white laid paper,
 18¾ × 12⅛ in.
Signed and dated at lower center: Mahonri /
 1903
Gift of Mrs. Howell Howard, 1956
56.57

MARYAM ZAFAR
(b. 1953)

Blues: 1:00 A.M.
Colored (wax) pencil, pastel, and white chalk
 on light gray wove paper, 30 × 22 in.
Inscribed, signed, and dated on reverse:
 "Blues: 1:00 A.M. Zafar 80"
Purchase, Samuel I. Newhouse Foundation
 Inc. Gift, 1980
1980.348.1

Abbreviations

Am. Art Res. Coun.	American Art Research Council, Whitney Museum of American Art, New York
Arch. Am. Art	Archives of American Art, Smithsonian Institution, New York
DAB	*Dictionary of American Biography*
Dept. Archives	Department of American Paintings and Sculpture, The Metropolitan Museum of Art, New York
MMA	The Metropolitan Museum of Art, New York
MMAB	*Metropolitan Museum of Art Bulletin*
MOMA	Museum of Modern Art, New York
PAFA	Pennsylvania Academy of the Fine Arts, Philadelphia
WMAA	Whitney Museum of American Art, New York

SHORT TITLES

Art Amateur 1890 — "The Pastel Exhibition." *Art Amateur* 23 (June 1890), p. 4.

Baur 1971 — John I. H. Baur. *Joseph Stella*. New York, 1971.

Bouyer 1904 — Raymond Bouyer. "Modern French Pastellists: Fantin-Latour." *International Studio* 24 (Nov. 1904), pp. 39–44.

Breeskin 1970 — Adelyn D. Breeskin. *Mary Cassatt: A Catalogue Raisonné of Oils, Pastels, Watercolors, and Drawings*. Washington, D.C., 1970.

Brown 1963 — Milton W. Brown. *The Story of the Armory Show*. Greenwich, Conn., 1963.

Burke 1983 — Doreen Bolger Burke. *J. Alden Weir: An American Impressionist*. Newark, Del., 1983.

Danenberg 1971 — Bernard Danenberg Galleries. *Max Weber: Early Works on Paper*. Exhib. cat. New York, 1971.

Davies Essays 1924 — Royal Cortissoz et al. *Arthur B. Davies: Essays on the Man and His Art*. Cambridge, Mass., 1924.

Dove 1932–37 — Arthur G. Dove, comp. Archival file cards, 1932–37. Arthur G. Dove Papers, Arch. Am. Art, microfilm 2803.

Ely 1921	Catherine Beach Ely. "In Praise of Pastels." *American Magazine of Art* 12 (May 1921), pp. 200–202.
Foster 1979	Kathleen Adair Foster. "The Watercolor Scandal of 1882: An American Salon des Refusés." *Archives of American Art Journal* 19, no. 2 (1979), pp. 19–25.
Gallati 1981	Barbara Gallati. "Arthur Dove as Illustrator." *Archives of American Art Journal* 21, no. 2 (1981), pp. 13–22.
Getscher 1970	Robert H. Getscher. "Whistler and Venice." Ph.D. diss., Case Western Reserve University, 1970.
Gordon 1974	Donald Gordon. *Modern Art Exhibitions, 1900–1906.* 2 vols. Munich, 1974.
Hale 1957	John Douglas Hale. "The Life and Creative Development of John H. Twachtman." 2 vols. Ph.D. diss., Ohio State University, 1957.
Harrison 1909	Birge Harrison. *Landscape Painting.* New York, 1909.
Harrison 1915	Birge Harrison. "The Case of the Pastel." *Art and Progress* 6 (1915), pp. 154–57.
Hirshhorn 1983	Hirshhorn Museum and Sculpture Garden. *Joseph Stella: The Hirshhorn Museum and Sculpture Garden Collection.* Exhib. cat. by Judith Zilczer. Washington, D.C., 1983.
Homer 1977	William Innes Homer. *Alfred Stieglitz and the American Avant-garde.* Boston, 1977.
Jaffe 1970	Irma B. Jaffe. *Joseph Stella.* Cambridge, Mass., 1970.
Jewish Museum 1982	Jewish Museum. *Max Weber: American Modern.* Exhib. cat. by Percy North. New York, 1982.
Kootz 1930	Samuel Kootz. *Modern American Painters.* New York, 1930.
Kuh 1962	Katherine Kuh. *The Artist's Voice.* New York, 1962.
Leidel 1885	Henry Leidel. *The Art of Pastel Painting as Taught by Raphael Mengs.* New York, 1885.
Lucas 1921	E. V. Lucas. *The Life and Works of Edwin Austin Abbey, R.A.* 2 vols. London/New York, 1921.
McCausland 1952	Elizabeth McCausland. *Marsden Hartley.* Minneapolis, 1952.
MacRae Diary	Elmer MacRae. Papers; Diaries. MS., 1911, 1913. Hirshhorn Museum and Sculpture Garden, Smithsonian Institution, Washington, D.C.
MMA 1983	MMA. *Manet, 1832–1883.* Exhib. cat. by Françoise Cachin and Charles S. Moffett. New York, 1983.
Morgan 1973	Ann Lee Morgan. "Toward a Definition of Early Modernism in America: A Study of Arthur Dove." Ph.D. diss., University of Iowa, 1973.
Morgan 1984	Ann Lee Morgan. *Arthur Dove: Life and Work, with a Catalogue Raisonné.* Newark, Del., 1984.
Mosca Interview 1983	August Mosca. Interview with Gail Stavitsky, Dec. 18, 1983.
Nelson 1983	Carolyn Nelson. "The Society of Painters in Pastel, 1884–1890." M.A. thesis, University of Texas, Austin, 1983.

North 1975 — Percy North. "Max Weber: The Early Paintings (1905–1920)." Ph.D. diss., University of Delaware, 1975.

O'Keeffe 1976 — Georgia O'Keeffe. *Georgia O'Keeffe*. New York, 1976.

Pemberton 1926 — Murdock Pemberton. "The Art Galleries." *New Yorker* 1 (Feb. 13, 1926), pp. 25–26.

Philadelphia 1969 — Philadelphia Museum of Art. *John Marin: Oils, Watercolors, and Drawings Which Relate to Etchings*. Exhib. cat. by Sheldon Reich. Philadelphia, 1969.

Phillips 1981 — Phillips Memorial Collection. *Arthur Dove and Duncan Phillips: Artist and Patron*. Exhib. cat. by Sasha M. Newman. Washington, D.C., 1981.

Pilgrim 1978 — Dianne H. Pilgrim. "The Revival of Pastels in Nineteenth Century America: The Society of Painters in Pastel." *American Art Journal* 10 (Nov. 1978), pp. 43–62.

Portalis 1885 — Roger Portalis. "Exposition des Pastellistes français à la rue De Sèze." *Gazette des Beaux-Arts*, ser. 2, 31 (May 1885), pp. 437–57.

Reich 1970 — Sheldon Reich. *John Marin*. 2 vols. Tucson, 1970.

Richmond 1927 — L. Richmond and J. Littlejohns. *The Art of Painting in Pastel*. London, 1927.

Salander-O'Reilly 1982 — Salander-O'Reilly Galleries. *Morton L. Schamberg*. Exhib. cat. by William Agee. New York, 1982.

Sawin 1967 — Martica R. Sawin. "Abraham Walkowitz: The Years at 291, 1912–1917." M.A. thesis, Columbia University, 1967.

See 1920 — R. M. M. See. "How Russell Executed His Pastels." *Connoisseur* 52 (1920), p. 166.

Sheldon 1979 — Sheldon Memorial Art Gallery, University of Nebraska. *Preston Dickinson, 1889–1930*. Exhib. cat. by Ruth Cloudman. Lincoln, 1979.

Smith 1944 — Suzanne Mullett Smith. "Arthur G. Dove: A Study in Contemporary Art." M.A. thesis, American University, 1944. Suzanne Mullet Smith Papers, Arch. Am. Art, microfilm 1043.

Société Anonyme 1984 — Yale University Art Gallery. *The Société Anonyme and the Dreier Bequest at Yale University: A Catalogue Raisonné*. Exhib. cat. by Robert L. Herbert et al. New Haven, 1984.

Stebbins 1976 — Theodore E. Stebbins. *American Master Drawings and Watercolors*. New York, 1976.

Stella 1960 — Joseph Stella. "Discovery of America: Autobiographical Notes." *Art News* 59 (Nov. 1960), pp. 41–43, 64–67.

Stieglitz Catalogue [1949] — "Catalogue of the Alfred Stieglitz Collection of Paintings, Drawings, Prints, etc." MS., c. 1949, Collection of Rare Books and Manuscripts, Beinecke Rare Book and Manuscript Library, Yale University.

Tomkins 1974 — Calvin Tomkins. "Profiles: The Rose in the Eye Looked Pretty Fine." *New Yorker* 50 (Mar. 4, 1974), pp. 40–66.

Utah 1969 — Utah Museum of Fine Arts. *John Marin Drawings, 1886–1951*. Exhib. cat. by Sheldon Reich. Salt Lake City, 1969.

Utah 1975 Utah Museum of Fine Arts. *Abraham Walkowitz, 1878–1965*. Exhib. cat. by Martica R. Sawin. Salt Lake City, 1975.

Van Rensselaer 1884 Mariana Griswold Van Rensselaer. "American Painters in Pastel." *Century Magazine* 29 (Dec. 1884), pp. 204–10.

Westmoreland 1979 Westmoreland County Museum of Art. *Kenneth Frazier A.N.A., 1867–1949*. Exhib. cat. by Paul A. Chew. Greensburg, Pa., 1979.

WMAA 1978 WMAA. *Synchronism and American Color Abstraction, 1910–1925*. Exhib. cat. by Gail Levin. New York, 1978.

WMAA 1980 WMAA. *Marsden Hartley*. Exhib. cat. by Barbara Haskell. New York, 1980.

Selected Bibliography

GENERAL

BEAUX, Cecilia. *Background with Figures*. Boston/New York, 1930.

BIGELOW, Bayard. "Painters in Pastel, Mediaeval and Modern." *Craftsman* 15 (Oct. 1908), pp. 8–17.

BOLTON, Theodore. *Early American Portrait Draughtsmen in Crayons*. New York, 1923.

"Drawing in Pastels." *Art Amateur* 15 (Nov. 1886), p. 120.

ELY, Catherine Beach. "In Praise of Pastels." *American Magazine of Art* 12 (May 1921), pp. 200–202.

HARRISON, Birge. "The Case of the Pastel." *Art and Progress* 6 (1915), pp. 154–57.

———. "Pigments." In his *Landscape Painting*, pp. 107–9. New York, 1909.

HOMER, William Innes. *Alfred Stieglitz and the American Avant-garde*. Boston, 1977.

MONNIER, Geneviève. *Pastels: From the Sixteenth to the Twentieth Century*. New York, 1984.

"Pastel Painting." *Art Amateur* 13 (Oct. 1885), p. 94.

"Pastel Painting I and II." *Art Amateur* 7 (July 1882), pp. 28–30; (Aug. 1882), pp. 49–52.

PILGRIM, Dianne H. "Introduction." In Hirschl & Adler Galleries, *Painters in Pastel: A Survey of American Works*. Exhib. cat. New York, 1987.

"Some Hints about Pastel Painting." *Art Amateur* 1 (Oct. 1879), p. 100.

STEBBINS, Theodore E. *American Master Drawings and Watercolors*. New York, 1976.

Yale University Art Gallery. *The Société Anonyme and the Dreier Bequest at Yale University: A Catalogue Raisonné*. Exhib. cat. by Robert L. Herbert et al. New Haven, 1984.

SECONDARY MEDIUMS

"Annual Watercolor Show." *American Art News* 11 (Mar. 8, 1913), p. 2.

BURKE, Doreen Bolger. "Painters and Sculptors in a Decorative Age." In MMA, *In Pursuit of Beauty: Americans and the Aesthetic Movement*, pp. 294–339. Exhib. cat. New York, 1986.

FABRI, Ralph. *History of the American Watercolor Society: The First Hundred Years*. New York, 1969.

Fogg Art Museum. *Wash and Gouache: A Study of the Development of the Materials of Watercolor*. Exhib. cat. by Marjorie B. Cohn and Rachel Rosenfield. Cambridge, Mass., 1977.

FOSTER, Kathleen Adair. "Makers of the American Watercolor Movement, 1860–1890." Ph.D. diss., Yale University, 1982.

———. "The Watercolor Scandal of 1882: An American Salon des Refusés." *Archives of American Art Journal* 19, no. 2 (1979), pp. 19–25.

GARDNER, Albert Ten Eyck. *History of Water Color Painting in America*. New York, 1966.

HILLS, Patricia. "The Genteel Media: Pastels, Watercolors, and Prints." In her *Turn-of-the-Century America: Paintings, Graphics, Photographs, 1890–1910*, chap. 4. New York, 1977.

HOOPES, Donelson F. *American Watercolor Painting*. New York, 1977.

"Paintings in Old Mediums." *American Art News* 11 (Jan. 11, 1913), p. 6.

SCHNEIDER, Rona. "The American Etching Revival: Its French Sources and Early Years." *American Art Journal* 14 (Fall 1982), pp. 40–65.

STEBBINS, Theodore E. *American Master Drawings and Watercolors*. New York, 1976.

TEALL, Gardener. "Wood-Engraving: The Opportunity for Expression It Affords to Artist and Craftsman." *Craftsman* 15 (Oct. 1908), pp. 43–47.

"Tempera Paintings at Powell's." *American Art News* 11 (Mar. 15, 1913), p. 9.

WATROUS, James. "Entering the Mainstream of Printmaking." In his *A Century of American Printmaking, 1880–1980*, chap. 1. Madison, Wis., 1984.

WILSON, Richard Guy. "Periods and Organizations." In Brooklyn Museum, *The American Renaissance, 1876–1917*, pp. 63–70. Exhib. cat. New York, 1979.

PASTEL TECHNIQUES AND MATERIALS

AIRY, Anna. *The Art of Pastel.* London, 1930.

Anonymous. *The Artist's Repository and Drawing Magazine, exhibiting the Principles of the Polite Arts in their various Branches.* 4 vols. London, 1788.

BECK, Walter. "Something about Pastel Technic and Its Permanence." *Technical Studies in Conservation* 2 (1934), pp. 119–23.

BLANC, Charles. *Grammaire des arts du dessin.* Paris, 1880.

BLYTH, Victoria S. "Electrostatic Stabilizing Plate (ESP): An Alternative Method for Stabilizing the Flaking Tendencies of Works of Art in Pastel." *Preprints, American Institute for Conservation.* Fort Worth, 1978.

BOWEN, J. T. *The United States Drawing Book.* Philadelphia, 1839.

BOWLES, Carrington. *Artist's Assistant.* London, 1783.

BRECKENRIDGE, Hugh. "Making Pastel Sticks." MS., c. 1899, Hugh Breckenridge Papers, Arch. Am. Art, microfilm 1907, frame 481.

BROWN, David Blaney. *Early English Drawings from the Ashmolean Museum.* Oxford, 1983.

CHAPMAN, John G. *The American Drawing Book: A Manual for the Amateur.* New York, 1847.

CHEVREUL, Michel-Eugène. *De la loi du contraste simultané des couleurs, et de l'assortiment des objets colorés, considéré d'après cette loi.* Paris, 1839. Translated as *The Principles of Harmony and Contrast of Colours and Their Applications to the Arts.* 1st Eng. ed. London, 1854.

CRAIG, W. M. *A Course of Lectures on Drawing, Painting, and Engraving.* London, 1821.

D'APLIGNY, Pileir. *Traité des couleurs matérielles.* Paris, 1779.

DAVIS, Gladys Rockmore. *Pastel Painting.* New York, 1943.

DOERNER, Max. *The Materials of the Artist and Their Use in Painting.* New York, 1934.

DOSSIE, Robert. *Handmaid to the Arts.* London, 1758.

DOUST, L. A. *A Manual on Pastel Painting.* London, 1933.

DUFF, J. R. K. "The Place of Pastel Painting." *Art Journal* (London) 73 (Nov. 1911), pp. 395–400.

"The Elements of Pastel Painting." *Art Amateur* 34 (Mar. 1896), p. 88.

FLIEDER, Françoise. "The Study of the Conservation of Pastels." In *Science and Technology in the Service of Conservation,* pp. 71–74. London: International Institute for Conservation of Historic and Artistic Works, 1982.

GONCOURT, Edmond and Jules de. *L'Art du dix-huitième siècle.* 3d ed. Paris, 1880. Translated as *French Eighteenth Century Painters.* London, 1943.

HAMILTON, George. *The Elements of Drawing.* London, 1812.

HARLEY, Rosamond. *Artists' Pigments.* 2d ed. London, 1982.

HAYES, Colin. *The Complete Guide to Painting and Drawing Materials.* New York, 1981.

HELLER, E. M. "Notes on Pastel." *Art Amateur* 30 (May 1894), p. 159.

———. "Painting in Pastels I." *Art Amateur* 25 (Nov. 1891), p. 138.

———. "Pastel Painting." *Art Amateur* 26 (May 1892), pp. 158–59.

KARL-ROBERT [Georges Meusnier]. *Le Pastel: traité pratique et complet.* Paris, 1890.

LABARRE, E. J. *Dictionary and Encyclopaedia of Paper and Paper-Making.* 2d ed. Amsterdam, 1952.

LALIBERTÉ, Norman, Alex Mogelon, and Beatrice Thompson. *Pastel, Charcoal, and Chalk Drawing—History, Classical and Contemporary Techniques.* New York, 1973.

LEIDEL, Henry. *The Art of Pastel Painting as Taught by Raphael Mengs.* New York, 1885.

LOMAZZO, Giovanni Paolo. *A Tracte containing the Arts of curious Painting Caruinge Buildinge written first in Italian by Io. Paul Lomatius painter of Milan and Englished by R. H. student in Physik.* Oxford, 1598.

MASSOUL, Constant de. *A Treatise on the Art of Painting. . . .* 1st Eng. ed. London, 1797.

MAYER, Ralph. *The Artist's Handbook of Materials and Techniques.* New York, 1940.

———. *The Painter's Craft: An Introduction to Artists' Materials.* New York, 1948.

MEDER, Joseph. *Die Handzeichnung: Ihre Technik und Entwicklung.* Vienna, 1919. Translated and revised by Winslow Ames as *The Mastery of Drawing.* New York, 1978.

MMA. *Manet, 1832–1883.* Exhib. cat. by Françoise Cachin and Charles S. Moffett. New York, 1983.

M. P. R. de C. . . . C. à P. de L. *Traité de la peinture au pastel.* Paris, 1788.

MURRAY, Henry. *The Art of Painting and Drawing in Coloured Crayons.* London, 1850.

OSTWALD, Wilhelm. *Colour Science. . . .* 2 vols. London [1931–33].

———. *Letters to a Painter on the Theory and Practice of Painting.* Boston, 1907.

"Painting in Pastel." *Art Amateur* 33 (Sept. 1895), p. 68.

"The Pastel Society." *Apollo* 17 (Feb. 1933), p. 48.

PECHAM, Henry. *The Art of Drawing with the Pen and Limning in Watercolors.* London, 1606.

"Pennell on Pastel." *Art Amateur* 34 (Feb. 1896), p. 64.

RICHMOND, L., and J. Littlejohns. *The Art of Painting in Pastel.* London, 1927.

———. *The Technique of Pastel Painting.* London, 1931.

RICHTER, H. Davis. "The Pastel Society." *Studio* 133 (May 1947), pp. 129–37.

RODDEN, Guy. *Pastel Painting Techniques.* New York, 1979.

ROOD, Ogden. *Modern Chromatics.* New York, 1879.

RUSKIN, John. *The Elements of Drawing and the Elements of Perspective.* London, 1857.

RUSSELL, John. *Elements of Painting with Crayons.* London, 1772. 2d ed. 1777.

SALMON, William. *Polygraphice; or, The Arts of Drawing, Limning, Painting, and c.* London, 1672; 1685.

SAYER, Robert, comp. *The Compleat Drawing-Master. . . .* London, 1766.

———. *The Complete Drawing-Book. . . .* London, 1786.

SEARS, Elinor Lathrop. *Pastel Painting Step-by-Step.* New York, 1947.

SEE, R. M. M. "How Russell Executed His Pastels." *Connoisseur* 52 (1920), p. 166.

TRIVAS, N. S. "Two Formulas by Liotard." *Technical Studies in Conservation* 10 (1941), pp. 29–32.

WATROUS, James. *The Craft of Old Master Drawings.* Madison, Wis., 1967.

WILLIAMS, Terrick. *The Art of Pastel.* New York, 1937.

EUROPEAN PRECEDENTS

BALDRY, A. L. "Pastel—Its Value and Present Position." *Magazine of Art* 24 (1900), pp. 277–80.

BOUYER, Raymond. "Modern French Pastellists: Fantin-Latour." *International Studio* 24 (Nov. 1904), pp. 39–44.

———. "The Pastel Drawings of Aman-Jean." *International Studio* 31 (June 1907), pp. 285–90.

BRIEGER, Lothar. *Das Pastell: Seine Geschichte und Seine Meister.* Berlin, 1950.

BUSCH, Günter. "Pastelle von Degas bis Matta." In Graphisches Kabinett Kunsthandel und Kunsthandel Wolfgang Werner, *Pastelle von Degas bis Matta,* unpaginated. Munich/Bremen, 1988.

CHILD, Theodore. "Joseph de Nittis." *Art Amateur* 11 (Nov. 1884), pp. 122–23.

DAYOT, Armand. "The French Pastellists of the Eighteenth Century." *International Studio* 21 (Feb. 1904), pp. 316–23.

FISHER, Melton S. "The Art of Painting in Pastel." *Magazine of Art,* n.s. 1 (1903), pp. 145–48.

FRANTZ, Henri. "Modern French Pastellists.—Jules Chéret." *International Studio* 23 (Oct. 1904), pp. 316–21.

———. "Modern French Pastellists: Jules Gustave Besson." *International Studio* 22 (Apr. 1904), pp. 121–26.

GEOFFROY, Gustave. "The Modern French Pastellists: Charles Milcendeau." *International Studio* 22 (Mar. 1904), pp. 24–29.

Grand Palais. *Autour de Lévy-Dhurmer: visionnaires et intimistes en 1900.* Exhib. cat. Paris, 1973.

JOURDAIN, Frantz. "Modern French Pastellists: J. F. Raffaëlli." *International Studio* 23 (Aug. 1904), pp. 146–49.

KEYZER, Mme Frances. "The Modern French Pastellists.—Alfred Philippe Roll." *International Studio* 22 (May 1904), pp. 228–35.

———. "Modern French Pastellists: L. Lévy-Dhurmer." *International Studio* 28 (Apr. 1906), pp. 144–50.

LOSTALOT, Alfred de. "Les Pastels de M. de Nittis au Cercle de l'Union Artistique." *Gazette des Beaux-Arts,* ser. 2, 24 (1881), pp. 156–65.

MONNIER, Geneviève. *Le Métier de l'artiste: le pastel.* Paris, 1983.

"The New Solid Oil-Colours: An Interview with M. J. F. Raffaëlli." *International Studio* 19 (Mar. 1903), pp. 22–27.

RAFFAËLLI, J. F. "Solid Oil-Colors—An Innovation in Paints." *Brush and Pencil* 10 (Aug. 1902), pp. 297–98.

RENAN, A. "Joseph de Nittis." *Gazette des Beaux-Arts,* ser. 2, 30 (1884), pp. 395–406.

UZANNE, Octave. "Modern French Pastellists: Charles Léandre." *International Studio* 24 (Jan. 1905), pp. 242–45.

———. "The Modern French Pastellists.—Gaston La Touche." *International Studio* 22 (June 1904), pp. 281–88.

EUROPEAN PASTEL SOCIETIES

CHILD, Theodore. "The Paris Pastel Exhibition." *Art Amateur* 17 (June 1887), p. 5.

DARGENTY, G. "Exposition des Pastellistes." *Courrier de l'art* 7 (Apr. 15, 1887), p. 113.

———. "Exposition des Pastellistes français." *Courrier de l'art* 6 (Apr. 9, 1886), pp. 172–73.

"Grosvenor Gallery." *Artist* 9 (Nov. 1, 1888), p. 332; 10 (Nov. 1, 1889), p. 336.

"The Grosvenor Gallery." *Art Journal* (London) 42 (Dec. 1890), p. 380.

"London Exhibitions." *Art Journal* (London) 56 (Mar. 1904), pp. 96–100.

MONKHOUSE, Cosmo. "The First Pastel Exhibition." *Academy* 34 (1888), p. 294.

"The Pastellist Exhibition." *Artist* 11 (Nov. 1, 1890), p. 321.

"The Pastellist Society. . . ." *Artist* 12 (Aug. 1, 1891), p. 240.

"The Pastel Society and the Pencil Society at the Burlington Galleries." *Apollo* 13 (Feb. 1931), p. 135.

PORTALIS, Roger. "Exposition des Pastellistes français à la rue De Sèze." *Gazette des Beaux-Arts,* ser. 2, 31 (May 1885), pp. 437–57.

RINDER, Frank. "London Exhibitions." *Art Journal* (London) 58 (Aug. 1906), pp. 240–42; 59 (Aug. 1907), pp. 247–49.

———. "Pastel Society." *Art Journal* (London) 60 (Aug. 1908), pp. 246–49.

———. "Some London Exhibitions: The Pastellists, British Colonials, and Others." *Art Journal* (London) 54 (Aug. 1902), p. 263.

"Society of British Pastellists." *Artist* 11 (Mar. 1, 1890), p. 74.

"The Society of Pastellists." *Artist* 11 (Sept. 1, 1890), p. 263.

"Some London Exhibitions." *Art Journal* (London) 53 (Aug. 1901), pp. 253–54.

STEVENSON, R. A. M. "Exhibitions in London." *Art Journal* (London) 51 (Apr. 1899), pp. 119–21.

THE SOCIETY OF PAINTERS IN PASTEL

American Watercolor Society. Minutes. Arch. Am. Art, microfilm N68–9.

"Art News and Comments." *New York Tribune,* May 20, 1888, p. 10.

"Art Notes." *Art Interchange* 20 (May 19, 1888), p. 161.

"Art Notes and News." *Art Interchange* 15 (Dec. 3, 1885), p. 152.

COOK, Clarence. "The Painters in Pastel." *Springfield Republican,* June 27, 1888, p. 9.

"The First Exhibition of the American Painters in Pastel." *Art Journal* (London) 10 (May 1884), p. 157.

Montezuma [pseud.]. "My Note Book." *Art Amateur* 8 (Jan. 1883), p. 29.

[W. P. Moore Gallery]. *Initial Exhibition of Painters in Pastel.* Exhib. cat. New York, 1884.

NELSON, Carolyn. "The Society of Painters in Pastel, 1884–1890." M.A. thesis, University of Texas, Austin, 1983.

"Open Questions." *Art Interchange* 12 (Mar. 27, 1884), p. 73.

"The Painters in Pastel." *New York Times,* Mar. 17, 1884, p. 5;

Apr. 21, 1889, p. 19; May 5, 1890, p. 4; *New York Tribune*, Mar. 16, 1884, pp. 6–7; May 2, 1890, p. 7; *New York Sun*, May 17, 1890, p. 6.

"The Pastel Club's Exhibition." *New York Tribune*, May 7, 1888, p. 6.

"The Pastel Club, Third Exhibition." *New York Tribune*, Apr. 21, 1889, p. 7.

"The Pastel Exhibition." *Art Amateur* 10 (May 1884), pp. 123–24; 19 (June 1888), pp. 3–4; 21 (June 1889), p. 4; 23 (June 1890), p. 4.

PILGRIM, Dianne H. "The Revival of Pastels in Nineteenth Century America: The Society of Painters in Pastel." *American Art Journal* 10 (Nov. 1978), pp. 43–62.

"Professors of Pastels." *New York Times*, May 5, 1888, p. 4.

VAN RENSSELAER, Mariana Griswold. "American Painters in Pastel." *Century Magazine* 29 (Dec. 1884), pp. 204–10.

H. Wunderlich & Co. *Second Exhibition of the Painters in Pastel.* Exhib. cat. New York, 1888.

THE PASTELLISTS

"Around the Galleries." *American Art News* 10 (Dec. 9, 1911), p. 6.

"Art Notes." *New York Times*, Jan. 31, 1914, p. 10.

"Calendar of Special New York Exhibitions." *American Art News* 12 (Jan. 31, 1914), p. 6.

"First Exhibition of 'The Pastellists' Suggests the Revival of a Charming Form of Eighteenth Century Art." *New York Times*, Jan. 15, 1911, sec. 5, p. 15.

GALLATIN, A. E. "The Pastellists." *Art and Progress* 2 (Mar. 1911), pp. 142–44.

MACRAE, Elmer. Papers; Diaries. MS., 1911, 1913. Hirshhorn Museum and Sculpture Garden, Smithsonian Institution, Washington, D.C.

MYERS, Jerome. *Artist in Manhattan.* New York, 1940.

"New Art Society Forms." *American Art News* 10 (Jan. 6, 1912), p. 3.

"News and Notes of the Art World: The Pastellists." *New York Times Magazine,* Dec. 10, 1911, p. 15; Dec. 17, 1911, p. 15; Dec. 24, 1911, p. 15.

"Pastellists at Folsom's." *American Art News* 9 (Jan. 14, 1911), p. 6; 10 (Dec. 16, 1911), p. 2.

ST. JOHN, Bruce, ed. *John Sloan's New York Scene.* New York, 1965.

INDIVIDUAL ARTISTS

Edwin Austin Abbey
BALDRY, Alfred Lys. "The Pastels of Mr. E. A. Abbey, A.R.A." *Magazine of Art* 19 (1896), pp. 224–27.

LUCAS, E. V. *The Life and Works of Edwin Austin Abbey, R.A.* 2 vols. London/New York, 1921.

SMITH, F. Hopkinson. "The Pastels of Edwin A. Abbey." *Scribner's Magazine* 18 (Aug. 1895), pp. 135–47.

Yale University Art Gallery. *Edwin Austin Abbey.* Exhib. cat. by Kathleen Adair Foster and Michael Quick. New Haven, 1974.

J. Carroll Beckwith
"Confessions of Carroll Beckwith." *International Studio* 66 (Jan. 1919), pp. xc–xci.

LARNED, Charles. "An Enthusiast in Painting." *Monthly Illustrator* 3 (Feb. 1895), pp. 131–37.

STRAHAN, Edward. "James Carroll Beckwith." *Art Amateur* 6 (Apr. 1882), pp. 94–96.

Robert Blum
Berlin Photographic Co. *Catalogue of a Memorial Loan Exhibition of the Works of Robert Frederick Blum.* Exhib. cat. by Martin Birnbaum. New York, 1913.

BLUM, Robert. "An Artist in Japan (with Illustrations by the Author)." *Scribner's Magazine* 13 (Apr. 1893), pp. 399–414; (May 1893), pp. 624–36; (June 1893), pp. 729–49.

Cincinnati Art Museum. *A Retrospective Exhibition: Robert F. Blum, 1857–1903.* Exhib. cat. by Richard J. Boyle. Cincinnati, 1966.

WEBER, Bruce. "Robert Frederick Blum (1857–1903) and His Milieu." Ph.D. diss., City University of New York, 1985.

Bryson Burroughs
Hirschl & Adler Galleries. *The Paintings of Bryson Burroughs (1869–1934).* Exhib. cat. by Douglas Dreishpoon. New York, 1984.

Index of Twentieth Century Artists. New York, 1936; rev. ed. 1970, pp. 536–41, 544.

MMA. *Bryson Burroughs: Catalogue of a Memorial Exhibition of His Works.* Exhib. cat. by Harry B. Wehle. New York, 1935.

OWENS, Gwendolyn. "Pioneers in American Museums: Bryson Burroughs." *Museum News* 57 (May–June 1979), pp. 46–53, 84.

Mary Cassatt
BREESKIN, Adelyn D. *Mary Cassatt: A Catalogue Raisonné of Oils, Pastels, Watercolors, and Drawings.* Washington, D.C., 1970.

BULLARD, E. John. *Mary Cassatt: Oils and Pastels.* New York, 1972.

GETLEIN, Frank. *Mary Cassatt—Paintings and Graphics.* New York, 1980.

POLLOCK, Griselda. *Mary Cassatt.* London, 1980.

SWEET, Frederick A. *Miss Mary Cassatt, Impressionist from Pennsylvania.* Norman, Okla., 1966.

Arthur B. Davies
CORTISSOZ, Royal. *Arthur B. Davies.* New York, 1931.

———— et al. *Arthur B. Davies: Essays on the Man and His Art.* Cambridge, Mass., 1924.

Institute of Contemporary Art. *Dream Vision: The Work of Arthur B. Davies.* Exhib. cat. by Garnett McCoy et al. Boston, 1981.

Munson-Williams-Proctor Institute. *Arthur B. Davies (1862–1928): A Centennial Exhibition.* Exhib. cat. by Harris K. Prior, with a recollection by Walter Pach. Utica, N.Y., 1962.

WRIGHT, Brooks. *The Artist and the Unicorn: The Lives of Arthur B. Davies (1862–1928).* New City, N.Y., 1978.

Thomas W. Dewing

CAFFIN, Charles. "The Art of Thomas Dewing." *Harper's Magazine* 116 (Apr. 1908), pp. 714–24.

ELY, Catherine Beach. "Thomas W. Dewing." *Art in America* 10 (Aug. 1922), pp. 224–29.

HARTMANN, Sadakichi. *A History of American Art.* 2 vols. Boston, 1902.

HOBBS, Susan. "Thomas Dewing in Cornish, 1885–1905." *American Art Journal* 17 (Spring 1985), pp. 3–32.

————. "Thomas Wilmer Dewing: The Early Years, 1851–1885." *American Art Journal* 13 (Spring 1981), pp. 5–35.

WHITE, Nelson C. "The Art of Thomas W. Dewing." *Art and Archaeology* 27 (June 1929), pp. 253–61.

Preston Dickinson

COLLINS, Enid Dickinson. "Biographical Sketch of Preston Dickinson." MS., 1934, Smith College Museum of Art, Northampton, Mass.

MILIKEN, William M. "Dickinson, Preston." *DAB*, supp. 1 (1944), pp. 246–47.

Sheldon Memorial Art Gallery, University of Nebraska. *Preston Dickinson, 1889–1930.* Exhib. cat. by Ruth Cloudman. Lincoln, 1979.

Arthur G. Dove

Art Galleries of the University of California, Los Angeles. *Arthur G. Dove.* Exhib. cat. by Frederick S. Wight. Los Angeles, 1958.

MORGAN, Ann Lee. *Arthur Dove: Life and Work, with a Catalogue Raisonné.* Newark, Del., 1984.

————. "Toward a Definition of Early Modernism in America: A Study of Arthur Dove." Ph.D. diss., University of Iowa, 1973.

Phillips Memorial Collection. *Arthur Dove and Duncan Phillips: Artist and Patron.* Exhib. cat. by Sasha M. Newman. Washington, D.C., 1981.

San Francisco Museum of Art. *Arthur Dove.* Exhib. cat. by Barbara Haskell. San Francisco, 1974.

SMITH, Suzanne Mullet. "Arthur G. Dove: A Study in Contemporary Art." M.A. thesis, American University, 1944. Suzanne Mullet Smith Papers, Arch. Am. Art, microfilm 1043.

Kenneth Frazier

Westmoreland County Museum of Art. *Kenneth Frazier, A.N.A., 1867–1949.* Exhib. cat. by Paul A. Chew. Greensburg, Pa., 1979.

William Glackens

GLACKENS, Ira. *William Glackens and the Ashcan Group.* New York, 1957.

WATTENMAKER, Richard. "The Art of William Glackens." Ph.D. diss., Institute of Fine Arts, New York University, 1970.

John Marin

Los Angeles County Museum of Art. *John Marin, 1870–1953.* Exhib. cat. by Larry Curry. Los Angeles, 1970.

Philadelphia Museum of Art. *John Marin: Oils, Watercolors, and Drawings Which Relate to Etchings.* Exhib. cat. by Sheldon Reich. Philadelphia, 1969.

REICH, Sheldon. *John Marin.* 2 vols. Tucson, 1970.

Utah Museum of Fine Arts. *John Marin Drawings, 1886–1951.* Exhib. cat. by Sheldon Reich. Salt Lake City, 1969.

Georgia O'Keeffe

Art Institute of Chicago. *Georgia O'Keeffe.* Exhib. cat. by Daniel Catton Rich. Chicago, 1943.

O'KEEFFE, Georgia. *Georgia O'Keeffe.* New York, 1976.

WMAA. *Georgia O'Keeffe.* Exhib. cat. by Lloyd Goodrich and Doris Bry. New York, 1970.

Everett Shinn

DE SHAZO, Edith. *Everett Shinn: A Figure in His Time.* New York, 1974.

G[allatin], A[lbert] E. "The Art of Everett Shinn." In his *Whistler Notes and Footnotes and Other Memoranda,* pp. 79–83. New York/London, 1907.

Joseph Stella

BAUR, John I. H. *Joseph Stella.* New York, 1971.

Hirshhorn Museum and Sculpture Garden. *Joseph Stella: The Hirshhorn Museum and Sculpture Garden Collection.* Exhib. cat. by Judith Zilczer. Washington, D.C., 1983.

JAFFE, Irma B. *Joseph Stella.* Cambridge, Mass., 1970.

STELLA, Joseph. "Discovery of America: Autobiographical Notes." *Art News* 59 (Nov. 1960), pp. 41–43, 64–67.

John H. Twachtman

Cincinnati Art Museum. *A Retrospective Exhibition: John Henry Twachtman.* Exhib. cat. by Richard J. Boyle and Mary Welsh Basket. Cincinnati, 1966.

CLARK, Eliot. *John Twachtman.* New York, 1924.

HALE, John Douglas. "The Life and Creative Development of John H. Twachtman." 2 vols. Ph.D. diss., Ohio State University, 1957.

Abraham Walkowitz

SAWIN, Martica R. "Abraham Walkowitz: The Years at 291, 1912–1917." M.A. thesis, Columbia University, 1967.

Utah Museum of Fine Arts. *Abraham Walkowitz, 1878–1965.* Exhib. cat. by Martica R. Sawin. Salt Lake City, 1975.

Max Weber

Downtown Gallery. *Max Weber.* Exhib. cat. by Holger Cahill. New York, 1930.

Jewish Museum. *Max Weber: American Modern.* Exhib. cat. by Percy North. New York, 1982.

NORTH, Percy. "Max Weber: The Early Paintings (1905–1920)." Ph.D. diss., University of Delaware, 1975.

WERNER, Alfred. *Max Weber.* New York, 1975.

J. Alden Weir

BURKE, Doreen Bolger. *J. Alden Weir: An American Impressionist.* Newark, Del., 1983.

James McNeill Whistler

Bacher, Otto H. *With Whistler in Venice*. New York, 1908.

Coe Kerr Gallery. *Americans in Venice, 1879–1913*. Exhib. cat. by Donna Seldin. New York, 1983.

Freer Gallery of Art. *James McNeill Whistler at the Freer Gallery of Art*. Exhib. cat. by David Park Curry. Washington, D.C., 1984.

Getscher, Robert H. "Whistler and Venice." Ph.D. diss., Case Western Reserve University, 1970.

Index

Page numbers are in roman type. Numbers in **boldface** indicate pages with color illustrations. Numbers in *italics* indicate pages with black-and-white illustrations. Figure numbers are so designated.